Who say Reload

The stories behind the classic Drum & Bass records of the 90s

Paul Terzulli & Eddie Otchere

ACKNOWLEDGEMENTS

My wife Rachel and our son Leo. Eddie and Colin for having faith in the idea and helping me get things off the ground and taking it to the next level.

All the artists that agreed to be involved and everyone that helped make the interviews happen, or at least tried! Brian Belle-Fortune, Tania at UMC, Adam at Charge, Bella at Triple Threat, Harri Davies, Adam at Storm DJs, Graham Warnock, Abel at Finger Lickin, DJ MK, Jaguar Skills, Frank at Vinyl On Demand, Alex at Bassic, Roz Sutoris, Rahul Verma, Megan Mann, Lee Horrocks, Karl Nielson, Simon Colebrooke, Nick Halkes, Matt at Alchemy PR, Jon Cork at Urban Agency, Jess at Insanity, Mark at ESP.

Everyone that offered some advice, encouragement or helped with research (whether they know it or not): Marium Raja, Andrew Emery, Craig Leckie, Imogen Clark, Pete at BBE. Jack Henwood for help with the chronology and providing some of the records for the pics, Tobie Scopes and DJ Kryptyonn for the flyers and all the contributors to the Roll Da Beats forums and on Discogs. Special big-up to my friends Sean and Symes for the support and putting up with me going on about this for the last couple of years, and everyone I went raving with back in the day.

Paul Terzulli, January 2021

First published by Velocity Press 2021

velocitypress.uk

Cover design
Protean Productions

Typesetting
Paul Baillie-Lane
pblpublishing.co.uk

ISBN: 9781913231088

CONTENTS

PREFACE

The aim of this book is not to present a history of drum n bass. The roots of the music are too far-reaching and encompass so many facets of other genres that it is almost an impossible task to document it concisely. Instead, the idea is to document its inception, progression, and impact from the perspective of those responsible.

Having considered the way other types of music have been endlessly explored in both print and visual media, I thought it was only right that someone stepped up to do the same for jungle. To have something in print is important to me. You can find all manner of information spread across the internet in blogs, podcasts, radio shows and on YouTube. Still, I felt there should be something tangible that consolidated it all into one place without the danger of it getting lost in the ether of the social media timelines. Taking inspiration from Brian Coleman's book Check the Technique (essential for fans of 80s and 90s hip hop), Uncle Dugs' interviews on his Rinse FM show and Ian Mcquaid's Gone To A Rave series of articles on theransomnote.com, I set about drawing up a plan to present the stories behind the classic jungle records of the nineties.

I wanted to speak to as wide a range of artists as possible and to cover as many of the influential tracks as I could, taking in the various styles, sub-genres and key record labels along the way. In some cases, it was a tricky decision as to which record to focus on when interviewing an artist. Many have numerous classics to their name, and in some cases warrant a book to themselves. Inevitably some might disagree with the omission of their personal favourites but if one of the results of the project is that it sparks discussion and further appreciation of a particular producer or label's catalogue then that's no bad thing.

Obviously, I'm keen to highlight the people included in the book, but some significant names are not featured, who despite my best efforts I was not able to make contact with or get a response from. With five Moving Shadow releases profiled, I would have loved to have spoken to label boss Rob Playford as his contribution on both the creative and business side cannot be overstated. Rebel MC is another, as he is one of the few that can truly stake a claim to having invented jungle with his early 90s fusion of hip hop and reggae with sped-up breakbeats. Alex Reece is not someone that gives interviews, but as Pulp Fiction is both a great piece of music and a vital record, it is an essential inclusion. Being a very close-knit, relatively small scene for most of the decade, the artists that do not have their own chapter still tend to get a mention, often more than once. The way the lineage of the music weaves in and out of the same names, places and events is a beautiful thing. The likes of Dillinja, Shy FX and Grooverider may not have contributed to the book, but their presence and importance to the scene are made clear in the stories of others.

The visual side of the story was also important, so as well as having images of the records in question I needed photographs that captured the essence of the era, rather than relying solely on present-day pictures and sanitised press shots. While searching online, Eddie Otchere's name kept coming up and having made contact with him it was a blessing that not only did he have a unique and impressive archive of photos taken throughout the 90s, there was the added bonus that he was, and still is, a fan of the music. He was entirely in tune with what I was trying to achieve and was instrumental in making some of the interviews happen and guiding the concept of the book with suggestions and ideas.

Finding a publisher that not only wanted to take on the project but also understood the music seemed unlikely to begin with, but in Velocity Press, we found the ideal partner. Having spent 25 years at the helm of Knowledge Magazine, Colin Steven knows a thing or two about drum n bass, and

with his assistance and connections, I was able to get a few more interviews in the bag to round things off and get over the finish line.

My own musical journey began when I was ten-years-old at a time when it wasn't uncommon to switch on Top Of The Pops and see early house music anthems like Voodoo Ray and Big Fun alongside now legendary rap artists like De La Soul and Public Enemy gracing the national charts. I was eventually more drawn to the hip hop side of things and reluctantly tolerated my friend Kevin's rave tapes throughout the hardcore era until one day he suggested I should check out his tape of DJ Hype's set at Dreamscape 12. Looking back at the tracklist now, all the anthems are present but hearing records like Terrorist, Champion Sound and, most significantly, Dred Bass for the first time was a real game-changer for me.

From there I would eagerly await Kev buying a new tape pack so I could see what else was waiting to be discovered. One thing that often puzzled me was the anonymity of the whole thing. Unlike my beloved hip hop, I couldn't find these records in Our Price, had no idea what the artists looked like, and I was still too young to go to raves. Being someone that likes to know as much as possible about the music I'm listening to, I initially felt there were some barriers to immersing yourself in jungle. In many ways, that eventually ended up making it more fun. Once I started raving, the weeks after an event would be spent trying to hunt down the records I had heard in local specialist record shops and on trips to London's West End where the likes of Unity and Blackmarket Records were nothing less than a mecca for both aspiring and established DJs. I was approaching 40-years-old when I started this book and looking back on that halcyon period, it struck me that not much had been done to chronicle jungle's place in the musical landscape over the course of the 90s and into the 2000s.

I hope that Who Say Reload is a book that will be different things to different people. Of course, it's very much a nostalgia piece and has been created from a fan's perspective; so if you were out raving during the 90s, it might well bring

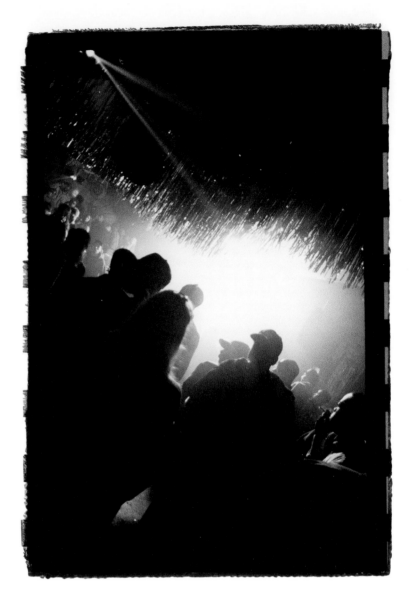

back that feeling (you know what I'm talking about!). DJs and record collectors might appreciate the trivia and small details of what went into making their favourite tunes. For those less familiar with the history of the genre it could well introduce them to records and artists they weren't familiar with. There's a good chance all of that might apply, but essentially it is about showing appreciation for the music that was the backdrop to a whole decade for so many of us and presenting the creators with a platform to tell us about it. In the words of the late great, Stevie Hyper D: "Junglists, are you ready?!"

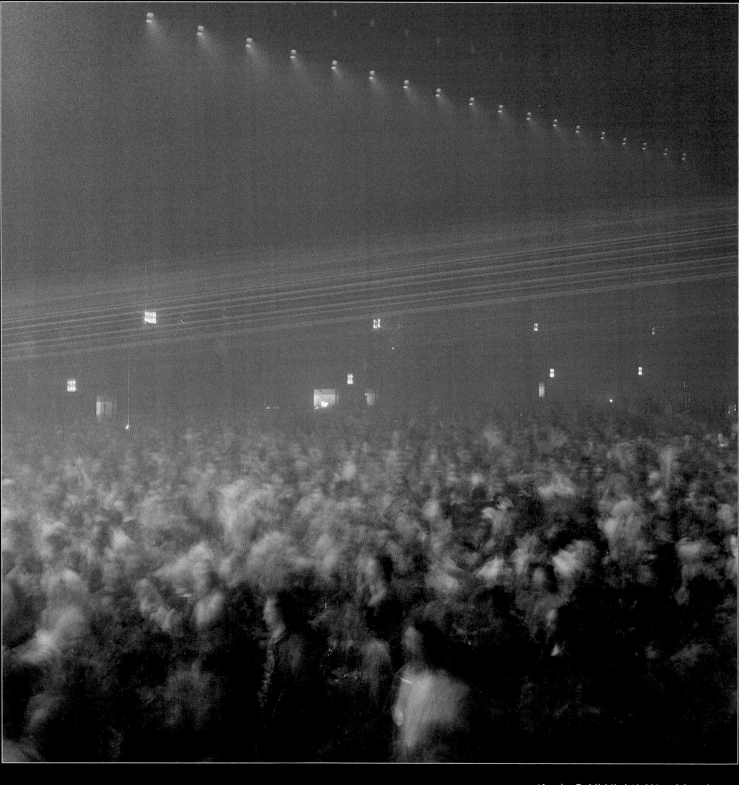

'Andy C All Night', Wembley Arena
(November 2018)

FOREWORD

Birthed in the early nineties and becoming the soundtrack to urban England by 1994, it's not an exaggeration to say that drum n bass changed perceptions of what could be done with dance music. Within constantly expanding parameters you would find elements of reggae, jazz, funk, soul, house, techno, hip hop, r&b, 80s electronica, film scores, and whatever else gave off the right vibe when it was underpinned by a rumbling bassline and crashing, rolling breakbeats.

Perhaps as important to the popularity of the music as the diversity of its influences, was the diversity of its creators. Tech wizards, skilled musicians, street hustlers and ravers appeared from the suburbs and council estates. A generation that had grown up witnessing the DIY aesthetic of punk and early hip hop now had access to rapidly developing and accessible technology. Friendships and creative allegiances were forged on dancefloors, in record shops, on pirate radio and at cutting houses. The shared goal of coming up with a tune that would tear down the place that coming weekend was the driving force, with commercial success and critical acclaim less of a consideration, if it was considered at all. Approval from fellow DJs and a reaction from the ravers was the target and it inspired a sense of friendly competition that would prove beneficial in allowing a relatively tight-knit scene to develop and progress for years to come.

Although the genre can be defined by the tempo of the music and use of breakbeats, identifying the first ever jungle record is not a straightforward task. Certainly, Lennie De Ice's We R IE is a contender, alongside early Shut Up & Dance releases, the Ibiza Records crew and Rebel MC's output in the early 90s. As house evolved into the hardcore rave sound that dominated 1991–1992, labels such as Production House, Reinforced, Moving Shadow, Formation and Suburban Base established themselves as the key players. The underground rave scene began to fragment in 1993, with sides being determined by those who still loved the uplifting piano led sound (what would become known as happy hardcore by 1994 and was increasingly based around 4/4 kickdrums rather than breakbeats) and those who favoured the more adventurous, darker sound being referred to as "jungle techno".

Crews began to emerge and build reputations that became more undeniable with each release. There was the De Underground camp that bought us Cool Hand Flex, Uncle 22 and the aforementioned Lennie De Ice. Deejay Recordings operated out of the legendary Lucky Spin record shop and gave a platform to future heavy hitters such as Trace, Ed Rush and DJ Rap, more often than not with a helping hand from Monroe Studios' engineer extraordinaire Pete Parsons. Jumpin Jack Frost and Bryan Gee set about laying the foundations for the V Recordings empire and linked up with Bristol's Roni Size, DJ Krust and DJ Die. DJ Hype would soon be rolling with Pascal, Rude Bwoy Monty and DJ Zinc as the Ganja Kru. LTJ Bukem had his ever-expanding Good Looking Records camp with Blame, PFM and Nookie packing out venues at their Logical Progression nights.

Perhaps most famously, Goldie created the Metalheadz label and club night and surrounded himself with an A-team that included Photek, Doc Scott, Dillinja, Lemon D, Wax Doctor, Alex Reece, Source Direct and Hidden Agenda. It's important to remember that despite apparent allegiances, it was very much the done thing for artists to release music on each other's labels and trade remixes with their peers. The prolific Ray Keith could be found on imprints such as Philly Blunt, Joker, Proper Talent and his own Dread Recordings, and Peshay and Nookie's catalogues span Reinforced, Good Looking and Moving Shadow.

With the involvement of major labels mostly restricted to licensing tracks for compilation albums, which would prove to be a welcome source of income for many of the scene's label owners, the artists were free to express themselves and take their music in whatever direction they pleased. Many producers and engineers were still finding their way around the studio, but the widely acknowledged understanding that creating a vibe was as important as anything meant that they ended up with tracks that caused mayhem everywhere from smoky basement clubs to 10,000 capacity warehouse raves. Some of these would grace the national charts, and others were sample-heavy productions that for legal reasons were only available as anonymous white labels but still sold in the thousands. There were exclusive remixes that never made it further than a select group of DJs' record boxes

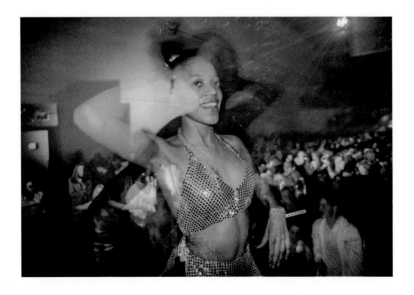

and some releases may not have had a significant impact at the time but in hindsight can be understood in a wider context as having created a blueprint and inspiring others that followed.

This book tells the story of the seminal records from an era when drum n bass was still in its infancy and was largely ignored, or not taken seriously by mainstream media types who were falling over themselves to throw plaudits at the likes of The Prodigy, Underworld and the Chemical Brothers. That's not to detract from the talent of such artists but their tendency to incorporate a more rock-influenced sound was obviously more palatable to white middle-class journalists and BBC appointed tastemakers. It's no coincidence that it was the wave of jazz-influenced tracks and "intelligent" drum n bass that came to be the acceptable face of British breakbeat and was considered less threatening than ragga vocals, Amen tear-outs or gangsta rap samples. Roni Size and Peshay had been releasing music for five years on various independent labels but it took the endorsement of Gilles Peterson's Talkin Loud and James Lavelle's Mo Wax label to introduce them to an audience that might have found venturing into the jungle a rather intimidating prospect.

That drum n bass was not heavily documented at the time was undoubtedly a factor in helping it maintain its longevity. Having witnessed how major labels had mishandled Black music in the past, those involved understood the importance of being self-sufficient and with their own studios, shops, distribution networks and pirate radio stations there was no need for the support of any

wealthy benefactors who even with the best of intentions might not have an understanding of what it was all about.

Having seen the impact this music has had on everything that came after it, it seems only right that those responsible can tell their stories. Twenty-five years after some of these classics were unleashed on an unsuspecting public, the sound of drum n bass does not seem so unusual. It can be heard on daytime radio, on TV adverts and as the backing music to football highlights, but it's important to remember that there was a time that a distorted reggae sample riding a wave of chopped up Amen breaks wasn't considered acceptable by the mainstream. In the years that followed, however, the influence could be heard in UK garage (particularly in its initial speed garage guise), grime and dubstep. Since then we have reached a point where the way music is consumed has changed drastically and with expense less of an issue, and music more accessible than ever, audiences do not need to rely on the decisions of those at the top to decide what they'll be listening to on a daily basis. DJ Fresh, Sigma and Chase & Status, artists who all have roots in

the drum n bass underground, are household names with regular appearances in the top end of the charts. Andy C sells out huge venues around the world on his own and his Ram Records label, started while he was at school in Essex, is now part of BMG, which is in turn part of the Sony empire.

At the other end of the spectrum, many of the originators are keeping things bubbling in the underground. Bryan Gee continues to bring new talent through, DJ Hype's schedule remains as busy as ever, and Ministry Of Sound can still sell a compilation of classic jungle records every couple of years.

As a genre that has ebbed and flowed over the years and seen a variety of trends and sub-genres come and go, it still holds an attraction for new generations of ravers seeking something different from the norm. The elders amongst them might not be in the clubs as often and the music may sound drastically different to when they first heard it all those years ago, but you do not just stop being a Junglist.

Paul Terzulli, January 2021

FOREWORD

SOME SHOTS HAVE A CERTAIN SOUND

Sunday night, YMCA, Tottenham Court Road, London. Crews of youths roll from all sides of England to congregate and gather within this one space for the duration of this, the drum n bass sermon at Thunder & Joy.

Preachers like DJ Ron, DJ Rap, Kenny Ken, Frosty and Nicky Blackmarket make their way down into the chamber beneath the entrance, to find themselves in an environment that feels like a wind tunnel of sounds. The dance is in its foetal stage. It's a foetus that's still to grow and define itself, in this dark, aquatic space. It's a foetus of syncopated rhythms that beat you into a trance; a bastard child with a diverse and almost spiritual following.

Freight weight bass rushes up the stairs, hyperballistic breakbeats blast through the venue. In our hearts and minds, you see a rush of liquid fire. The vibe is now, brave and strong. A vibe that hits hard but yields no pain.

The drum n bass winds up the heads, the MCs chat ceaselessly to a crowd eager to experience and see visions of a new world. For even though it's just a dance and the music can be deemed as noise, it demands you move and distorts your senses and your perception of yourself and your world.

You are now a lion in the heart of darkness, rather than a cog in a company conveyor belt.

Within these dark chambers of wall-to-wall sound, voices carried from 24-kilowatt amplifiers,

Reese bass, drums, sweat, heat, feverous passion: one hardly imagines six floors above the cold realities of life. This is the music of the unsafe and unsure: the movement of youth who find society too rigid for their bodies of fluid and tissue. Dancing in this red womb you feel safe, you feel maybe, as you contemplate, red-eyed and blunted, that you can believe in yourself and conquer the world.

The record is spun back to its very edge, the needle nestles in its groove, the DJ's steady touch takes control, he pauses, tokes what's left of the Buddha and lets the record spin. The needle strategically tears through the vinyl, creating a twisted musical noise of beats and bass. The space is lit up with bodies contorting to the beats. The MC screams: "Can I get a 'Yes, Yes'", at once the DJ is ready to reload and rinse again. He blows out a cool blue smoke as he keeps the fires in our hearts burning. I smoke beats as he plays. I hear the analogue waveforms transmit the message in the music. I feel total peace of mind. The mix is smooth, the drums wrestle with each other while the bass pounds.

Your head begins to nod, your mind sinks into the groove, words seem irrelevant as you envision angels and demons at play, your mind becomes a part of the stream of positive and negative flux, your life is just a movement of energy reforming from state to state. Smile, the high forms visions in his mind.

Eddie Otchere, winter 1994

STEREOGRAPHY

There was a time when I used to dance. My crew, all crew, all tribes, all souls under one roof, raving. We did this because we could, the economic exhaustion had emptied spaces in our cities that we filled. We danced in the former halls of industry, we danced in old town halls, in schools, in fields, in airports. The summer of '88 sowed a cultural seed that only really began to bear fruit in the 90s. It was in these liminal and sonically emblazoned spaces that I began to witness the shoots of a culture that forged the Junglist drum n bass sound.

The roots and fruits of this culture became an obsession for me. I wanted to build a world of the raves and the promoters. I wanted to capture the producers and the DJs. The emcees and the dancers. The life of being a Junglist; from the estate to the studio to the pressing plant. I wanted to represent them even if they didn't want visual representation because we came from the same nexus. The space where dub, reggae, hip hop and skunk weed collided. Musically, you can plot a journey from acid house to grime and see jungle in its path, but it became bigger than a sub-genre in a musical tree; it was my culture, and it fed me.

I shall end my preface with a reminiscence; there are words I wrote at the time and pictures I took at the time, but it's the conversation we're having today that reminds us why. That is to say; it was in our dancing and dances that we let the world know we're right here – all crews and all races as one family.

This family
was the greatest
gift this culture gave
to England at its inception,
but personally, it made me see
a new type of photography, a visual
poetry crafted in the sonic baptism of sound
and street photography. I became conscious, as I leant into the war-like sounds around me, that we were in the midst of something amazing and that it needed to be documented. I adapted my cameras to shoot the raves and document the experience, as well as the pioneers of the genres that emerged from its genesis in the early 90s. The raves, the studios, the radio stations, the cars and the producers that drove them, they're all here. These images are of that time, these stories were recorded by Paul as a living testament to the craft of carving beats and rhythm purely from a feeling. These stories are of that time when we used to dance.

Eddie Otchere, summer 2020

13

4 HERO

MR KIRK'S NIGHTMARE (REINFORCED, 1990)

It is hard to condense 4 Hero's history and influence into a brief paragraph but suffice to say their early releases are a prominent part of the foundations of drum n bass, as is their label Reinforced. Better known as the duo of Dego and Marc Mac, 4 Hero's first incarnation was as a foursome with Iain Bardouille and Reinforced co-founder, Gus Lawrence. Mr Kirk's Nightmare is a decidedly London take on dance music, replacing the euphoric sounds that had been so popular in raves with an edgy, grimier approach to huge effect.

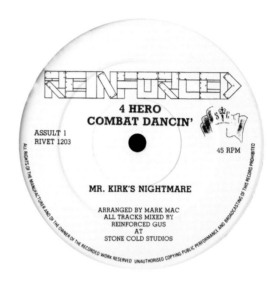

Gus: We were at college together, and we were all into hip hop. Marc had a drum machine and I asked to borrow it; I started programming it at home and it was something that came to me quite easily. I got drafted into a hip hop group called Trouble, bought a sampler, and set up a studio in my bedroom. I was pretty much self-taught. Marley Marl was my favourite producer back in the day; everyone wanted to be like him and make stuff like the Juice Crew records. Mantronix too, he was great at drum programming but I thought I was as good as him. I liked putting as many breaks together as I could without them clashing.

I produced some tracks on MC Mell'O's first album and they were all uptempo so when it came to doing the first Reinforced releases, I was using the same method. By that time I had a really big catalogue of breaks. When I was in Trouble, DJ Pogo gave me a whole bunch of his records, and Marc and Dego had loads of rare groove and all the rest of it, so they gave me records and I had a big library to draw from which made things easier when I was making a tune. Marc and Dego's musical scope was much more vast than mine. I was a hip hop head through and through, which was anti-house music. When we started working together, they introduced me to house music. We had a

radio station called Strong Island and we'd make the jingles in my bedroom studio. Iain came down too and we wouldn't rely on the library of breaks I already had, they'd bring stuff with them.

I had loads of hip hop productions that weren't being released, and I'd tried labels like Rhythm King and Jive, so Marc suggested we should start our own label, which ended up being called Reinforced as my production name was Reinforced Gus. The experimentation that Marc bought along meant that our original idea of doing hip hop records went somewhere else, and became drum n bass. The first record we released was All B 3, which we only did 700 copies on a white label. The second release was a five-track EP called Combat Dancin' which included Mr Kirk's Nightmare.

We didn't make that track in one day. I had that b-boy mentality that you should try and do things on the drum machine and on the sampler that hadn't been done before. That's how I ended up with the loop going backwards and forwards and staying in sync. I think Iain did the bassline

and once we had something we liked I could embellish it after the others had gone home. The vocal sample was in a bunch of records that Marc bought round. I put it on the record and didn't tell the others until I played it to them. Marc wasn't happy with it and wanted to take it off but I thought that as it was controversial, it would sell records.

If you think about the 4 Hero guidebook, rule number one was to do something different. That ethos stayed with Reinforced and spread through the artists. Mr Kirk wasn't a house record; it didn't have a genre at the time. We did what we liked, and we thought other people would like it.

"Rule number one was to do something different."

We didn't make it with clubs or DJs in mind, just ourselves and the record shops, although I remember we thought Steve Jackson would like it and he championed it on Kiss FM. We pressed up the first 1,000 copies and sold them in one weekend. In those days all the pirate radio DJs got their music from the record shops so we took it to Zoom in Camden and they took 250 copies. Blackmarket took 250, and two other shops took 250. They sold out and we went back a week later with another 1,000 copies, and they all sold too. That was all done out of the back of my mum's Nissan! It was popular straight away. The shops didn't normally take that many copies at once; they might take a box of 30. They'd play it while we were in there and people would start asking what it was. We hadn't experienced that before as the first release did 700 over about two months, and half of that was probably given away as promos. There was a big difference, and we knew we were onto something.

Pacific Records contacted us and wanted to distribute it as a proper single, so we released it as a three-track 12", which is how there came to be 2,500 copies of [catalogue number] RIVET 1202, which was the five-track EP, but 28,000 copies of RIVET 1203. That should have set up the

Dego DJing in East London (1994)

label financially, but then Pacific went bust and didn't pay us any money, apart from one cheque which bounced. We had pressed up the amount of records they asked for so we owed the pressing plant £15,000. In addition to that, I'd invoiced Pacific for the money they owed us, and that was on their books when they filed for bankruptcy. I'd included VAT, but I didn't really know how that worked at the time and ended up with the taxman knocking on my parents' door saying I owed them £7,000! I didn't have that money and it got sorted out eventually.

Fortunately, the pressing plant knew about our situation so they gave us some more credit to press records so we could earn the money to pay them back. They'd seen we'd had a hit so would be good for it and had faith in us. We started making records under different names so we could put as much music out as possible to pay back the money. That was what set up Reinforced Records as we ended up putting out a new release every few weeks. We had Tek 9, Manix, more 4 Hero records, all selling 25–30 thousand each. There was a Music Week article that said the most successful independent labels for the first quarter of 1991 were Virgin, Jive and Reinforced. We didn't really get too much interest from major labels at the time though. I think maybe they were afraid of us, being four black guys from north west London. It was easier for them to approach Sub-urban Base or Richard Russell at XL Records, who had both started up around the same time.

We recognised when people were sampling us and doing patterns and arrangements that we'd done, but we weren't aware of our impact then like we are now. We just thought people were biting our style. There were a couple of occasions where there were incidents with other labels, but you can't put them in print!

Gus in the Reinforced studio, Dollis Hill (1996)

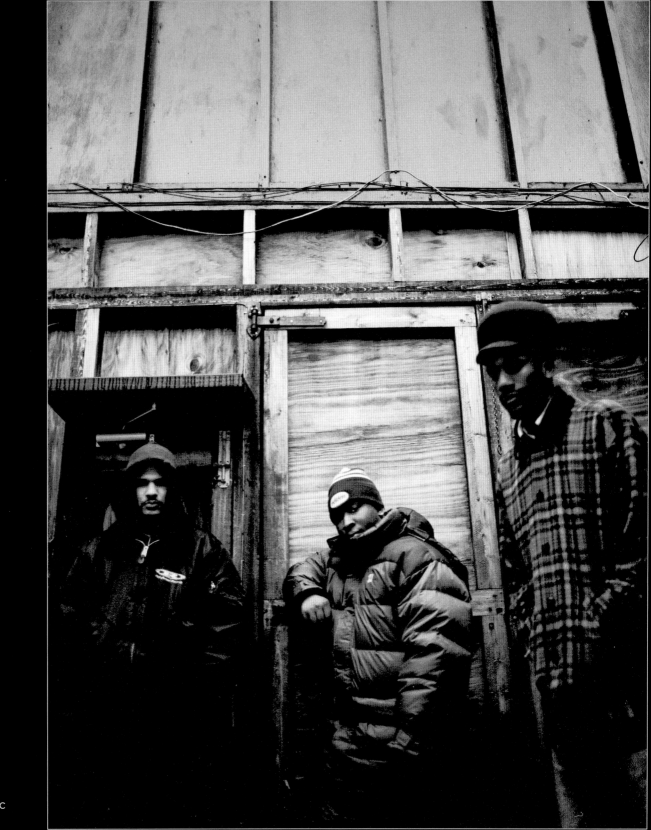

4 Hero: Iain, Marc Mac
and Dego (1997)

THE RAGGA TWINS
SPLIFFHEAD (SHUT UP & DANCE RECORDS, 1990)

Much is made of the influence of reggae sound systems in the history of drum n bass. The Ragga Twins are where that crossover begins. Performing for various sounds around London during the 80s, Flinty Badman and Deman Rocker linked up with Shut Up & Dance and the turn of the decade and 1990 saw the release of the ground-breaking Spliffhead, a fusion of uptempo breaks and reggae that gave birth to a whole new era in British music...

Flinty: We had been part of a reggae sound system called Unity but in 1989 we decided that would be our last year on the sound as we weren't releasing enough records and we wanted to do more in the studio. We didn't think we'd end up doing acid house music though. That was when Smiley from Shut Up & Dance came to see us as he had sampled Deman's voice from a tape of the sound system for their track Lamborghini. He asked us what he could do in return for using the sample.

We already knew them as we went to primary school with PJ, and Smiley had a sound system that played against us when we were teenagers. When they met Deman, he said he was going to bring me in with him and we went into it wanting to be solo artists: Deman Rocker and Flinty Badman each doing our own tunes. It was their idea for us to come together as a joint act. They had been in the game for a couple of years and had some big tunes, so we went with it and came up with the name Ragga Twins.

We weren't into their music to begin with. We had heard about acid house, and it was in the news at the time but all we knew was that there were people taking ecstasy and having a good time! A few of our mates were going out and didn't know about our tunes with Shut Up & Dance so they'd be telling us they heard our voices in the raves.

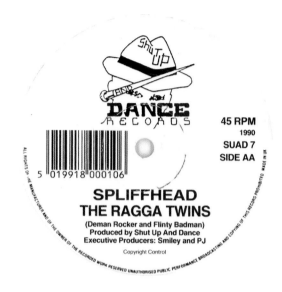

We didn't even know they were being played at that point. When we first started doing PAs we would leave straight after and end up at a reggae dance or just go home. We weren't sticking around to hear the music, but one day there was a show at the Essex County Show Ground with us and The Prodigy headlining. It was an outdoor event and a nice sunny day so we decided to stay and see what it was all about. We ended up staying until the end; no Es, just smoked weed and danced the night away. I think it finished at 6am. From then on we didn't look back, I think we were going raving every weekend.

PJ and Smiley would do all the tracks. They had already done 5, 6, 7, 8 and Dance Before The Police Come before we got there so as far as we were concerned they knew what they were doing, and we didn't get involved with any of the music side, we just came in as vocalists. We had a mix of new lyrics and some stuff from when we were chatting on the sound. As reggae MCs we wrote lyrics and would chat them live over a certain riddim; then what

would happen is you would get that riddim and release it on vinyl because people are feeling it when they hear it in the dance every week. So that was how we worked when we came over to Shut Up & Dance; we had lyrics people knew from the raves when we were freestyling, so then we can put it on a record. For Ragga Trip, Deman already had the lyrics about acid raves and ecstasy tablets so that fit in well with what we were doing.

It opened up a whole new audience for us, and it also opened up a whole new audience for reggae music. People wanted to know where the samples were coming from. They started to feel reggae music which was predominantly black people's music. The kids in the suburbs didn't have sound systems where they lived so when they started to hear us it was like a blessing for them and something different. We didn't even realise how big it was and then the album [Reggae Owes Me Money] got to number 26 in the national charts. At the time we were fresh into learning how the music industry works. Back in the 80s when we were doing reggae you would release the tune and wouldn't see the producer again, you didn't get no royalty statement, nothing!

When PJ and Smiley ran into problems with Raving I'm Raving [the duo were subject to legal action by US singer Marc Cohn for sampling his song Walking In Memphis without permission] they got hit hard in the pocket and that put a stop to our second album. They told us they couldn't afford to release it so we parted ways and signed to Positiva/EMI in 1994. There was a group called US3 who had a big hit with a track called Cantaloop, and they started doing some production for us. We did a few demos and Positiva liked what they heard. It wasn't their usual thing but they said they could work it, but in the end, they couldn't! It was a good album, people loved it and the build-up to releasing it was on point but for some reason, they held it back and then by the time they put it out, the hype had died down. That was another learning experience for us and we decided once that contract had run out we wouldn't stay with them.

Deman Rocker at Jungle Fever, Roller Express (May 1994)

Through that time we were still going to jungle raves and performing as MCs. The label didn't like it and told us we shouldn't do it. We tried to tell them we had a big fan base in that scene and that's what we should use but they had different ideas. They did some remixes but we should've had an original jungle track at that time. With EMI's backing, it could've been big but they had other

ideas. Nick Halkes [Positiva label manager] is a good guy though and we still talk. Later on, they ended up putting out some jungle tunes. We were always ahead of our time.

In the early days, around 1992, MCs would mostly just host and be behind the DJ. Me and my brother would go to Roast and would just grab the mic and go to the front of the stage like we would in reggae, and that started the evolution of the MC being a frontman. We did Kool FM which was owned by Eastman who had a sound system back in the day, so that connection was there already. We went up to the station with Navigator and started chatting over the beats and people that knew us from reggae would start locking in to Kool. A good jungle scene started developing and there were more black people coming to the raves and more producers were using reggae samples. We were bringing the wheel-ups and reggae slang. We definitely had a big influence in building the scene on the MC side of things.

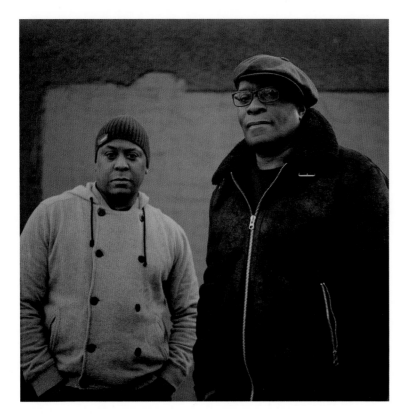

Shut Up & Dance, East London (December 2020)

I had no idea those early tunes would do that type of damage and still be doing damage now, thirty years on, and people still love that album. When we first came out, we had no idea it would have an impact like that. Respect goes to Shut Up & Dance.

PJ from Shut Up & Dance: We were listening to hip hop like early Marley Marl, LL Cool J, Whodini, Run DMC, Kool G Rap, Big Daddy Kane and a lot of Public Enemy. We were really into the Bomb Squad's production. We had a sound system called Heatwave at the time and we played all different kinds of music. We played reggae and rare groove, and then when hip hop took the UK by storm, we went out and bought some Technics. We had DJ Hype on the decks cutting it up with me and Smiley rapping over the top and Smiley's brother Daddy Earl is a reggae MC so he'd be up there too. We had love for all types of music and when we moved into production we carried on with that and experimented and put it all in the mix.

We had a few studio sessions where we tried out some engineers but none of them were really any good. One day we worked with a guy called Alex, and he went on to be our engineer for years. He showed us the ropes on the technical side but as far as how to put tunes together, we just learned as we went along. This was in the late 80s and we weren't getting any love from the UK hip hop scene. There were stations like LWR and Dave Pearce had his rap show, and there was Westwood. We'd send in our demos, but they wouldn't play it, so we got fed up and decided to put out a tune out ourselves, which was 5, 6, 7, 8. We pressed up 500 copies and drove around the West End and left a box in each record shop.

Smiley had a younger brother who was a raver, which we weren't into at the time, and he told us that 5, 6, 7, 8 was getting caned in some club. That club turned out to be Dungeons on Lea Bridge Road in East London, so we went down there and the tune got played and it smashed it. It just tore the place down and we realised that we had something.

That went well and once we had that heat DJs would come to us asking for an exclusive on our next tune, or trying to get it upfront before it hit the shops. Obviously, Hype got a lot of our stuff before anyone else. Really it was the pirate stations that made us; we were lucky we got a lot of love there as they were very important in getting the music out to the people. Back in the day, you could tune across the FM dial and with every turn you'd find another station. There must have been 20 to 30 pirate stations and they'd all be playing our stuff.

"When we look back, we realise we were part of something and we were literally there at the start, and that it was something unique that came out of the UK."

After our first couple of singles, we started hearing what people like 4 Hero and Rebel MC were doing. As we'd been so influenced by hip hop, we had this whole breakbeat sound and we wanted it to be danceable so we started speeding the breaks up. We didn't just want slow b-boy rap because we'd been into body popping and breaking. We wanted something a bit faster.

We didn't really like the piano stuff. We liked the odd tune but on the whole, we kind of hated it. We decided we'd do our thing with raw breaks and very reggae-influenced basslines and melodies. That's how we came to sign the Ragga Twins. We knew them from the sound system days and as our production went more in that reggae direction we thought we should try to use some reggae MCs. At the time it was just an experiment as no one was doing anything like that. The records we made with Ragga Twins are definitely the first things we made

that had a direct influence on what would become jungle music. We were the first to fuse sped up breakbeats with reggae vocals, and when our sound became big people started to copy that.

As we got more successful money was coming in, and we had a licence to be more experimental with the music, so we ended up signing Nicolette which was more jazz-influenced. We held an audition at our studio one day and she came down. She was from Cardiff but happened to be in London. She sang Summertime by Billie Holiday over a raw breakbeat production and we realised we had something. We would experiment with each artist and try and show a different side of us. The soulful side, the jazzy side, the reggae side. That's what it was all about.

We made the decision to stay working in the studio producing music rather than trying to DJ at the same time. That kind of helped the Ragga Twins get big as when people wanted to book us we'd send them out instead, and it meant people could put a face to the music.

We'd go along to the raves with Hype. As a producer, you have to go out and see what your tune is doing and what the vibe is. As we moved into that jungle era, we set up a sister label called Red Light which was initially just to give Hype dubplates. If he was playing at Fever or wherever that weekend we'd have a dubplate ready for him to collect on the Friday. Then people started coming to us asking what the tunes were so we started putting them out but it was very limited edition and very low key.

Obviously, at the time we were aware people were beginning to copy our sound, but then we really noticed our influence years later when DJs and producers tell us they got into this because of Shut Up & Dance. Some of these people are big names now but the first record they bought was one of ours. When we look back we realise we were part of something and we were literally there at the start, and that it was something unique that came out of the UK.

LENNIE DE ICE
WE ARE I.E. (REEL 2 REEL PRODUCTIONS/IE RECORDS, 1991)

We Are I.E. was one of the first records to signal a shift away from the European and American music that had dominated the raves of the late 80s. With its Amen break, reggae bassline and gunshots it laid the groundwork for a style that would become uniquely British and eventually develop into what would become jungle...

Lennie De Ice: Growing up I was into the new wave of hip hop and electro like Mantronix, Jonzun Crew and Afrika Bambaataa, plus I'd grown up in the era of Gary Numan, the new romantic and ska era, so I had been blessed to have those eclectic styles of music around me. Mantronix was one of the main people I was fascinated by; he's very underrated and really influenced me. I used to go into the local music shop on my way home from school and play around on the drum machines. They would let me stay in there and mess about until closing time. I was fascinated with these little boxes that you could make beats out of.

Around 1986 I got my first keyboard which was a Juno 106 and my first drum machine was a Roland 505. I couldn't work it and was on the verge of throwing it out of the window when a mate came over and showed me how to use it. I was also DJing around that time and I'd warm up for people like Linden C and Dez Parkes playing rare groove and hip hop. I was part of a sound system with my friend ET, who I would later make jungle tunes with, and we'd use the drum machine to make sounds effects and little jingles for ourselves; it was a hobby that grew into a passion.

Around '87 I was introduced to acid house when I went to a rave on Carpenters Road in East London. After that, I went to Sunrise, Energy and Metamorphosis. I remember hearing A Guy Called Gerald at Dungeons on Lea Bridge Road in East London and thinking to myself 'yeah, this is on!'

1. DANCE BAD
2. WE ARE i.e.

3. AT IT AGAIN
4. FEEL THE RHYTHM

It gave me goosebumps. It was an eye-opener going from the sound systems and house parties to these warehouse raves and there would be hundreds, sometimes thousands of people just having it. I was still a b-boy then and I used to be known as Lennie De Ice Fly MC because I used to MC when I was younger.

I started playing for a promotion called Empathy which was mainly at The Dungeons and we also did Astoria and Milk Bar. Me and my mate that had shown me how to use the drum machine would perform live at the illegal raves as Ill Tempo. We had the keyboards and sequencer on stage, I think we might've been doing that before Guru Josh and Adamski. Everyone at these events was wearing shell suits or dungarees but our style was more like the hip hop boys because that was where we came from.

In 1989 in we did a PA at The Dungeons and Adamski was there and started playing along with our set. It was going off and I wanted to replicate the excitement of the rave and capture that feeling in a tune. I'd already set out

the beats for We Are I.E. in December '88, but it was done at 118 bpm. I took the Amen break off King Of The Beats by Mantronix and then it was just a matter of finding the rest of the samples. I found the spinback and the gunshot off a Simon Harris sample compilation. It wasn't common to have a gunshot on a dance record back then but I was coming from the sound systems where they would use it as a sound effect. I found the "we are e" sample, and it was part of a whole chant. I was worried people might think I was messing with religion as it sounded Arabic. I found out it wasn't but I didn't know if it would work and go down well with the whole Saddam Hussein thing that was going on at that time, with the Gulf War about to start. I left it and made a few other breakbeat tunes which were really good.

I'd been building up my studio equipment so I had a reel to reel, a sampler and an Atari which cost about £800, and it only went up to 4MB! Uncle 22 showed me how to use Cubase on the Atari and I met up with Coolhand Flex's brother Long John [John Aymer] who ran Reel 2 Reel and his other brother Michael ran the De Underground record shop. Randall, Uncle 22, Flex and A-Sides were part of their crew so I would play them my stuff and they'd call the music we made Wacid which was like acid but with reggae basslines. Some of the tunes we were making would just be called Wacid 1 and Wacid 2 until we could work out a title.

I was playing John some tunes, and We Are I.E. was probably about the 15th one I played. He thought that one was the winner. I thought the tunes I made after it were better because I was learning more about production as I went on and my technique was improving. I was trying to get him to take the last four I'd done. He wanted We Are I.E. and another track. We used to go and see Paul Ibiza and Potential Bad Boy from Ibiza Records as they had a studio and had been around for a while. John played it to them and they thought it was very advanced and didn't know if people would take to it. It was a hybrid tune, I didn't really know what I was making. I wanted to make a tune that symbolised everything I was into – the breakbeat was hip

hop, the gunshot and rewind from the sound systems and the 4/4 from acid house.

We took it to Shadowlands studio in Forest Gate to re-master it. John decided to put it on an EP with tunes by Uncle 22 and Coolhand Flex. The label was going to be IE Records and We Are I.E. would be the one to launch it. We decided to get a dubplate cut and went to Music House; back then Music House was always booked for the reggae labels like Jet Star but we were lucky and Chris gave us a slot. He liked cutting our stuff as it wasn't the reggae he was used to.

"We never got mainstream play – they would play Ebeneezer Goode but not We Are I.E.!"

There was a big rave that night called Living Dream at Eastway Cycle track in Leyton. Randall was playing that night and he loved the tune. He had dubplates of the whole EP, which no one had heard before. I remember his set and while I was standing by watching what was happening he told me he was going to drop my tune. It wasn't a normal 32 bar intro; there was no set pattern, it was just a groove. You have to listen to it first to know where the changes are before you can mix it. We Are I.E. came on, and there must have been at least six thousand people in there but I could only see the first couple of thousand and it looked like they were dancing to it, but slowly. I wasn't sure if they understood it or if they liked it, and wondered if John had picked the wrong track. Then Randall said he was going to play it again at the end of his set. When he played it the second time, I could see more movement than before. They were familiar with it and liked it. The people at the front were having it and as I walked further back, the crowd was into it.

John would go to record companies and try and pitch our tunes. A couple of times I went with him to Rhythm King and another independent label in Greek Street. We tried a couple of majors too and got told that "breaks and bleeps"

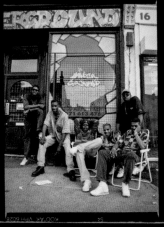
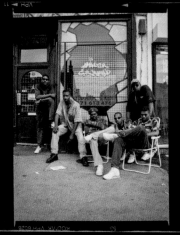

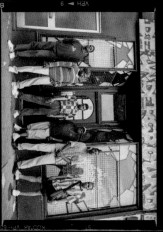
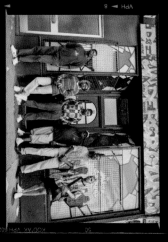
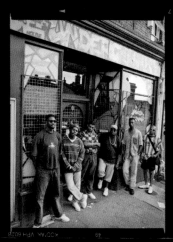
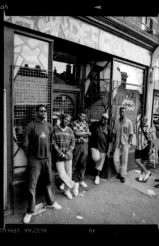
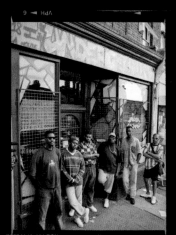
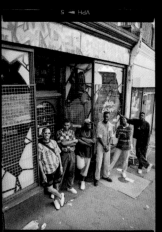
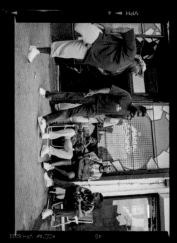

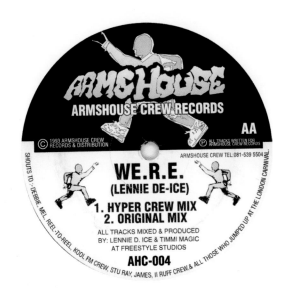

weren't really in, and it was dated. The thing was there were no bleeps in We Are I.E., so they obviously didn't get it. We had seen what happened at Living Dream and if we could've filmed it that it would've made the pitch easier but we didn't have that back then so we got knocked back. We never got mainstream play – they would play Ebeneezer Goode but not We Are I.E.!

Around the time it was released I went away for something that happened about four or five years prior which had caught up with me. It wasn't my proudest moment and I had to do my time. It sounds crazy but the whole time the tune was being played out the only times I got to hear it was on Kiss FM or on the pirates because I was

locked up on F-Wing in Brixton. At night time when all the screws had gone, people would put the radios on and have a little rave inside their cell with some puff or whatever drugs they had; trips were rife inside. I was locked up at the same time as a few of the rave promoters from back in the day and a lot of the people inside had been ravers. I remember Colin Faver playing it one Saturday night; people knew it was my tune and they all had the plastic cups banging against the bars in the cells when it came on. It was sad but a proud moment at the same time. It's a shame I never got to see the full impact that the tune was having apart from that night at Living Dream. I came out of prison at the start of '93. Reel 2 Reel had been taking care of the record and sold about 16,000 copies out of the boot of the car.

It took me a long time to make but I did it exactly how it was supposed to be done. My mate had rapped on One Tribe's What Have You Done which came out around the same time and I originally wanted something like that on We Are I.E. but because of the way it came out I decided that less was more. It resonated with people. I felt like we were a musical family on a mission, an example of the future. It still gets played in old school raves and on the UK Garage circuit but I never had an ego about how big the record was as the people around me kept me grounded. To be considered one of the pioneers for the template of jungle is an honour.

A GUY CALLED GERALD
28 GUN BAD BOY (JUICE BOX, 1992)

With 808 State's Pacific State and his own Voodoo Ray, Manchester's Gerald Simpson was involved with two of the records that soundtracked the peak of the acid house rave scene in the late 80s. Having been cast at the forefront of the UK's burgeoning dance music scene, he began working on breakbeat infused tracks in the early 90s. Born out of an ill-fated deal with Sony's Columbia imprint, the releases on his Juice Box label would contain some of the earliest examples of the elements that would go on to be the foundations of drum n bass. The raw breaks with stripped back drums and aggressive vocal snippets found favour with DJs that had gravitated to similar records by the likes of Shut Up & Dance and 4 Hero...

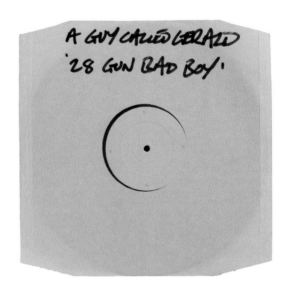

Gerald: Sony signed me off the back of the success of Voodoo Ray and they wanted more of that, but as soon as people had started making all the cheesy rave shit I wasn't interested. I'd never wanted to make any commercial shit. As soon as I signed to Sony I bought myself a recording studio. I'd been given my own imprint, which was called Subscape and that's when I made my first breakbeat tracks. I spent a year making an album off my own back, but Sony said it wasn't good enough and they wanted me to go into their studios. So, like a fool, I took my tapes down to them and redid the tracks with their engineers, exactly the same as I'd done it in my own studio. After I finished it they wouldn't give me the masters and said they owned them. They wouldn't answer my calls; they didn't drop me, they just cut me off. Total disrespect.

In 1992 I went off and started a label called Juice Box, which was also the name of the sound system I had with MC Tunes. My breakbeat tracks were born out of pure anger with the Sony situation; we put out stuff like Digital Bad Boy which was great; that was the sort of thing you can make when you don't have anyone telling you what to do. There was no sample clearance, it was all underground. I was listening to what was going on with Shut Up & Dance and, later on, the guys from Reinforced were a big influence on me, as well as the reggae, hip hop, and techno stuff that was around. Everything rolled into one and I had the freedom to do what I wanted to do. 28 Gun Bad Boy was made out of pure aggression against Sony. 100% pure aggression.

There were no superstar DJs wanting to play your records back then. I was just in the studio and my management company started up a distribution company called Deltra so they would send the records out; I didn't know where they were going. The first time I knew people were playing them was when I got a phone call from Goldie saying to come and check him, as the tunes were smashing it down in London. 28 Gun Bad Boy and Anything were

out by that time. I was just banging out about four tunes a week. There was a scene for the music in Manchester but you couldn't do anything because the kind of people interested in it were shooting up the place with guns and shit. It was very hard to do a dance in Manchester. Even if we went out of town, they'd go to somewhere like Coventry and cause havoc down there.

I don't survive off DJ bookings; I'm a studio guy and I was running the label. People didn't book me, and Sony had me touring the US and Europe but kept me away from the UK. England was like a no-go zone. When people were going to Ibiza and the whole summer of love was happening, I wasn't involved in all that. I always did my own thing. I went to the US and I got mad support though. When I had some differences with 808 State there was no support for me in the UK; my management was trying to get me to shut up and not talk about it but when I went to Detroit these guys had a reception for me wearing t-shirts that said Get Gerald Paid! I got mad love from Detroit from day one and I was always supporting them too when they had tunes out. There was a shared common ground with what we were doing.

> *"The rave scene was a mixed bag of people and that's what made it fresh and kept it new, people were excited by it."*

The UK has always been at the forefront of this. I moved over to America for a while, which had been a place of inspiration, and they're looking to the UK for what's next. Even now you can go to Japan and they're into what the UK is doing, whereas before jungle I don't think was the case. Rave was mainly a UK thing when it started and other countries did their own thing with it. The rave scene was a mixed bag of people and that's what made it fresh and kept it new, people were excited by it.

Gerald in DJ Ron's studio (1995)

I'd come down to London to get away from all the shit that was in Manchester at the time and go to Jungle Fever, Jungle Splash and all that. I hadn't seen anything with that atmosphere ever. As soon as you get in the door, the heat hits you and everyone's just shocking out, it was fucking mental! You can't buy that feeling, the music creates it. Everyone was dressed well and there were girls there and bottles of champagne. It went from that to lads in anoraks talking about Amens, which I don't mind but it gets too much. I grew up going to blues parties and shebeens throughout my teens and there would be women there and they'd be dancing and that helped make the atmosphere. That was what the music was for, you didn't get trainspotters! There was no room for that for me; I can get into the technical side too but I like the balance. I don't like it when it just sounds like machines, that's what happened with techno and it starts plodding on. I understand people being into it on a technical level but leave it in the studio. I grew up going to places where people would physically stop one track and put another one on and the crowd would still be vibing. You can't have the same sounds playing all night.

I was into some of the reggae jungle because I had that background but some of it got too cartoony. I really liked

the dark stuff and the dark stuff with the vocals like Internal Affairs [Goldie and 4 Hero]. I loved that, to me, it was like jazz. It had all the elements you wanted and my studio was built for that; being able to experiment with melody as well as with breaks and textures of sounds. It was perfect for that.

By the time Metalheadz was happening I was living in London. The first time I met Goldie he was saying I should do some stuff with them at Reinforced, and in a way, I would have loved to, but I was working in a totally different way and I still do now. They were all working with Atari STs and stuff like that and I was in a professional studio recording on two-inch tape using 36 channels with no regard for sampling memory. Everything was going on the tape. When it came to working with someone else it was a different world.

If someone wanted to do something they had to come up to Manchester and I wasn't too keen on working with anyone else at the time. I saw where it was going with some of the commercial stuff and I decided to stay on my own vibe; I was on my own from day one. I was really lucky that I have constantly stayed doing my own thing and I don't really follow anything. If it sounds like something else I'll try and switch it up. The way I see it is that everything I've done in the past is part of my pallet so if I do a tune it can have elements of jungle or acid or whatever. It will be a mixture of all the things I've done before.

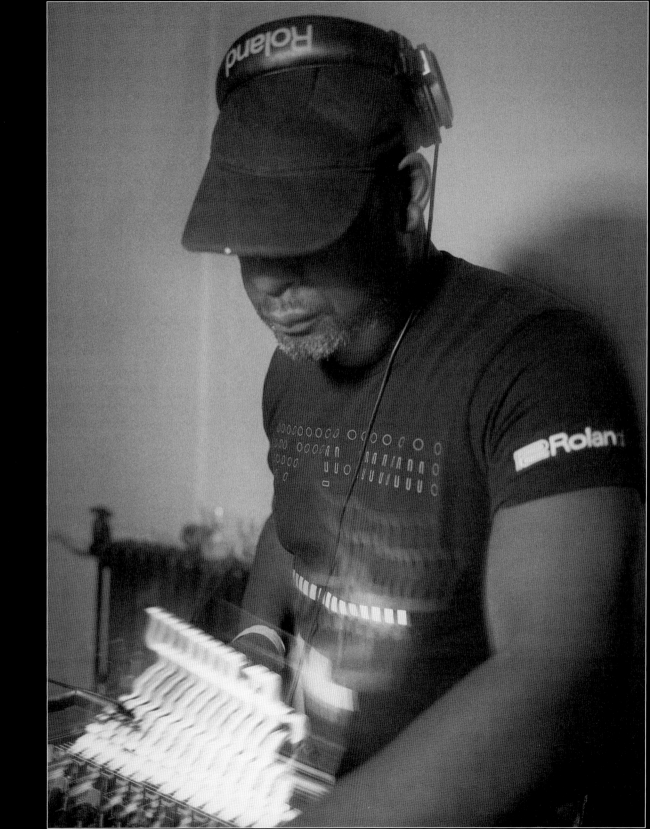

A Guy Called Gerald
at Bussey Building in
Peckham (2017)

BASEMENT PHIL

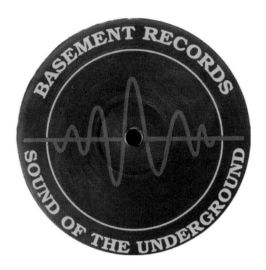

Phil Wells, aka Basement Phil, is the founder of Vinyl Distribution, Basement Records and the Record Basement shop in Reading, Berkshire. All played an important role in the scene throughout the decade as the music shifted from house to hardcore, into jungle and drum n bass.

Phil: Originally everyone was together in the rave scene. That was a great period and records were selling in large amounts. Then things broke up as the music changed, and you had people like Pete Tong, Paul Oakenfold and Andy Weatherall who all went off and created their own thing, which meant there was a bit of a dip in sales. There was a copy of Mixmag around that time with the headline "Raving is dead" because everyone had moved away.

There was Flying Records in Kensington which is where Rocky & Diesel were, and that was where the indie dance scene was. Carl Cox and Oakenfold were playing the harder stuff and then there was the house and garage lot like Brothers In Rhythm. The d&b and hardcore scene then split, so there were happy hardcore DJs like Slipmatt and Seduction. They went one way as their music got faster and eventually led to the Bonkers albums. What was left over was maybe 150 people from the rave scene and that's what drum n bass emerged from.

Jungle was reigning supreme at one point and it was scaring some people off. I was receiving demos from artists that were making this new sound that we now know as drum n bass. I decided that's what I'd concentrate on with Vinyl Distribution. We stopped selling everything other than the new drum n bass stuff. I started putting my time and effort into artists like Photek, J Majik, Peshay, Dillinja and labels like V Recordings, who had Roni Size. This was around mid-1993 and record sales dropped through the floor. We'd only press between 250–500 copies of most records so it was bad. I'd ring shops up trying to offer them

these records and they would tell me that it's not really selling but we like you so we'll take a few copies to keep you in business! That is what it was like in the early days and that's why now a lot of those records sell for so much money because they weren't pressed in large quantities. What happened next was that d&b evolved and started to find its place.

Fabio and Bukem started doing Speed and that was a massive influence on the scene. There were maybe 50 people in that club when it first started but all the people in there were producers or label owners, so everyone heard each other's stuff every week and that helped create the formula. That was the start of it really, and "intelligent" drum n bass – as the press called it – suddenly became very popular. At the time a guy called Leo ran Speed. He worked as an A&R at East West Records so he was friends with all the celebrities in the house scene and started bringing famous people down, so you'd see Bjork, David Bowie, Everything But The Girl, loads of different people in there. The club took off and you couldn't get in. Drum n bass started getting played by a wide variety of DJs, like Mixmaster Morris, Colin Faver, Colin Dale, and even John Peel.

By that point in 1995, we were selling big numbers of some records, but we'd only sell through the independent shops. The top labels of the time like Metalheadz or V Recordings would be doing around ten thousand copies in the first week of a release. The average sales would be between 10 and 30 thousand. The major labels wouldn't believe it and didn't understand how big it was. I would often go to meetings where a label like Sony was signing an artist I'd worked with so I knew what they could sell. I would explain to them that there was a whole underground network they didn't touch and if they cut the artist off from that they would lose a lot of sales because that audience wouldn't go out and buy a CD. The first time I had a meeting with Sony about a record I told them we wanted the exclusive rights for the vinyl, they asked why they should do that and I asked how many they'd sell, which was a couple of thousand, whereas I could do 20 or 30 thousand. We had a different approach towards selling the music. I would call Blackmarket Records on a Monday morning and speak to Nicky and he'd take a thousand copies of a record. That allowed us to generate more money for the labels and artists.

Around 1994 I met DJ Rap for the first time. She came down to see me and as we were chatting it became clear she hadn't really earned any money from her music. Her records were selling large amounts but she'd either not been paid or been paid very little. I offered to set up a label for her, which was Proper Talent, and off her first record, she got a cheque for about thirty grand. That started me off setting up a whole load of labels for people. I'd call up DJs and suggest it to them so they could sign the tracks they loved.

Around that time all the labels suddenly started appearing. Some people didn't need my help, like DJ Hype who was perfectly capable of setting it up himself, and Ganja Records was a massive label for the company. I had Jon Black on board as my in-house artist, so when we had a new label coming out I'd go and talk to him and that's how the artwork would evolve for each label. We pressed everything at EMI so we had beautifully pressed records.

We could turn things around and restock quickly so we were able to power forward, and it was during that period that the majority of big d&b labels in the 90s were set up with us. The only ones we didn't have were Reinforced, Moving Shadow and Suburban Base who were with SRD [Southern Records Distribution] from day one. I tried to get them to move but they were being treated well as they were the top labels at SRD and if they'd have moved over to me they'd have been one of many.

"The top labels of the time like Metalheadz or V Recordings would be doing around ten thousand copies in the first week of a release."

I was proud of the music we were selling and I was proud to represent all these different people. I wanted to do the best job possible because I adored the scene and loved the music. I used to pinch myself because I couldn't believe that this is what I was doing for a living. It was a great period of time and I loved every moment of it.

LTJ BUKEM

DEMON'S THEME (GOOD LOOKING, 1992)

One of the pioneers, LTJ Bukem and his Good Looking Records stable pretty much created an entire sub-genre of drum n bass. The melodic, soulful sound attracted a loyal following that remains decades later. Demon's Theme was the one that kicked things off in 1992 and was followed by a stream of future classics such as the seminal Music, Atlantis and Horizons, all of which were evidence that drum n bass was a genre without boundaries and had a huge influence on a generation of producers...

LTJ Bukem: Creativity for me in 1990 started with finding a great sample, be it a sound or a break, or finding a great preset in a synthesiser to play a chord or lead sound with. With samples in those days, none of us realised the implications of taking a piece of someone else's tune, so it was a general free for all at this stage, with some great results mind! Trial and error was, of course, a big factor in all of this. I've always said some of the best tunes were born out of mistakes from inquisitive minds just pressing buttons.

When I was first able to afford bits and pieces of equipment I got a lot of help from fellow producers and staff in the music equipment shops that sold you keyboards and samplers which I was very grateful for. Everything came with a manual which you would sit and read, and try to get your head around but you would acquire information from wherever and whoever.

I actually wrote Demon's Theme at the beginning of 1991. I wanted it to be a track with two stories. One being melancholic and lush, with beautiful strings and generally rolling. The other being quite ravey with that stabby mid-section, before ending up where we began towards the end of the track. I think I achieved that and it's funny because that's how I've always viewed my DJ sets from then right up until now: a mix of rough and smooth.

could be wrong but I think the opening strings for Demon's Theme is from a Korg M1 keyboard. It was very late at night, and I was messing around playing some keys and ended up with a little chord progression I liked. That night until the morning I found more samples and basically had most of the ideas ready by 8am, and the rest just fell into place over the next two or three days. I think the beats I used came from one of the Zero G Datafile CDs. That was one of the first series of sample CDs ever – the first good ones anyway. Zero G was the brainchild of Ed Stratton, who also produced under the name Man Machine. He actually made one of my favourite tracks from 1989, which is Cyber/Genetik with The Forgemasters but that's another story!

I just did what any producer does on a day-to-day basis. I had fun in the studio and wrote something hoping that someone in the world would eventually connect with the resulting idea. I feel very honoured that I managed to come up with a piece of music 30 years ago that still resonates within people's minds today. I don't think any producer sits in the studio, composes a piece of music, and knows

exactly what effect that composition will have on people or its longevity. I guess you have an idea but ultimately time tells the real story.

It took a little while to get the track mixed properly. I can't remember where I played it out for the first time, but it was off a DAT from a little portable DAT player I owned, so I couldn't even pitch it up like you could with a turntable. The following week I cut it onto a dubplate and started playing it out properly. I also cut a couple more plates, went down to Rage the same night and gave them to Fabio and Grooverider. To hear it on the sound system at Heaven was a fantastic moment.

Reaction wise, I didn't actually think anyone was really into it, to be honest. I fell more in love with it the more I heard it but at this point, I had never really thought about releasing it. I think Vinyl Mania Records expressed an interest due to the fact I'd released my Logical Progression 12" on their label a year earlier. Apart from them, I don't think anyone else asked about it to be honest, which only cemented the thoughts within me that it was an ok track but nothing special.

Back in those days, there was a culture of making a track, it sitting on a dubplate and then being released six months to a year later, sometimes longer. I guess it used to annoy a lot of music collectors who would hear DJs play tracks on a weekend, then rush into a record shop only to find it wasn't for sale yet. I also think back at the beginning of the 90s record labels had to consider the cost of releasing a piece of vinyl as it wasn't cheap, so to test a track on dubplate for a few months and gauge the reaction from different heads up and down the country was kind of essential to understand if it was worth releasing.

As we entered 1992 thoughts of starting our own label emerged. My best mate Paul secured the name Good Looking Ltd from Companies House, and we just said let's do this and Demon's Theme was the first release. Much to my surprise the track actually sold really well, and we owe a lot of that to the hard work of Phil Wells at Vinyl Distribution. I think we both helped each other to be honest as

he was starting his distribution company around the same time Paul and I were starting the label.

I definitely had a long term plan and ideology for Good Looking and it was very simple. I wanted it to be about music that moves my soul, music I love and believe in, and think to myself that in my opinion, I could hear this track in 20 years time and still feel the same way about it. Every single track you hear on the label was A&R'd by me in the same way. The very same process still takes place today that decides how I select a track for my DJ sets.

I wasn't at all aware of the impact my music was having at the time, so I didn't feel any pressure. I think I was part of a unique group of artists who were all very excited to be spending time in the studio exploring their creative boundaries. I think we were more in competition with each other than ourselves; I say that in a complimentary way. I was always so fascinated and amazed with what other artists produced, as I still am today, so you went back into your own studio ultra inspired to see how you could contribute. There was no room or time for pressure.

I've always been a DJ that plays whatever inspires me regardless of what's going on around me. Speed provided that space for a fearless DJ to express themselves. Speed was a church, not just for myself and all those involved with the night, but for all the producers making those tracks. It was a place full of encouragement, education and inspiration for what was to follow. It's well documented that when the night first started up the crowd mainly consisted of the producers creating these amazing pieces of music showing up to hear their tracks being played. There were barely ten or twenty people in the club for the first few months before it exploded into a weekly line around the block.

The beauty and attraction of drum n bass has always been in its inclusiveness. A melting pot of people's ideas from all walks of life and every genre imaginable, so when the reggae flavoured jungle was big in the mid-90s I didn't feel at odds with the scene at all. There had been loads of tracks with ragga influences from the offset. In 1990 you had MC Showbiz – Gotta Turn The Music Up,

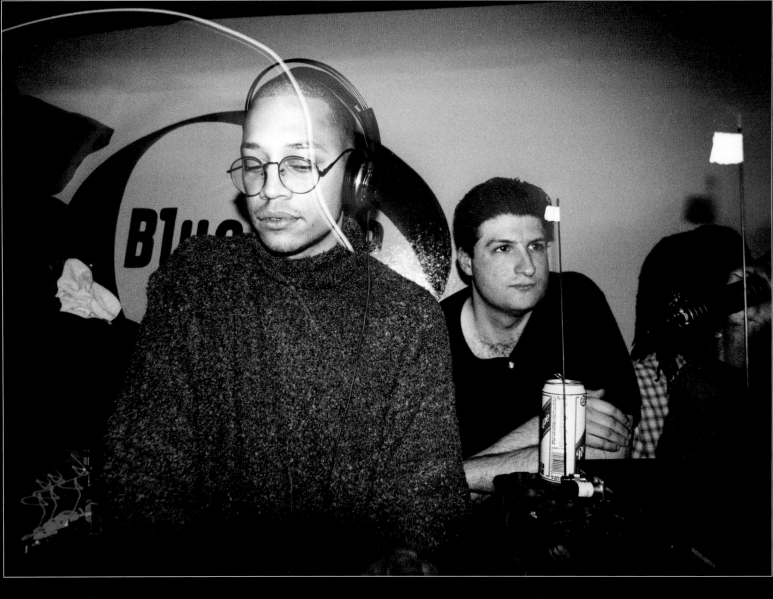

LTJ Bukem and Peshay at Metalheadz Sunday Sessions (1996)

Pressure by Ability II and Genaside 2's Sirens of Acre Lane. In 1991 there were tunes like Masters at Work's Blood Vibes, SL2's Way In My Brain, and A Guy Called Gerald's 28 Gun Bad Boy, and the list goes on. I championed all those tracks then and still love them today. Reggae has been there from the start and always will be an important part of drum n bass.

> " *I definitely had a long-term plan and ideology for Good Looking and it was very simple. I wanted it to be about music that moves my soul, music I love and believe in.*"

There was a feeling in the early days that we weren't being taken seriously as musicians by the media and the rest of the music industry. I think a lot of us felt quite offended when you would read press articles slating drum n bass, basing their criticism on what they thought was a bunch of artists with no musical ability, telling their readers this new movement won't last five minutes but guess what? Here we are 30 years later, and this fact we should celebrate every single day. I think the same journalists should now write articles apologising, expressing to everyone how wrong they were. But I doubt anything like that's gonna happen any time soon.

I feel so blessed to have the most amazing fans that have supported me over the three decades I've been doing this. Many were there from the start and I still meet them now at events every weekend, and their sparkle is still as bright as it was at Dreamscape in the Sanctuary Warehouse, or in the middle of a field at Weekend World. There's a common quality that I always come across in all these people which allows our minds to connect on a musical level. I can't put my finger on it, but they know who they are! At the same time I've been lucky to welcome a fresh wave of younger fans into the movement showing the same enthusiasm as the original crew, discovering this music for the first time, so to say I'm blessed is an understatement.

I must say I feel so proud to be part of the most amazing musical movement that has spanned three decades and is still growing ferociously today. Like I said before, to have even contemplated back then, that tracks I wrote would have any impact on anyone now, is something I never really expected and leaves me speechless. I thank all the fans, producers, DJs, distribution companies, record shops, promoters, people I share a true love with, that have been present during the whole or part of my journey, supported me through good times and bad, and are still there today inspiring me to feel the way I do every day I get up and think about this music. I feel as passionate now as when I started and it feels special. I love you all and thank you for that.

METALHEADS
TERMINATOR (SYNTHETIC, 1992)

The most recognisable face in drum n bass and a true innovator of the genre, Goldie has consistently pushed the boundaries since he first appeared as Rufige Kru in the early 90s. Terminator was the track that drew a line in the sand and signified a movement away from hands-in-the-air piano tunes towards an edgier, futuristic sound that would become a template for the next decade.

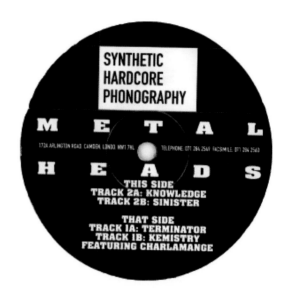

Goldie: Around 1990, I was hustling in the West End and going to The Wag Club and The Brain. I had spent time in America, but I quickly realised something was happening in England. I was living in Dorney Tower [in Camden] and as I looked out over London from the 18th floor I thought there was something buzzing about this city that I didn't quite understand.

I came into the scene more established than I thought I was, in terms of b-boy culture or what I refer to as b-boyism. I had been in America with other graffiti artists and had that understanding of what it meant to be in a crew and the impact that has. Individuals that by disparity are split up and they have no family and all they have is the culture; the street corner and the hustle being the father, and the art being the mother. With that in mind, I was always going to gravitate towards Marc and Dego from 4 Hero. I saw Manix and Nebula II perform at Astoria and it blew my mind; I think it was the first time I thought: "oh my god, this a fucking incredible sound". It was the sound of rave from Europe, which was completely foreign to me but with the breakbeat thing, and that galvanized me. It flipped me over the edge and I thought that I had to do this, I wanted to do this.

I was hanging out with Kemistry in Crouch End in an area we called The Triangle because magical shit happened round there; it might have been the pills we were doing at the time. I was experimenting with acid and watching Kemistry and Storm play music and going to Green Lanes and listening to Chris at Music Power. I wanted to make music, but I didn't know how that was going to happen. I was known as an artist, and it hit me that even though I had this history with graffiti and was doing artwork for 4th & Broadway, I felt there would be something that special that was going to happen. It was almost as if by being a new kid in London from Birmingham – via New York – that wasn't recognised by that scene that I felt like I had a duty to cause some damage.

At this time, I felt I was a servant of the music. I wanted to be a producer and Kemi & Storm were going to be DJs. They were slightly ahead of me and already buying records, things like Homeboy Hippi & A Funki Dred coming out of Archway, and Ragga Twins were doing something over on the east side, Absolute 2 Records from up north, and there was Nebula II with Seance. My first excursion into music was the Ajax Project EP with a guy called B from Iceland. It was a dirty little 12" and Grooverider played

a few things off it. I used to hang out with a kid called Lin-ford (DJ Freebass) who had a great record collection, and I had even more ridiculous arrangement skills. We did two EPs together as Rufige Kru, which were the Dark Rider EP and the Menace EP and they were really good. I wanted to make a mark and once we had done those I was thinking: how the fuck can I make something better than that?

It was at a time when I felt that rave was splitting and becoming a bit too "Ren & Stimpy" in terms of it being so happy; it was so happy my teeth were cracking at one point. I felt it was a little bit too unreal. I like the idea of being sur-real and I like the idea of being anonymous and the music being faceless. Kikman Records and Ibiza Records were a big influence on me because they had that bass element, which was predominantly black producers like Potential Bad Boy. It was also dark, and I don't mean that from a colour point of view, it was just dark music. There would be a sea of people that were resonating not just on the buzz of the drugs but the buzz of the energy that was being shared within the music. I had seen how people reacted to great tunes and I thought wouldn't it be amazing if a record could just cut through everything? Completely cut through the lot and just sever the head off everything so it would get noticed.

John Truelove came on the scene and offered me a £10k deal for two EPs, which would be Terminator and the Angel EP. I told Reinforced I wanted to go and do it, and they said I should go ahead. Marc specifically said: "You've got to do what you've got to do because this could be bigger, this could be huge for you". If they had said no, I wouldn't have done it but John had a platform that we never had. We were selling records out of the back of cars when Reinforced was first set up. Part of the deal with Truelove was that I could put Terminator 2 out on Reinforced as a thank you.

I got some money and hired William Orbit's Cargo studio in Crouch End. John Knowles was my manager at the time and he was also managing Howie B, so I was hanging out with him as he was engineering for Soul II Soul at Mayfair

Studios and Utopia Studios. Everyone else was working in small rooms and bedroom setups. I would rave at the weekends and just be sitting in a studio during the week, so I had an idea of how the bigger studios were set up. I knew that a programming room wasn't used for making records, it was just used for pre-programming, then you go into the studio with the two-inch tape and the big mixing desk. I was working with Mark Rutherford, who was a mon-ster of an engineer, and Johnny Gosling at Cargo; they had a pre-programming suite with an Atari and it seemed like a situation where I could do something big.

We did Kemistry, which stepped things up a level as we used a real vocalist for the first time. John Knowles was managing Diane Charlemagne who was in Urban Cookie Collective and [British jazz-funk band] 52nd Street. I had heard the stuff she'd done and was already a fan of 52nd Street so it was a no brainer, I sang the melodies that I liked for Kemistry and she nailed it. Knowledge was based on Shelley's which was a place of legend and when I went there it was pandemonium. That is where was hardcore was set in stone up north without a doubt; Shelley's in Stoke and The Eclipse in Coventry. The other track on the EP was Sinister, which is the unsung hero in the story really because that was not to be fucked with. That was Fabio's

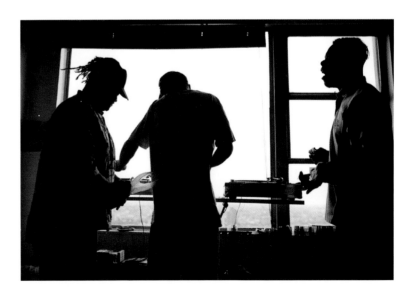

Goldie, Randall and Trenton in Dorney Tower, Camden (1995)

Cleveland Watkiss, Goldie and Grooverider at Metalheadz Sunday
Sessions at the Blue Note, Hoxton (1995)

tune; it was made for him in the same way that Terminator
was made for Grooverider.

I think the premise for Terminator came about as I was fas-
cinated with cinematography and Terminator the movie was
a big thing for us. It was like a turning point in cinema in a lot
of respects. The whole idea of Sarah Connor and going back
to stop shit happening and save a situation; that freaked me
out a bit. He was trying to talk to her about something that

> ## "It was the sound of rave from Europe, which was completely foreign to me but with the breakbeat thing, and that galvanised me."

hasn't happened yet. It's kind of like Back To The Future.

We started making the track and Linford left – with great
regret I think – to get the last train home. I guess it kind
of proved to me that I liked to work alone. In terms of the
creative process, I was very self-indulgent but I enjoyed the
times we had getting samples and stuff. I was really into hip
hop mixtapes to breakdance to, breaks like Mary Mary and
UFO and the Hustlers Convention album and the whole idea
of breakbeat culture. My whole thing was that if we were
going to use breaks they had to be edited and cut to pieces;

Linford had a massive hip hop collection and I couldn't have
made it without him in that respect so I have to thank him
for that, and of course, he's credited for it on the EP.

I was in the studio asking Mark about the equipment.
I was shown a harmonizer which was used for acoustic
instruments, like playing analogue guitar at different
pitches without changing the speed. I asked what would
happen if you put a breakbeat through it, and he said they
hadn't tried that. We wired it up and had Funky Drum-
mer running at 155–160 bpm. There's a wheel on the front
of the harmonizer and I got into the idea of accelerating
it bit by bit, and of course, it's pitching up. It was the
weirdest experience, it felt like I was bending time. So, I'm
moving the wheel in increments and the beat is staying at
the same speed, which I still couldn't get my head around.
I was thinking about where to place the sample of Sarah
Connor saying "we're talking about things that you hav-
en't done yet", and this had never been done, so it was
perfect for that line. I was about to show you a move that
hadn't been done. I think that came from b-boys and the
idea of showing off, doing a move to one-up the rest of
you. At the end of that move would be the abrasive Men-
tasm that would bury anything; you bring in the napalm
and obliterate everything and then drop an H-bomb.

It sounded like the future to me. I took it from the
pre-programming room into the studio and loaded it up.
The harmonizer was a very good red herring because
everyone thought it was time stretching but it wasn't, I was
changing pitch, which before then had been impossible to

do without changing the speed of something. It's almost an inversion of what time stretching is. I think time stretching really came from Dego in the sense of turning the wheel on the 950 and elongating the sample time. This was something completely different to that, it was the best technological breakthrough. With Reinforced it was always experimental; we would record to DAT and have the sound running through the desk, then record back to DAT on one channel, then two, then four, then eight. That was why you couldn't work Reinforced breaks out, because they were layered. If you record two tracks together onto a DAT and put it back through one channel, it becomes two colours together making one colour, so we have this idea of block colouring. The idea of changing the wheel on the harmonizer was the tip of the iceberg, you could throw anything into it. We used an Akai S1000 as opposed to the 900 so we had more sample time and every track on there filled up three S1000s, which was unheard of at the time. When we hired the studio, it was a day for sounds and sampling, a day for arrangement and a day to put together and mix.

I felt saddened when Linford came back and heard it because he had missed out. I felt awful but part of me as an artist said I just had to keep going and I can't stop. When it was finished, around five or six in the morning, I phoned up Grooverider. He would probably tell you that the biggest mistake of his life was giving me his phone number! Groove never did drugs and I did copious amounts, so I would ring him at any time, but this gave me a reason to call him. He was at Donnington Park when I rang, and I said to him I think I've done something that's gonna change it. He says: "yeah man, alright man, cool… yeah".

Later that week, Chris from Music Power came by the house. We played him the track, and it blew his mind; when the record finished everyone was just quiet. We went to Music Power, Groove came in so I gave it to him and it just blew his fucking mind too. I think that Terminator was a b-boy tune that was ahead of the curve. It was very Public Enemy; I saw them at The Hummingbird [in Birmingham] and that whole album stuck in my head, it was crazy. The

layering of the breaks is parallel to breakdancing and its moves. Can you backspin to head spin into something else? The idea was "look what I can do".

Terminator lived on dubplate for nearly 18 months. It was an independent label putting it out which took a long time. We cut dubplates knowing they would wear out, and then re-cut them. I would wait for Groove outside Rage, and see him come down the stairs from Villiers Street from the other entrance and hand him the dubplate through the wired fence. Everyone cutting dubs back then just used the black plate and I wanted an identity, so I'd give him a dubplate with the Metalheads logo on the front and Reinforced logo on the back; it was a statement. That first week at Rage he never played it. I'm waiting in the crowd, and I'd run up the stairs to the balcony that overlooked the floor and put my hands on the cage where they were playing, and I'm waiting thinking we're running out of time here, it's going to end in the next half an hour. He pulled a record out but that wasn't it, something else, that's not it. It didn't happen. The next week I went back, and I saw the record pulled out… he put it in the diamond [i.e. pulled out at an angle in the record box] so it's going to get played. I saw him put it on the deck. It was EQ'd beyond anything

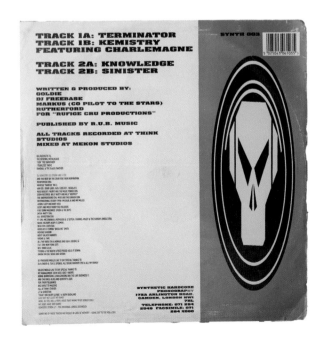

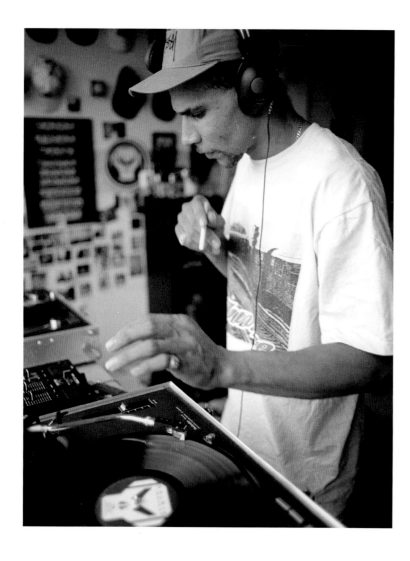

every week, and it was obliterating everything. DJ Hype used to play two copies at the same time, and he'd scratch them. He was the one guy that really championed that hip hop style, which for him is what the breaks were about. One of my favourite moments was when I was at Rage with Doc Scott. He had cut the Dark Rider EP at Music House that day and given me a copy. Groove mixed Dark Angel with Terminator and it was game over. We had both just come up on our E, and we're sitting on the edge of the podium and then Terminator didn't sound like Terminator anymore and Dark Angel didn't sound like Dark Angel. They just collided, it was the most incredible mix. Scott hadn't decided what he was doing with Dark Angel and I told him I wanted it for Reinforced, he held my hand and told me I could have it. Simon Bassline Smith still won't speak to me, he's had the hump for years! I pulled him up in Rage, I said Doc Scott is no longer on your label, he's on Reinforced now, and that's the end of it. He didn't like that, but there was nothing he could really do about it.

I felt things were getting a bit too candy road for my liking. I was slightly embarrassed by certain tunes at that time. I wasn't into politics, but I was into massive change, and it was a dark time as far as social change. I had come back from America and wanted to make a fucking noise. Most of the big records from that time like Renegade Snares and Valley of The Shadows were instantly recognisable. I think the best thing that ever happened at that time was Foul Play, and their music was very instant and immediately recognisable. Terminator was a little bit too ahead of its time, and it took a while and it was the same with Inner City Life, which didn't even get played at Speed. The production was too much. I still get asked to play Terminator, and when I do it goes off, it was actually the last track Fabio played at The End. It still sounds great.

that had been done at that point, because Mark Rutherford knew what he was doing so the sound of it coming in was incredible. It was fucking loud and I can't remember what he mixed it with, but I wasn't expecting what happened next: everyone just stood still. They didn't know how to react or how to dance to it.

I went upstairs as everyone was leaving and Grooverider let me into the booth, which was sacred ground. He told me not to worry about it and to give it time; he played it

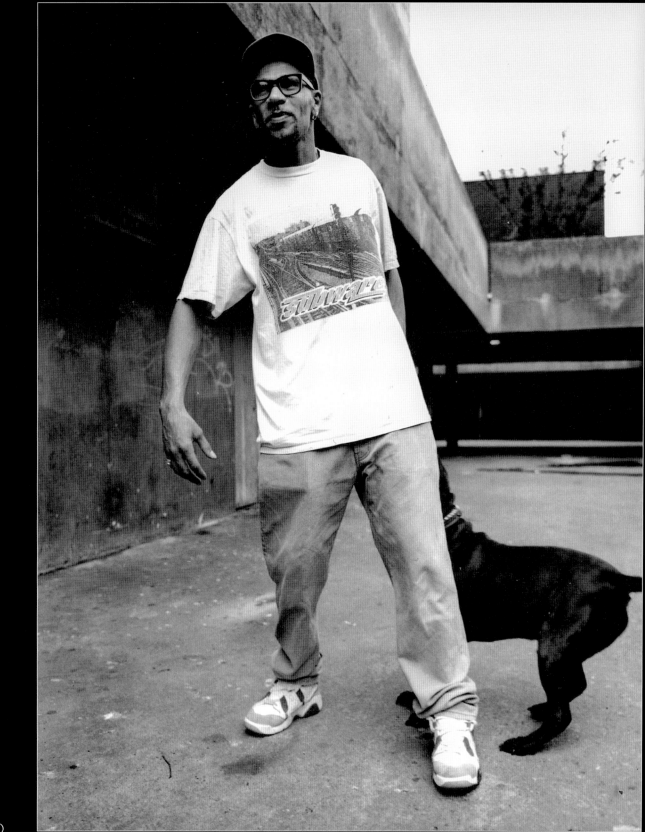

Goldie, Camden (1995)

FABIO

Fabio is one of an elite few DJs responsible for, well, everything really. The iconic nights at Rage alongside Grooverider have been well documented and their impact on what followed is undisputed. His residency at Speed with LTJ Bukem in the mid-90s took on a similarly influential role. Fabio and Rider also took drum n bass onto legal radio, initially on London's Kiss FM in 1994 and then BBC Radio 1 in 1997 for 15 years, always pushing new music and breaking new artists along the way. It's not a stretch to say that the man basically IS drum n bass...

Fabio: The hardcore days were amazing fun. I loved it and it's still a massive part of my DNA but it started to sound a little bit Mickey Mouse to me. Goldie had changed everything with Terminator when he time-stretched the vocal, and we decided that was the future. There were Slipmatt and them guys on one side and we were veering towards a more urban sound and going in the jungle direction. We started to find that hardcaore and jungle weren't mixing that well and so then there was a divide. There was a more serious side of the music coming through and I went with that in the end.

I remember being at Dreamscape one night when Carl Cox decided he didn't want to play hardcore anymore. Grooverider came on after him and had Terminator and all these tunes and smashed it with all these new remixes and Goldie tracks. Carl came up to me and said he was thinking of stopping playing this music and was going to start playing techno and more house stuff. When I asked why he said it was because he couldn't get the tunes we had and all the dubplates – "Where's Groove getting these tunes from? I can't get 'em!" – so he moved into techno and house. That was when around the time the split happened. You either stayed with hardcore, went into house

and techno or jungle, and we went with jungle. I only play what I like and I don't care about what tracks are big. Never in my career have I played a tune that I didn't like.

Jungle was made for crowds that had come from reggae, new jack swing and soul so they identified more with that sound and less with the squeaky hardcore sounds. That's why it got so big. It was more urban and out of it came ever more soulful music, and then there was another divide and I went with the more cosmic, liquid sound. It was all about making choices as a DJ.

> *"There would be a sea of people that were resonating not just on the buzz of the drugs but the buzz of the energy that was being shared within the music."*

Demon's Theme was the one that had really started it, and then Peshay and producers like him came to the fore and Omni Trio was doing some really good stuff. Bukem made Music and then Horizons and it spawned a whole movement in the end. We were thinking that you couldn't really play these tunes at certain venues. At one point there weren't any small intimate clubs, it was always quite big venues or warehouses so you always had to play pretty grimey. I had been getting a bit sick of doing that so Bukem and I decided to do a night, which was Speed because we couldn't really play soulful stuff in a big venue. That was around 94–95. It was all a matter of taste and I'm a soul boy. I came from soul music and so when I first heard soulful d&b and jungle it had a much warmer sound than hardcore.

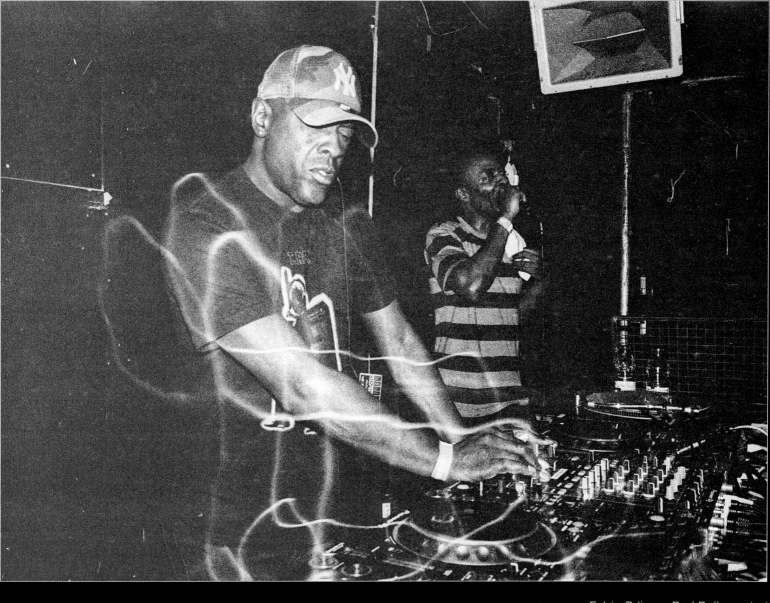

Fabio DJing a Red Bull event at
Egg London (February 2019)

NOOKIE

RETURN OF NOOKIE EP (REINFORCED, 1993)

Nookie's status as a legend of British breakbeat music is undisputed. Having built up a reputation on the underground in 1992, he went on to release music for Good Looking, Moving Shadow and Labello Blanco. As hardcore morphed into jungle, Shining In Da Darkness from his Return Of Nookie EP on Reinforced blended pianos and a euphoric vocal over breakbeats and was one of the anthems of its time...

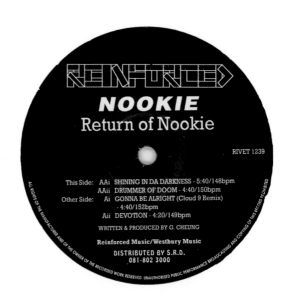

Nookie: I'm from the days of early Detroit techno and Chicago house, and then hip-house which is when the breakbeats were introduced. I was there from the beginning when we started speeding things up and taking it to the next level. I was self-taught in the studio. I was quite handy on the computer but there weren't any music courses back then. I saved up and bought some equipment and started off with a drum machine, an Atari ST, Korg M1 keyboard, a mixer and an Akai sampler which had about 22 seconds sample time and that was in mono! I've always said that it doesn't matter what you use, it's how you use it; push it to the limits and get the best out of what you have. That's when you start experimenting and the creativity comes in.

To be honest, we had no clue what we were doing back then! We had no idea. Even with the producing, EQing or mastering. Not many people knew what quantizing was back in the day which is why the tunes were all over the place which made things harder to mix. It was all part of the learning curve, but it came from people messing about in bedroom studios and catching a vibe. It's very easy to over-produce a tune these days. A lot of people produce with their eyes because of how the sequencing programmes are laid out on the screen. Back in the day, it was all numbers

and you had to use your ears more. Sometimes now I'll turn the computer monitor off and just listen to the track rather than seeing the structure of the song as it plays.

Now it's a lot easier, you have everything you need in your computer and people are flooding tracks with all these different sounds but it doesn't always have a vibe to it. Some of the classics are very simple, like The Helicopter Tune for example. I'd always produce at whatever the current tempo was, but there were people like Ibiza Records and Third Party who were well ahead of things in that respect. If we were doing 145 bpm, they would be doing tracks at 155 bpm. Some people would think it was too fast and six months later it would be normal as things were changing quite quickly back then. We had no idea where it would go or how big it would become. No one was using live singers or musicians, you'd just grab a load of records to sample and put a track together and roll it out. Sometimes that's the best way.

Back in the day, I was working in Red Records in the West End and the one in Peckham as well. That was a really good experience as I met a lot of DJs and producers and people from labels. I started making music and I would play my tunes in the shop. My first record was a hip hop remix of a ragga tune under the name of Main Attraction, which was a South London sound system that belonged to the manager of Red Records. I did a mix of Zig It Up by Flourgon & Ninjaman, using I Come Off by Young MC. The guy from [reggae label and distributor] Jet Star heard me play it in the shop, loved it and it got released. After that, I did a remix of The Stopper by Cutty Ranks.

"This music was based on going against the grain and doing what we want on a street level and not letting the corporate labels dictate what we should be doing."

In 1992 I started my own label which was called Daddy Armshouse, but it was so much hassle doing the artwork, labels and mastering, and then there's the distribution and collecting money and it became a chore and I wasn't enjoying it. So I decided to step back and produce music for other labels so they could handle that side of things. I made the Love Is... EP which I put out on a white label, and then Simon Bassline Smith picked it up for Absolute 2. I knew Rob Playford from back in the day and he'd always wanted me to do some stuff for Moving Shadow, I was actually going to put Sound Of Music out on Moving Shadow, which Rob has never let me forget! It was originally put out in 1992 on a white label called the Back To Detroit EP and it was titled Gonna Be Alright and became known

Nookie in his home studio (December 2020)

as Sound Of Music because of the vocal sample I used when I remixed it in '93. Goldie had contacted me and said I should do something for Reinforced, which ended up being the Return Of Nookie EP. I already knew the Reinforced guys as they would come in the shop selling their tunes. It was a small community of us back then. There was no separation and everyone was pushing in the same direction. That was the reason that when Red Records changed its name we called it Unity. We wanted to bring that vibe back.

There was probably less than a year between Back To Detroit and Return of Nookie. The white label created a bit of a buzz, so I thought maybe I could do a remix and I found the vocal sample that went really well. I'd have made it longer if I had realised how big it would be, but I made it to fit on the EP so it's only just over four minutes. It could've been a single on its own with two or three different mixes, but at the time you just never know. I gave it to a few people like Grooverider, Fabio, Randall and Ray Keith and it just went off in the clubs. I'd be in the raves regularly as I'd meet the promoters and get guest lists through working

in the shop, and I'd go along with Ray or Rider or Micky Finn when they were playing out so I'd see the reactions to my tunes when they were dropped. I'd be at Rage on Thursdays, that was a big meeting point for people in the scene. Fabio and Rider would come into the shop so I was selling them the new records that they'd end up playing down there. This was before the dubplate thing so it was all test presses and white labels. A&Rs from the major labels would come in to find out what the big imports were so they could sign it.

I had a few labels trying to sign me but it was something that was taken with a pinch of salt. It didn't work out for a lot of people and everyone was cautious about how it could impact on your career. You didn't want to end up with a label dictating to you as a producer, what you should or shouldn't be doing. This music was based on going against the grain and doing what we want on a street level and not letting the corporate labels dictate what we should be doing. You might get a few artists that break through but it always goes back to the underground.

Nookie, Potters Bar (2020)

ORIGIN UNKNOWN

VALLEY OF THE SHADOWS (RAM RECORDS, 1993)

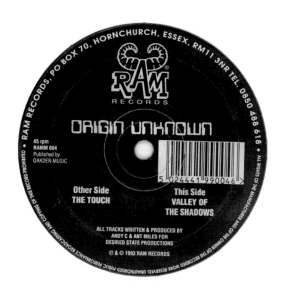

Valley Of The Shadows – often referred to as 31 Seconds or Long Dark Tunnel – is one of the most popular and enduring records the genre has offered up. At a time when fresh dub-plates and exclusives were the order of the day for selectors, it stayed on setlists well into 1995, and just as it seemed to be fading away the 1996 remix appeared and gave it a whole new lease of life. Over 25 years later it still sounds like the future. As the fourth release on the emerging Ram Records label, it proved to be a key moment in the career of Andy C, the man who would end up being the biggest d&b DJ on the planet in years to come. Here, Andy and his Origin Unknown co-pilot Ant Miles break down the making of a certified classic.

Ant Miles: I had been a guitarist since I was about nine-years-old and when I was 16, through my guitar tutor's con-nections, I became a tape operator in a studio and my job was to operate the multi-track machine. After some time watching and soaking up all the techniques in the studio, I eventually progressed to being more of a sound engineer. This was around 1980. I was very lucky that the engineer I worked with was Richard Ball who was an extremely tal-ented guitarist and engineer and a wonderful guy. He ended up working with Incognito later on and is still going strong now; he basically taught me everything that he knew.

Around 1985 the Atari ST came out and I was lucky enough to get one, as well as an Akai S900 sampler. I was quite fortunate to have those two milestone products, along with a Yamaha DX7 keyboard. I was making music at home as a hobby then Richard said I should bring it into the studio and do some more serious stuff with it. We would work with all sorts of artists in the studio and one day The KLF came in with a programmer called Nick Coler, who ended up work-ing with Girls Aloud and groups like that. He gave me floppy

disks with loads of sounds out of his library. I was very lucky to have mentors like him and Richard around me.

We had a 70s group called The Rubettes recording in the studio, and I ended up engineering and doing quite a lot of work for them and Andy's dad Mick was the bass player in the group. I'd popped round his house one day to pick something up and Andy was making hardcore stuff on his Dad's Atari. I thought that was brilliant and mentioned I had my own studio at home, and suggested he come over and knock his tracks into shape. He brought the equipment he had round to my place and we had quite a decent setup. I left the studio I was working at and we started working together. He would've been about 15 at the time so as soon as he got out of school he would come over on his bike and we would carry on with whatever project we had going.

Andy C: I had an obsession with breaks off old funk and early hip hop records. When I learnt that you could put them in a sampler and repeat them that was all I wanted to do.

Whenever possible I'd try and get them from the original records, like the original Amen break off The Winstons track. However, some of the breaks on our early stuff, like Cause N Effect, for example, was a break I'd recorded off pirate radio and we sampled it off the cassette when we made the tune. Most of our early material would feature samples off cassettes that I'd recorded on my Alba hi-fi! Nowadays it's bizarre how up their arse people get about sound quality because when people look back on the old records with fondness they're not thinking about whether it was a sick mix down or if it was EQ'd fantastically, they just remember the feeling and the emotion of the song itself and how it resonated with them. Some people, especially these days, are too preoccupied with technical one-upmanship on other producers, rather than just going with the feeling and seeing if it ends up sounding good.

Ant: We started off as Desired State and put out a record called Turn On which was very hardcore based and very industrial sounding. We always had a love of drum breaks and the live feel of a classic break like Hot Pants or Amen. We had the same technology to cut them up as everyone else did but Andy was very intricate in the way he could make a new rhythm out of a well-known break and layer them up.

Andy: Our first ever release as Desired State was at 128 bpm and featured loads of hardcore stabs and 4/4 beats, then we did a piano track, and then a couple of breakbeat tunes. Then I did the Sour Mash EP which was the first release on Ram which was a collection of four completely different tracks. The second Ram release never came out properly as it wasn't deemed good enough. Ram 3 was another EP and I was getting in tune with what music I wanted to be playing. I was only 15 or 16 at this point so I wasn't old enough to get into clubs but I was collecting records and knew what I liked.

Ant: Andy was born to be a DJ. He had fantastic mixing skills even at that age and was really into his vinyl, so he would show me which tunes were big and get me to listen

to certain things like 4 Hero, A Guy Called Gerald and stuff like that. We were making hardcore and were influenced by the records that were around at the time. We had become good friends with the guys in the local record shop, which was Boogie Times. Andy would be in there a lot and they would ask him to spin tunes for the customers, so he was getting first-hand experience of what was selling and what wasn't. We were grabbing samples from everywhere back then and buying sample packs and creating a huge arsenal of sounds, effects and breaks. I was using tips that I had picked up from working with Nick Coler and back in the acid house days some producers were using a simple sine wave down low that would create a wonderful, pure, warm bass. When you turned on the Akai it made that sound and we were mucking around with that when we were working on a track called The Touch. Tunnel – as I call it – was made out of the sounds that we didn't use on The Touch.

Andy: Valley Of The Shadows was done in a four-hour session one day. I would like to say it was created with

Andy C backstage at Wembley Arena (November 2018)

Andy C at Wembley Arena (November 2018)

the intention of it standing out, but it definitely wasn't the case.

Ant: It almost started to write itself that one afternoon. It was such a good vibe that day and it's something Andy and I have often talked about over the years, but it seemed that in literally four or five hours it just fell out of the computer. The only formula we had was a tempo of 160–165bpm. It was just a case of what emotion and what visions the track would create when you heard it.

> *"I had an obsession with breaks off old funk and early hip hop records. When I learnt that you could put them in a sampler and repeat them that was all I wanted to do."*

Andy: There were a lot of happy accidents in the studio back in the 90s as it was still a learning process. A lot of things came about just from wondering what would happen if we tried something different. When I was doing the beats for Valley the traditional thing to do was use the Akai to timestretch something longways, so you'd get that metallic effect. I thought I'd see what it would sound like if I time-stretched it so it was really fast, so in the end, it was layers of breaks, one at 40% one at 60% and one at 100%. It made the breaks sound really fast and if you slowed it down it gave it a lovely shuffle groove.

Ant: I took the long arpeggiated sample off a Future Music CD. I found a section of it I could re-trigger and tuned it in time at around 160 bpm. We pitched the sample down and had it running in time with the Hot Pants break. The tune was kind of done, but I told Andy I had this crazy, profound vocal I thought we should try. When I first got my sampler in 1985 I was sampling anything I could, such

as the TV, and there happened to be a BBC documentary on near-death experiences on a programme called QED. By chance, I sampled that lady saying "I was in a long dark tunnel". The meter of her phrase was a perfect fit for the bassline Andy had written. We were laughing away as everything just seemed to fit together, it was just a case of exploring; that's what we did in the studio, it was like a sound laboratory. It was on three floppy disks and it was 3MB whereas a tune is 1GB now!

Andy: Every sample we tried sounded great and every idea just worked. When it came to arranging it in Cubase you would lay the track out on the screen in blocks, and I remember Ant was dancing around the room while I'm sitting in front of the computer and deleting the blocks as it was playing. It got to the end, and we thought right, that feels good! It was relatively short and it was changing every eight bars which was down to me deleting things as it played. When we played it back we realised we had something a bit different. We weren't sure what it was but we really liked it. It was the first track we'd done where we both really liked it and it sounded cool. I played it to Scott [Red One] the next day and he said he thought we might be onto something. Then I took it to Boogie Times in Romford as I went there religiously every day after school. I played it to them but they weren't really feeling it. They preferred The Touch and said it would do better, so on their advice The Touch was the A-side and Valley was the B-side. It's probably the best B-side we have ever done!

Ant: A lot of people loved it as it was so simple and it had that vibe and had the magic ingredient of not being overproduced. Because it wasn't that hardcore sound that Desired State was known for, we used a new artist name, which was Origin Unknown. I'll never forget Andy calling me the following weekend after he'd played it out: "Ant! It went off!"

Andy: It was never on dubplate, we went straight to vinyl. I wasn't involved in the dubplate scene then as I was too

young. I'd be doing the profit and loss figures for the label in my exercise books at school! I think we did 100 promos and then we put it out. We pressed 3,000 copies and took them to the distributors and it went insane. It came out on a Monday and by Tuesday they wanted another 1,000 on Wednesday they wanted another 2,000, Thursday another 4,000. Everything really changed after that. I remember DJ Hype coming into Boogie Times, as he was doing records for Sub Base. Winston and Danny introduced us and told him I'd made that Long Dark Tunnel track, and he was like: "What you made that?! Nah! I really like that!". He was playing it a lot.

Ant: If I had to pick xone DJ who really got behind it, it would be DJ Hype as he really loved that tune. Without a doubt, we owed a lot of our success to Hype. He'd come over to the studio and his dog would be wreaking havoc in the garden! Randall supported us a lot too. We already had some success as Desired State and Andy was playing out and making contacts, so we had been steadily establishing Ram and our sound. Rob Playford at Moving Shadow was a massive influence on Andy and me, and he was very helpful on the business side of things. It was good having friends like that to advise us.

Andy: I went up to Blackmarket Records to introduce myself to Ray and Nicky and I played them the VIP mix we'd done. They gave me £100 to go round the corner and get it cut on dub for them, so I went to Porky's Prime Cuts just off Wardour Street and cut Nicky Blackmarket and Ray Keith the first ever dubplates of any version of Valley Of The Shadows, which was pretty surreal. All very innocent times. I'd started playing for Telepathy at the Wax Club around that time. That was my training as a 16-year-old; I had to smash it and it was a fantastic learning curve for me that stood me in good stead for the future. You had serious people running the night and running the door and legends coming in to DJ. I remember Micky Finn dropping The Helicopter Tune for the first time down there.

I was a resident alongside Devious D, Funky Flirt and SL so it was a great initiation. I would get thrown in the deep end and some weeks I'd be there all night and not play, or I could get there at 10pm, and someone wouldn't turn up and I'd go on at 4am. Other times, there might be a big name DJ playing and Sting [the promoter] wouldn't like what he was playing so he'd pull him off and stick me on, I'd be thinking you can't do that, and he'd say: "it's not down to you it's down to me". One night Sting said he had this new MC he wanted to try out on my set and it turned out to be Stevie Hyper D. He put us together to see how it went and from there he ended up coming on the road with us when we did PAs of Valley Of The Shadows. Brockie and Det and the guys from Kool FM would be in there too and ended up asking if I wanted to go and play on the station, and from there I ended up doing Jungle Fever.

Ant: I had just become a dad when Ram started in '92 so I went out occasionally but nowhere near as much as Andy. I was always in the studio. We had offers to do PAs a few times but I was happy to be in the background. Any love I get is from the music; that's always been enough for me, maybe that wasn't the best financial decision though!

Andy: When you've had a record as big as Valley, it does put some serious pressure on you to follow it up. I think we definitely made a conscious decision to avoid replicating it though. We didn't load up the break again for years as we thought we couldn't better what we'd already done with it, and we didn't want to plagiarise ourselves, plus I always wanted to try different beats in every track.

Ant: We made a decision not to do loads of remixes. There was the Long Dark mix on RAMM4R, which we made as a VIP mix so people had something a bit different to play, and the Awake mix that came out in 1996. Both of those retained the feel of the original version. We didn't want to mess around with it too much as there's the danger you do

Ant Miles, Wembley Arena (November 2018)

a remix that doesn't have the same vibe and it can kill the track. Nearly 30 years later it still gets so much love.

Andy: We did Truly One as Origin Unknown but we had other pseudonyms and used Desired State for our Amen bangers, and we put out Cause N Effect as Concept 2 which I'm so proud of and it was such a big tune for us. In retrospect, I wish we'd done that as Origin Unknown as I think it would've stood the test of time as an OU track, but at the time it was very much a case of not wanting to dilute the name.

Ant: After Valley Of The Shadows, I took more of a liking to the music we were making. Drum n bass became more melodic and musical so I found it more pleasing to make than I had with hardcore, which had got a bit intense and there would be rhythms going against each other. With

d&b I could get everything in the same key, whereas with hardcore it could be all over the shop. I had been working in an environment where I had to do as I was told on the mixing desk and now I was free to have more creative input with the person I was working with. We had a very open-door policy in the studio so Andy's mates from school like Shimon would come in and bring some sounds to make a tune with me, so I was passing down the knowledge I'd got from Richard Ball and Nick Coler to Andy, Red One and Shimon.

There's loads of unreleased material from that era. Things would get started and not finished and we'd move on to something else if someone had a new idea. The inspiration would be flying around and we'd inspire each other. Truly One had the wobbly, oscillating bass sound that I made and it was interesting to see what other artists went and did with that. Andy and Shimon did Quest and it was just a really creative period. In time Shimon set up his own thing and became passionate about learning the equipment and we started Ram Trilogy, which was an awesome collaboration. Shimon would create some heinous bass sounds with the samplers and filters, and Andy was always wonderful with creating rhythms and I would bring the panoramic intros and guitars. It was a great period of my life, I look back at that time in the 90s and we really were riding the crest of a wave. We'd often be in the studio through the night, often just to get music ready for Andy to play in his sets that weekend. I was in the studio day and night for eight years and eventually took some time out from music for family reasons. Andy obviously carried on and went from strength to strength.

There was no other genre that we were tempted to flirt with. Drum n bass put food on the table. You see these kids after a hard week at work they need something to get their body moving; the tempo and those bass frequencies filling up your chest is just wonderful.

RETURN OF Q PROJECT
CHAMPION SOUND (LEGEND, 1993)

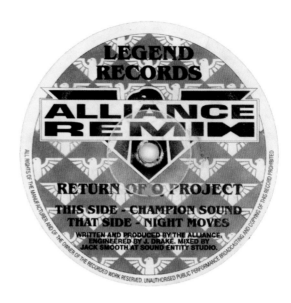

Making his vinyl debut in 1992 with the Freestyle Fanatic EP, Jason Greenhalgh (aka Quiff) would go on to be one of the most prolific artists in drum n bass. His partnership with Paul Smith as Total Science has resulted in tracks for Good Looking, Metalheadz, True Playaz and 31 Records amongst others, and their own CIA Recordings and its various offshoots have been a source of quality d&b since 1996. With a discography of such depth and variety, it's testament to the impact Champion Sound has had that it still stands out as a highlight of his catalogue. With its distinctive techno stabs and chunky rolling breakbeats, it was one of the standout tracks of the era, with the Alliance remix perhaps proving to be the most popular version. A remix by than Doc Scott followed in 1994, and it was given a revamp in 2000 with Total Science's Hardcore Will Never Die version updating it for the new millennium, confirming it was still as effective on the dancefloor as ever.

Quiff: I had a studio set up back in the 80s when I was into electro and hip hop, things like the World Class Wreckin Crew. I didn't really know what I was doing but I had quite a lot of equipment. The whole rave thing started and we were all going out and partying a lot, listening to techno in a field. You'd go to these parties and some were euphoric; Doc Scott playing at Enstone Airfield while planes were flying off in the sunset and hearing Gypsy Woman. Those were wonderful experiences. Shut Up & Dance and A Guy Called Gerald came along and tunes like Mr Kirk's Night-mare and they started doing these things with breaks that I recognised from hip hop and rare groove records. I had always wanted to make music and this was what was going on in the UK. Where I was from a lot of people were into reggae and there would be sound systems in the park in the summer. I wasn't a massive fan of it but I loved dub and the basslines, and when that came together with techno, hip hop, electro and then and the chatting of the MCs, that sound resonated perfectly.

I met Graham Mew, who produced as The Invisible Man. He was DJing at a club in Oxford and we got chatting. I went into his studio and made the Freestyle Fanatic EP, which came out in '92 but the tunes were all made in late '91. I borrowed some money from my girlfriend at the time and got 500 white labels pressed up, and they all sold.

From then on, I would just grab a selection of records that seemed to fit together and go round Graham's to see if I could make something out of them. I would stick notes on the records so I knew which bits to use. Sometimes it never went anywhere and sometimes it would turn into some-thing. We were using the Cheetah S16 sampler and I think we only had 16 seconds of sample time. That's how we got the riff for Champion Sound: I pressed the button on the sampler and because it was so degraded in the sample, like

8 bit or something, and it was such a slow sample rate it made that noise (that ended up being the riff in Champion Sound). That weekend we had been to this free party in some fucking horrible, nasty warehouse place. Everything about it was horrible, it was some dark warehouse with shit dripping off the ceiling and crack heads in there. I was still hammered when I went to the studio on Monday and that noise was how my head felt at the time!

At that time everything was very chop-and-change in the music. Tracks would switch from pianos to stabs in 16 bars. I thought I'd just make something that rolls. I sped up the Hot Pants break which gave it a tinny edge that I quite liked. I borrowed some soundclash tapes off a mate and that's where I got the vocal. I thought it was just the MC chatting live on the tape and I recently found out it's actually off a record but I'm not gonna say which one! So I chucked that in and it all came together; no euphoric bits, I just let it build and I was happy with it.

> *"Grooverider played it and it tore the roof off the place. 20,000 people reacted when that riff came in."*

That was the back end of '91 when the West Country free raves like Spiral Tribe were happening and DJs like Easygroove were playing. There were raves all around Oxford, Avon and Cheltenham and we would go all the way up to Peterborough. There were lots of farms around there and lots of ravers. You would get a call, arrange to meet somewhere and 200 cars would descend on a field; it was brilliant. We were parked up in a convoy so I put the tape on and played it really loud, and we ended up with a crowd around the car. People were asking what it was.

Smithy [Spinback] was DJing at the free parties at this point so we were kind of known, and we'd met the West Country lot like Roni, Die and Krust. I went to school with

Suv and he was originally from Bristol. Before I'd even made any tunes I'd also somehow managed to make friends with Micky Finn. We'd got chatting somewhere, and I met up with him one day and he took me to JTS to get Champion Sound cut on dubplate. I got three plates cut, one for myself and one each for Fabio and Grooverider. I think Micky paid for his own, so fair play to him for that! That version had slightly different bits in it that I took out before it was released. Micky gave it to Grooverider for me and then we went to World Dance at Lydd airport. Groove played it and it tore the roof off the place. 20,000 people reacted when that riff came in. He'd always play the early morning set when everyone was a bit twisted up. I couldn't believe it; I was off my tits at the time, going around grabbing people. All I wanted was to have Grooverider play a tune of mine so I'd achieved my goal by 1992. Job done!

People were asking who made the tune. Goldie told me to take it to Reinforced so I went and met Gus, but Manix had done something similar so they didn't want it. At the time I was a bit disappointed but looking back I'm glad it didn't happen. At first, we were going to Jack Smooth's studio in Reading and then Gwange, who was a friend of ours, had started making tunes too, so we clubbed together to get a studio set up in a friend's garage and decided to start Legend Records. These were the days when things were on dubplate for years. Champion Sound had been done about 18 months beforehand. I had made Night Moves and we thought let's release it as The Return Of Q Project. That was the original mix. Graham and I would take boxes of the records to the different distributors in a red Mini Metro. Half of them wouldn't pay you, another one would go under. It was fucking hard work just getting paid. It wasn't until Vinyl Distribution came along that things became easier. They streamlined the process and were running a proper business so you could figure out what was actually being sold.

The Alliance remix was just the whole riff sampled and played two octaves up on the keyboard. The Doc Scott remix sold loads and the Alliance remix sold even more. It was luck of the draw really. The elements of the track were

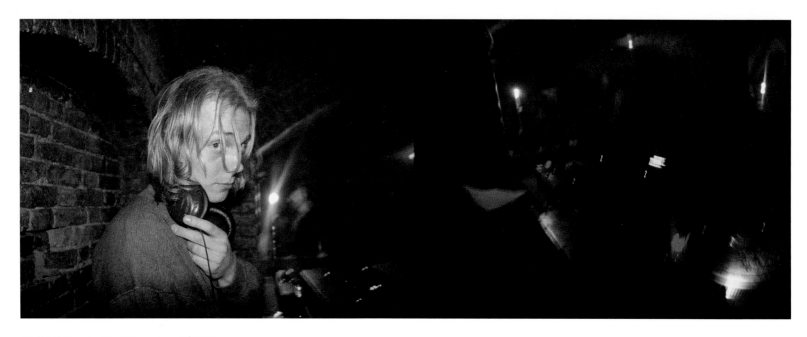

Quiff DJing in East London (1994)

all part of what was going on in the culture at the time, so it resonated with people. They needed a bit of a switch from the DJ Seduction type of stuff that was around, which was great, but some of it was getting a bit cheesy.

It was just a time where we enjoyed making music. We were both on the dole and had nothing else to do. We were going out all the time back then – I can't remember not going out! The best place was AWOL at the Paradise Club in Islington and Randall was always one of my favourite DJs. It could be a bit scary down there but a lot of our friends were bouncers from when we were playing in and around Oxford and they would end up coming up out with us.

When Fabio and Bukem were doing Speed I felt that drum n bass started getting noticed more. It was all a bit fashionable but people who knew about music would be in there. Around 1995 Alex Reece, Wax Doctor, Lemon D and all these people signed all these big record deals and Goldie was the only one who didn't end up fucked. Maybe Photek came out of it alright too. We saw what was happening and decided we'd rather just release what we want. Good Looking tried to sign us but we thought we'd just stick with our own thing. There's been peaks and troughs but at least if things didn't go our way it was down to us.

Even back then I hated the fact that things started getting fragmented. I liked that the scene incorporated all of us, wherever you were from, whatever your background was. Lager louts who would normally be out glassing people would all be E'd up, peaking in the back of a van. Everybody was there. Then it started splitting into liquid funk, techstep or jump-up, and I'm thinking, hang on, it's not, it's all just what it was when it started out: jungle techno.

MC GQ

Having held down the microphone while hosting legendary nights at AWOL, World Dance and pretty much everywhere else at one time or another, MC GQ is the voice of drum n bass. A commanding presence on the stage working the crowd while almost effortlessly in tandem with the DJ and music, GQ set the standard for other MCs to follow...

GQ: It was a special era with consistently good music. Even though I wasn't a DJ, I'd go to Music House as everyone would congregate there, and you'd hear the dubplates before they got played out. I'd go to DeUnderground in Forest Gate, and Randall would be mixing in the shop. I'd go and check Hype or Gachet and listen to them play the new tunes they had and sometimes you could tell which

ones would mash up the dance. Certain producers, like Dillinja for me, were titans. People were serious about making music, but they were also having fun with it.

I never listened to the tapes of the raves back then. I would just do my thing, whether it was being recorded or not. Sometimes people would sample the tapes, and I'd hear myself on some tracks. There was a tape doing the rounds in Toronto of me and Fabio at Paradise Club, and people told me it was their bible over there, and it was that tape that got me booked in Canada. At the time I didn't realise but looking back those tapes were important. I was at Hospitality in The Park about to go on stage, and I got introduced to this guy called Jake, who was there with his mum, and he's blind. He started to reel off all my lyrics from all these old tapes. He was 22-years-old, and he's telling me about all these tapes and vocals I did that came out before he was born! The tapes are a big part of this; they were paramount without people even realising. Without them, some people wouldn't even know about the music. We had pirate radio, but it wouldn't reach that far. Tapes would get to people all over the world, and I would get bookings as a result of that.

AWOL was one of the pinnacle clubs at that time. What made it so unique was the following we had, the production, the promoter JP changed history by taking a chance with that club; he doesn't realise that, and he's not someone that looks to take credit for his contributions. He did World Dance at Lydd Airport too, but he was a reggae man before jungle came along. A white guy from Southend, part of a firm of white guys who loved reggae music that would come into London to the reggae clubs back in the day. They might've been the only white guys in the club, and they got involved in doing these parties.

He told me he wanted to do this thing called AWOL at the Paradise Club. The people he had in there were titans:

Kenny Ken, Randall, Micky Finn, Darren Jay and Dr S Gachet. What was super special about it was that you would never hear the same tune twice in there, which was quite rare at the time. Every DJ playing knew they were coming there to do damage. It was a family unit, and there were never any problems amongst us which was really important. The music spoke to the crowd, and they knew what they wanted. If you were a guest DJ, you had to have your shit on lock. If you came in and hadn't done your homework, you'd have a problem because the crowd would let you know! They were used to hearing some dubplate specials. That was one of the best vibes I have seen in my life. We would start at 10pm and run until 1pm the next day sometimes. The trajectory never took a dip; it just kept going up. Man would come in and lash out some mixes, and you had to be on point.

A lot of the DJs that weren't booked there would come

"The tapes are a big part of this; they were paramount without people even realising. Without them, some people wouldn't even know about the music"

down when they had finished at wherever they were playing, so you might see Grooverider, Fabio, or DJ Ron in the corner. Goldie would be in there, or a young Andy C with his long hair looking like Meatloaf! You could see all the top dogs in there just hanging out. There was no other place in London that was consistent like that every week for years. You had the house room downstairs with Roy The Roach and Richie Fingers. The music quality overall was 100%. The lights would come on at 1pm, and people didn't want to go home, they wanted one more tune.

That place is one of the best places I have worked in my life. It helped me in a lot of ways, and it gave a lot of people great memories; people still talk about it online now. What you would get musically was something you wouldn't get anywhere else. The DJs would prepare; Micky had his own style with his ragga tunes and specials. There was no competition; they all had their own styles and selection and would come in and show their skills. No one was moaning about their name not being at the top of the flyer which you get with some people now. If you got the call to come over there, you better come with some dubplates and some tunes. The crowd were used to hearing wicked tunes. They were spoilt!

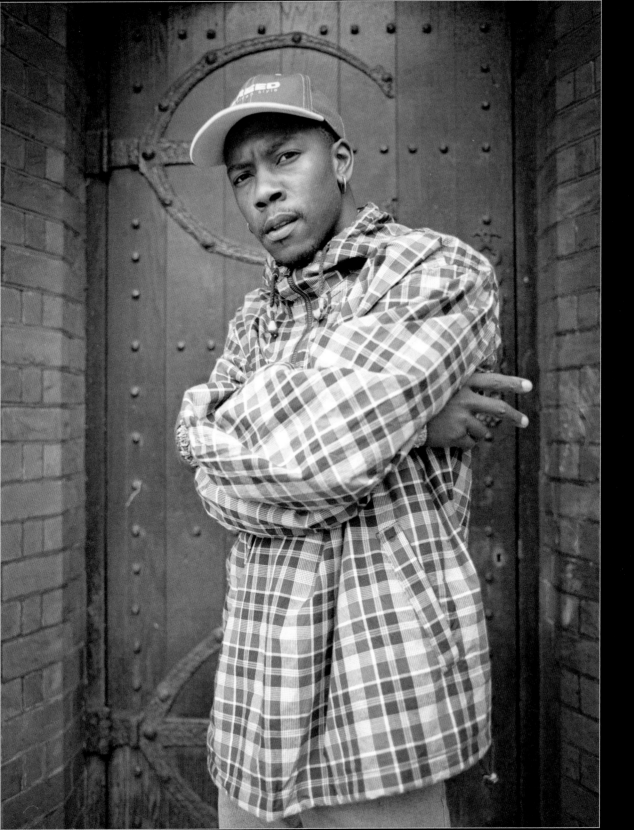

FOUL PLAY

OPEN YOUR MIND (MOVING SHADOW, 1993)

Northampton based trio Foul Play (John Morrow, Steve Gurley and the late Steve Bradshaw) played an important part in this music's history, with their heightened production values resulting in era-defining tracks such as Finest Illusion and Being With You. Open Your Mind is a perfect example of the transition from hardcore to drum n bass that was happening towards the end of 1993...

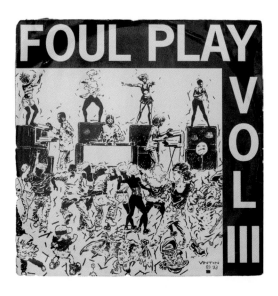

John Morrow: My musical background was as a hip hop and house DJ playing locally around the Northampton area in the late 80s and early 90s. I fell in love with the hardcore scene in '91 as it was a complete mash-up of all the music I loved growing up. Both of the other Foul Play members were also DJs. Steve 'Brad' Bradshaw was a member of Northampton sound system Krush Inc. and Steve Gurley was a DMC finalist who was mainly active around the Milton Keynes area.

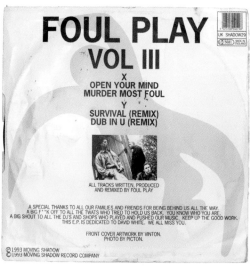

There was no set creative process in the studio, and we all chipped in ideas and the direction the tracks should go in, but Steve Gurley was an incredible talent and certainly the most competent producer of the three of us. Brad and I learned a lot from him in the two years we worked as a trio. The Reinforced guys were way out there in front as far as pushing the boundaries and they were a massive influence on us in the beginning.

We submitted four tracks to Moving Shadow for Foul Play Volume 3, one of which was Finest Illusion. Although Rob Playford and Simon Colebrooke loved the track they felt they couldn't release it due to the SOS Band sample and as a result, we needed a fourth track to complete the EP so we went away and came back a few days later with Open Your Mind. Due to the quick turnaround, we didn't have the opportunity to road test it with any DJs. We just submitted the first version we made and it turned out to be the strongest track on the EP. I think this shows there's something to be said for just going with your gut rather than worrying about what other people might think.

As far as I can remember, everyone at the label was really positive about the track from the outset and it

also got good feedback on promo. I think the fact that we never got the chance to road test it with some of our favourite DJs was one of the reasons we decided to remix it. The Foul Play remix of Open You Mind was given to Top Buzz first as we'd got to know Jason well and he'd been really supportive of our stuff so we went to Music House with him and he got the dubplate cut before anyone else. LTJ Bukem and Randall followed shortly after as they were always given our music first. I think it was exclusively with those three for several months before we gave it to the label. In that time we'd heard it played all over and realized it was probably going to do pretty well.

"We always tried to make our tracks quite uplifting, but it was essential they were always heavy on the drums and bass."

I remember when the hardcore and jungle scenes began to separate we were quite lucky as our music seemed to appeal across the board. We always tried to make our tracks quite uplifting but it was essential they were always heavy on the drums and bass. Tracks like Open Your Mind and Finest Illusion seemed to walk the line quite well with both hardcore and early jungle dancefloors responding well to them. Once Shadow told us they wanted to sign Volume 3 everything we did for the next three years was made with the hope that it would be released by them and we were pleased they liked everything we sent them. Our only project outside the Shadow family was a collaboration with Yomi from Tone Def Records as Four Horsemen of the Apocalypse specifically made for his label.

We didn't really pay too much attention to what other people on the scene were doing although we obviously kept our ear to the ground. We just made the music we wanted to make and as we weren't following trends we felt we could keep things on dubplate as long as we wanted. For example, our track Being with You was on plate for almost a year before release.

We always picked our own remixers, it was never something the label decided, so we always fully trusted them to do their thing. Also, I've always thought of remixes as the remixer's track and not our own; it's their baby really so I've never really felt protective over any of our tunes. The Open Your Mind remixes by Nookie and Tango worked out really well and were completely different from the original so it turned out to be a pretty decent package.

It's crazy to think it was all 25 years ago and people are still interested in the music, and it's always extremely flattering when you are told by someone that your music means something to them. If anyone had told us back then we would be a part of such an important period in UK music we wouldn't have believed them but it makes me really proud to know we were a part of something so special.

BOOGIE TIMES TRIBE
THE DARK STRANGER (SUBURBAN BASE, 1993)

Suburban Base was arguably the biggest label of the hardcore era and was at the forefront of the transition into jungle, with a steady stream of quality releases by a variety of artists including DJ Hype, Remarc, Krome & Time and DJ Rap. As well as being one of the more astute businessmen in the scene, label boss Danny Donnelly also found time to get in the studio, recording as Q Bass and then linking up with Jay D'Cruze to become Boogie Times Tribe for The Dark Stranger...

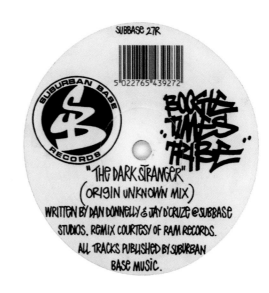

Danny: When I was 17 I opened a record shop (Boogie Times in Romford, Essex) and that was meant to be my core business; that was what I wanted to do so I'd reached my goal as far as I was concerned. I only started a label so we would have exclusive records in the shop. Before Suburban Base, we were just pressing up some white labels at 500 or 1000 copies a time. I'd give them to friends that were on pirate radio and then it started to grow as the only place you could get it was Boogie Times, so it was good publicity for the shop. Then people wanted them all over London and all over the country. So, I went from keeping them exclusive to selling them out of my car to other shops around London to getting a distribution deal sorted out.

It happened so fast and suddenly, I was running a record label. There was no grand ambition, it just happened. Within a couple of years, the Sub Base logo was known and we started doing merchandise so everyone was buying a jacket or a record bag. We were one of the first labels to really do that on the merchandising side of things and a lot of others followed our lead. We had a strong brand identity when people were still putting out white labels. We always had artwork on the sleeves and a very defined look.

As far as going into the studio, it was just a bunch of mates hanging out and having hit records by accident really. We would go to a rave and come back with ideas or a friend might bring a DAT into the shop and we'd press it up and that grew into the label. We would meet other people and some weren't even musicians. Austin Reynolds wasn't into the rave scene but we met him through a friend, and he was a trained musician and great in the studio so he became involved in engineering some of our stuff and started working on his own material.

When I first met Danny Breaks he was coming in the shop looking for breakbeats because he was a scratch DJ; I had him in my address book as Danny Breaks and that became his name. We were putting each other on and making tracks with our friends. We even let our illustrator Dave [Noddings, the artist responsible for the Sub Base sleeve and label art] make a track and he wasn't a DJ or a producer! It was all just a case of meeting people and collaborating. It was the same with Rob Playford at

Moving Shadow; there was never any rivalry between us, and we would go raving together and he would stay at my house. He didn't live in London, so he had my guest room every weekend. Andy C started coming out with us too. I have known him since he used to come into the shop in his school uniform. He would end up helping behind the counter.

For Dark Stranger, I worked with Jay D'Cruze. He was one of my favourites and such a lovely guy. I was a hip hop head and into rare groove and soul and I had a huge record collection, so I had picked out some records with all the samples and had some ideas that I wanted to use in a tune. Jay was engineering it for me, but it became more of a collaboration and Mike James ended up mixing it down for us afterwards.

I think we did Real Hardcore first, which became the B-side. It was at the cusp of a change: 1992 was all hardcore, and then '93 was the moment between rave and drum n bass. The pianos were starting to be phased out and it was getting a bit darker. We put that phasing effect on it and just went all-in on the darkness! We wanted to give people an experience, so if they heard it in a rave they might be a bit freaked out. It was experimental because there were no rules about what you could or should make.

When you listen to Dark Stranger and Real Hardcore, which are largely a lot of the same sounds and styles, they don't sound like anything else that was around at the time. We just threw the kitchen sink at it. That was why the Origin Unknown mix worked so well because it just smoothed all that out and took those experimental ideas and just rolled it out. I'm proud of the original version but the remix really took off. We knew it was amazing and it immediately became an A-side in its own right. In my opinion, it is one of the best things Andy has done – the best one that never came out on Ram and I would say it's as good as Valley of The Shadows. Dark Stranger was around the same time as that and Andy went from being a school kid in the shop to absolutely nailing it. I took him to a couple of his first-ever raves; his first AWOL was with me, his first trip to the

US was with me. He's the best Sub Base artist that never was. He was always around us but he had his own imprint, which was great.

Dark Stranger was initially released on a black label with no information and DARK 01 etched into the vinyl. It was partly as a teaser, but also to see what sort of reaction we got because it was so different. If we got a good response, we knew we could put it out properly on Suburban Base. One of our biggest tracks was Far Out by Sonz Of Loop Da Loop Era [Danny Breaks] and that was originally on Boogie Times, our smaller offshoot label because we couldn't cope with the volume of releases and it could get a bit overwhelming at times; there could've been another 100 Sub Base records, but it wasn't possible. Our distributor couldn't pre-sell that many and get them into stores. Far Out was used in a Suzuki commercial years later and that was great, nothing could give me more pleasure than to give my old mate a substantial cheque after all that time.

We were structured like a proper, larger record label. Even as a 17-year-old I had this instinctive knack for business and knew what needed to be done. I don't know where that came from but that's what allowed us to grow into one of the biggest labels. I was already VAT registered and paying taxes because of the shop so we ran things properly from the start. I would share business ideas with Rob Playford and we ended up doing a Suburban Base and Moving Shadow album together called The Joint, as we wanted to show the scene that there was no rivalry and we were two of the biggest labels in the scene working together.

I loved the Reinforced guys too and I think we all respected what each other was doing. I believed we were all friends and there was an unwritten rule about artists and signing tracks: I wouldn't even consider approaching any of their people, and vice versa. That was why we would swap remixes and collaborate in whatever way we could. There were so many people that we worked with and wanted to work with. I might have wanted to do something with Mark from Altern8 for example, but he was on

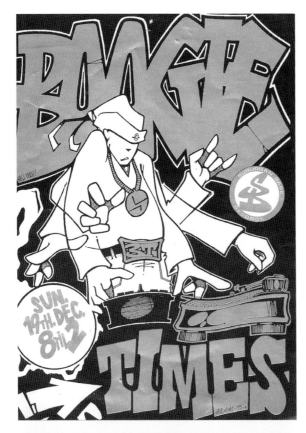

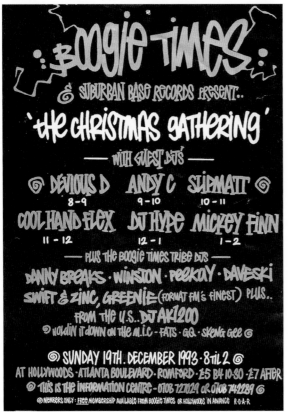

another label so we would exchange remixes. One of Roni Size's first remixes was of My Soul by Boogie Times Tribe. I couldn't sign a track of his as he was on Full Cycle and V Recordings so it allowed us to work with people that we really liked and promote their sound and collaborate. I started the concept of swapping remixes, partly because I was trying to keep costs for the label low, but I thought we could double our releases, get another name on a project, and they get a remix from us and so on. Andy C and Ant Miles did Dark Stranger and they got one from us for their label [Sonz of Loop Da Loop Era remixed Andy's track Bass Constructor on Ram].

The label was flying high by then. We had a consistent output, strong branding, and it was all fun. I was approached by major labels quite often and turned them down. At that time it was the right thing to do as we couldn't have kept creative control. I couldn't have had my mate as a full-time cartoonist drawing pictures in the corner! I couldn't just offer guys that hung around in the shop studio time with one of our engineers if a bigger label was involved. We were trying to impress each other within our own crew and just keep creating and moving things forward. For me, that was the joy of it all. We weren't actively seeking music to sign, but a lot of it would come to us from DJ Hype. He would put us onto things and was like an A&R for us, so he was very important to the label beyond his own releases.

I was still a hip-hop head during the acid house phase but I got into hardcore because of the breakbeats, and then it kind of split and the happy hardcore stuff came along, but jungle was what we were into. You can almost trace the evolution of the music through the label's catalogue. Our releases in 1991 differ to what came out in '92, and it changed again by '93. Things were moving so quickly and everyone was just trying to best their peers. No one was following a format so you would hear something different each time. I think that's why I got a little disillusioned with it later on when everything was Amen based, and everything was rolling out in a similar way.

Looking back, I was wrong about some of it and now I love some of those tunes and the consistency of it. In hindsight, that built the backbone of the scene but when you're living it and have been part of the progression, it felt different and I was trying to work out how I was getting enjoyment from it. I stopped Suburban Base in 1997 and went on to do other things. People thought it was a weird decision as we were still selling a lot of records and still big but I didn't want to do it half-heartedly as I had ambitions and ideas in other areas of business.

We had the garage label Quench so we got to know DJ EZ and I then started the Pure Garage album brand and they went multi-platinum. My company started the Euphoria series of compilation albums which did equally well. More recently we've been doing a whole range of Pure branded albums – Pure Deep House, Pure Grime and many more so that brand is still strong and I use that brand name for the movies I do too.

There was a lot of politics in the scene at one point and everyone was taking themselves too seriously so it didn't seem fun anymore. We were having hit records and there was a mild backlash with some people calling us commercial and saying we were selling out but we were just selling a lot of records and surely that was the goal. We were doing it for as many people to enjoy it as possible. It was the same records that had been on pirate radio six months earlier but now lots of people were buying them.

I love drum n bass but I needed to move into other areas of business to keep progressing. I did what I did and laid some foundations. We played an important role in globally exporting the genre too; Sub Base was the first UK rave label to have an office in the US and the first to sign US d&b talent, releasing AK1200 and Dieselboy's first albums. We were the first to have a label deal in Japan and South America. I discovered DJ Marky out there in Brazil – his first three albums are on Sub Base in South America.

"It was experimental because there were no rules about what you could or should make."

I wasn't surprised at d&b going mainstream or how long it took although I was surprised that it wasn't the people I had come up with doing it. I would have expected it to be someone like Andy or Roni so I was wondering who these guys from Australia were; I love Pendulum and their sound and I think what they did moved things forward in terms of bringing in the live performance element.

I get a lot of joy out of seeing Andy being one of the main headliners these days, or when I see Goldie still putting in amazing performances. Those are the originators so that's always nice. I saw Dillinja play in LA recently and he was amazing. He would crush it on the main stage at EDC or one of the big festivals. He had a major label deal back in the day and I thought he would be one of the first to push through and cross over.

You look back on it now with nostalgia and people will tell you it was an amazing time in their life, or it got them through a hard time. We gave people experiences and a bit of hope and light in life. It's only entertainment but we did something good and worthwhile.

ENGINEERS WITHOUT FEARS

SPIRITUAL AURA (DEEJAY, 1993)

Having played on London pirate Fantasy FM in her early days as a DJ, by 1993 DJ Rap already had a few releases under her belt, most notably 1992's Divine Rhythm. Aston Harvey had been part of breakbeat innovators Blapps Posse and working as an engineer at Double Trouble's Noisegate Studios. Combining to form Engineers Without Fears, they originally released Spiritual Aura on Deejay Recordings, later remixing it for release on Rap's Proper Talent label.

Mixed by Pete Parsons (aka Voyager) at Monroe Studios, it was a huge record that combined lush melody with tough jungle breaks; something that would become a hallmark of Rap's sound in years to come. Following a couple of singles for Suburban Base, the duo went their separate ways. Aston would find success using a variety of aliases but is best known as one half of The Freestylers. Rap cemented her place in jungle's A-list and with the success of Proper Talent would eventually sign a deal with Sony's Higher Ground imprint where she showed her versatility as an artist on her album Learning Curve...

Aston: I met Rap at City Sounds in Holborn when we started talking about music. At the time I'd been working with Blapps Posse and doing some stuff for Rebel MC.

Rap: We ended up releasing a track called Run To Me under the name New Direction, which came out on Paul Oakenfold's Perfecto label.

Aston: I used to go raving at Roller Express a lot, and places like Ministry Of Sound and Club UK. I had DJed since I was 16, in the early days of the first raves at The Mud Club. I developed my production skills through my love of DJing. I

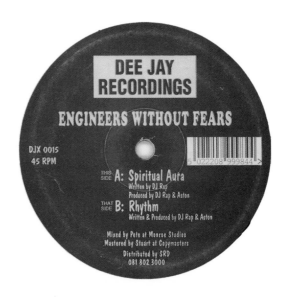

was friends with Sasha at Lucky Spin who asked me to do a track for his label, so I spoke to Rap, and Spiritual Aura was born. It was done on an M1 keyboard, a sampler and Cubase in Rap's bedroom.

Rap: If we had some money we would go to a studio, but we usually recorded at my house or Aston's house. I had come back from a rave and I was feeling – probably due to the drugs – like I'd had a religious experience. I was glowing and felt connected to God. Back in those days, you'd do tons of acid and pills. I felt I had religious experiences on a weekly basis! That tune was about God. Pure love shone through when I made it. It's an astonishing thing to have that feeling: those strings and that bassline. I loved dark keys, but I'm a songwriter at heart so it's always about the melody for me and it has to start with a vibe, a feeling or something I'm trying to express. The technical aspect is the last thing I concern myself with.

Aston: I was really into Masters At Work, and they'd do this thing where their beats would fade in and become louder and at the start of the track. I don't think anyone had done that in drum n bass before. I liked using weird sounds and was inspired by the hip hop and electro I listened to. I wanted to chop beats up as madly as possible and try and do things with the breaks that hadn't been done before. I wanted it to stand out.

Rap: Aston did the beats, he was great with beats. It was an awesome combined effort. He may dispute this, but when I played the bassline to him he said it was rubbish!

Aston: I didn't like the track to begin with; I didn't like the "get raw" sample. Once we had finished a track, we'd put it on cassette and listen to it in the car. Rap took it to Monroe Studios, which was the biggest studio at the time. So many big tunes were mixed or made there, and Pete Parsons did a lot of work back in the day for a lot of big-name DJs and producers. He had a massive influence.

Pete Parsons: It was DJ Seduction who first brought Rap to me to mixdown one of her earlier tunes, which was Divine Rhythm, I think. After that session, we began working together on a lot of stuff. Spiritual Aura was all done at her place with Aston before they brought into the studio, so there were no big changes to be made really, it was just to get it mixed down. As far as I can remember, they brought in the samples, and we mixed it in the studio, but they may well have brought it in already mixed, and it just needed a tweak here and there.

Rap: I initially hired Pete as an engineer. I'd go to the studio the day after a big night out with all these great ideas, and he could help me focus and channel those ideas, so we started collaborating. Like Aston, he's an amazing engineer. They're both really good at what they do. Aston and I eventually stopped working together as our tastes became so different.

Pete: We had a lot of fun in the studio, Rap was always totally vibed up in every session. She knew exactly what she wanted, and was great at getting her ideas out from her head and into the studio. One of the great things about working with DJs was that they were constantly hearing new music, they were living it and totally in it 24/7, so when it came to the studio it was an instinctive thing. Especially Rap as she was insanely busy gigging everywhere.

DJ Rap, London (1997)

Rap: I'd be playing four or five gigs a night which was normal for any DJ killing it back then. Every time I drove to a gig, I would hear it being played. It was played so much it was insane. I walked into Astoria, and it was playing, I'd walk into Telepathy and it was playing, I'd hear it maybe ten times in a night. It seemed like everything I made in those days just lit up right away; I don't know what I was on. It was a good run. I made sure Jumping Jack Frost, Fabio, Grooverider and Hype got everything first. We were like a family, so I was eager for them to play it. I didn't like to keep things on dubplate for too long though. I thought that hurt the scene.

> *"It was played so much it was insane. I walked into Astoria, and it was playing, I'd walk into Telepathy and it was playing, I'd hear it maybe ten times in a night."*

I was known as a good DJ, but Spiritual Aura meant people took me seriously as a producer. That catapulted me into the Illuminati of d&b. Nobody had made a record like that before, with the strings, tunes didn't start like that. The DJ rule was you start with beats and make it mix friendly. It was different from everything else out there. You could say it was one of the first liquid tunes. It wasn't intentional; I wasn't thinking "how do I get noticed?". I got fucked up, had a religious experience and poured it all out on a keyboard and made a track, and I did not know what that would do for my career. After I'd released Ruffest Gunark, I remember being at Music House and Micky Finn saying to me: "you're getting a bit dangerous

you are". I'd had hit after hit, and it was freaking people out a bit.

Aston: We used to do these PAs. We did some big event at Crystal Palace, and I left the DAT at home. I had to go back to North West London to get it! I didn't see much money from the sales of the record though. I don't know how many it sold, but it was a lot, and it was on pretty much every compilation that came out.

Rap: It was a huge fucking record, but we never got paid, and that's why I decided to start my own label. After being on Sub Base and Deejay, and them taking all our publishing, with us being naive artists at the time and not really making any money, I set up Proper Talent and asked Ray Keith to remix Spiritual Aura. We were making a lot of money as DJs, but it made business sense to look at what other people did with their labels. I learnt a lot from watching how Paul Oakenfold did his business model and studying people like Pete Tong at FFRR.

Pete: Spiritual Aura definitely stood out at the time, and there were some serious tracks about back then as well. There was so much amazing new music around, it was incredible. I think this track struck a perfect balance between all of its hooks, you only had to hear it once, and you knew it was gonna drop! The intro sets up the first drop perfectly with the pads, strings and arpeggio, plus the breathy vocals that pulls you into the beat drop perfectly. The combination of the syncopated beats and bassline is just pure steppers; it's got that emphasis on the first downbeat of each bar which you hear so much in a lot of funk tracks. I knew it couldn't fail, I knew it was classic from the first time I heard it.

DJ Rap, London (1998)

OMNI TRIO
RENEGADE SNARES (MOVING SHADOW, 1993)

Approaching things from a completely different angle to other drum n bass producers, Rob Haigh's musical history begins in the early 80s, releasing experimental art-rock on his own label. Discovering the burgeoning dance scene in the late 80s, he began applying his talents as a pianist to the emerging breakbeat sound. Recording as Omni Trio, he created some of the most unique drum n bass tracks ever. Renegade Snares is perhaps his most recognised track, with the Foul Play remix being a classic of the genre...

Rob Haigh: I was coming from a post-punk background and the music I had made before Omni Trio always had an experimental edge to it, so when I started dabbling with sequencing and sampling this was just a continuation of me looking for ways to experiment and find different ways of working. At that time jungle or drum n bass wasn't a genre. There were house and techno and rave, which all felt fresh and exciting and aside from the more mainstream side of the music, there was a definite experimental side coming from labels such as Warp, R&S, Mute and Nu Groove. It was that side of the music that drew me in.

In terms of the genesis of drum n bass, things like the first Depth Charge 12" were important. DJs used to play it at 45 instead of 33. It was unlike anything else around, and this was in 1989. Of course, no one person invented D&B, it was a movement which evolved collectively, but jokingly, if asked who started it all, I'd say the DJ who first thought to play Depth Charge at 45. There was also Shut Up & Dance and, of course, 2 Bad Mice who were early pioneers of accelerated breakbeats, and not forgetting LTJ Bukem who from the start had a real sense of vision which made him stand out from the crowd.

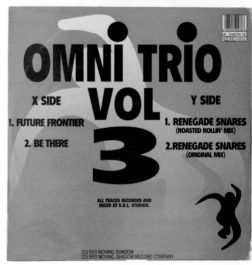

Foul Play was a great inspiration too. When Dubbing You came out it was one of those moments where everyone knew that they had to up their game, and they just went from strength to strength with tunes like Open Your Mind and a string of blistering remixes. I was a big fan of theirs, so I was thrilled that they got involved with some of my tracks. You knew you were in safe hands with them.

They brought a really powerful dance floor dynamic to their remixes, as is evident on Renegade Snares. They were great producers, sadly often overlooked in the drum n bass story.

In 1989 I had opened a record shop in Hitchin called Parliament Music, and that definitely played a part in shaping my sound. From the off, we were getting first picks on the latest white labels and imports. I soon amassed a library of beats and a capellas, some of which eventually found their way into early Omni Trio tunes. The fact that the music was still very much in its infancy meant that there was something of a blank canvas and that very much appealed to me. There were no rules or right or wrong ways of approaching things apart from the obvious need to make an impact with a tune. I think that it was this open-mindedness that gave d&b its edge in the early to mid-90s.

Experimentation and inventiveness have always been important to me, so that comes quite naturally, but at the same time, I'm not interested in being obscure or difficult for the sake of it.

In the autumn of 1992 a friend of mine, DJ Syko, had been in touch with LTJ Bukem with a view to letting him cut some of his tunes. They met up at my studio in the back of my shop. After taking a selection from Syko's DATs, Bukem asked if there was anything else. I mentioned a tune that I had just finished and he asked to hear it. I didn't have a DAT player at that time and mixed everything to 1/4 inch tape. I think that the saturation of the analogue tape made the bass booms especially punchy. He loved it and cut it that week and basically wore it out. That track was Mystic Stepper (Feel Good). Soon after I was getting calls from other DJs about this tune or any other new tunes that I might have, and that's what really kicked things off for Omni Trio. In that sense, I owe a debt to Bukem.

I knew the guys from Moving Shadow as they were often in the shop. Simon from 2 Bad Mice was doing A&R for Shadow and signed me on the strength of the Mystic Steppers EP. From then on, I had no reason to shop around, these guys were mates, and they just happened to run the best label around. They released practically everything that I presented to them – singles and albums – without any interference. I remember Rob Playford making a few suggestions about my fourth album in terms of the opening track and running order, which I was happy to adjust. Apart from that, they went out as I had presented them.

> ## "Drum n bass was kind of a renegade movement. It was on the outside of the mainstream."

Moving Shadow was very important to the success of Omni Trio. They put a lot of trust in me and let me do my thing, and even though I occasionally got the odd raised eyebrow along the way they were always supportive and committed. And of course, they were a highly respected label, so people took a chance with virtually everything they put out. That certainly made life easier. I didn't really think about the label or the scene when I was in the studio. I always had a load of new ideas that I wanted to explore and so was never tempted to repeat a formula, mine or anyone else's.

The only concession I've ever consciously made was to add a few more bars at the start and the end of some of my tunes to make them a little more DJ friendly. Other than that, I was largely immune to shifting trends and expectations. I was approached by two major labels, and I was told that a third had spoken to Moving Shadow, but I wasn't interested because I know how the business works and that it would have involved me doing a lot of stuff that I wasn't remotely interested in. Besides, I was under contract with Moving Shadow and perfectly happy, and with majors, it never ends well.

Renegade Snares began as the musical element, so I just had the pianos and pads which I had written as a kind

of Philip Glass type minimalist tune with no beats. Then I started experimenting with beats over it, and it came together really quickly. Originally I did two mixes of the tune, the Roasted Rollin mix and a slightly more rave version which got titled as the original mix. They were done at the same time although I actually finished the Rollin' mix before the original. In the intro of the Rollin' mix, there was this unusual breakbeat which I've been told is a challenge for DJs to mix, and on the end of every bar, I put a lone Amen snare before eventually letting loose into a cut-up Amen break. On one level we could think of these Amen snares as the renegade snares, but the title also works on another level as drum n bass was kind of a renegade movement. It was on the outside of the mainstream, totally independent, and like punk years before it, it created a minor revolution with its back firmly turned on the establishment.

I think that I knew that drum n bass had the potential to stick around. There's something about the combination of progressive ideas and powerful dynamics that works well in music and gives it a kind of longevity. You can find it in early psychedelia and later in post-punk music, and it comes to the fore again in 90s electronica, especially drum n bass.

John Morrow (Foul Play): We had done Feel Better for Omni Trio, which was a remix of his track Feel Good and he must have liked it enough to give us a go at remixing Renegade Snares. Not every track we remixed was a hit, so it's always a nice surprise when one starts to take off. I remember hearing Renegade Snares a lot and it seemed to be getting a really good response. There was one night in particular at the Que Club in Birmingham on New Years Eve 1993, and I remember hearing almost every DJ playing it and the reaction was always crazy; that was the night I realised we had contributed to making a big track.

Fabio: Renegade Snares is a classic, a great tune. It bridged a gap as the Amen breaks gave it that jungle feel, and the piano meant it still had that hardcore element. It's got a bit of early intelligent d&b mixed in there too. I was all over it, it was one of the biggest tunes of the time because of that flow and that feel.

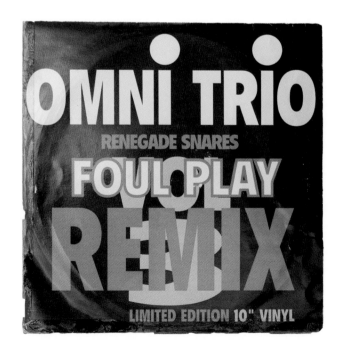

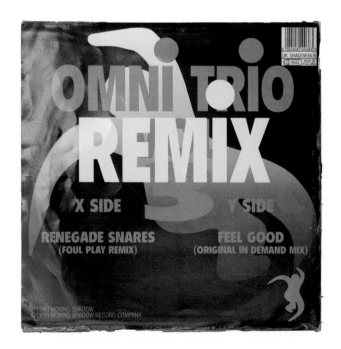

DEEP BLUE

THE HELICOPTER TUNE (MOVING SHADOW, 1994)

As part of 2 Bad Mice, Sean O'Keeffe helped put Moving Shadow on the map with early rave anthems such as Bombscare and Hold It Down. His first solo outing as Deep Blue had a similar impact. Incorporating a breakbeat that would go on to become a staple in the drum n bass world, The Helicopter Tune was instantly recognisable, sent dancefloors crazy and is now a certified classic...

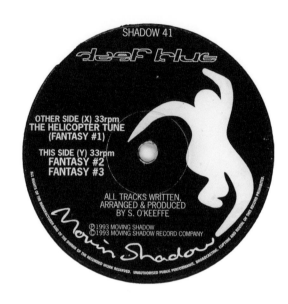

Sean: When we were doing the 2 Bad Mice stuff we would get one evening a week in the studio with Rob Playford. However, once things started to take off and I got my first royalty cheque, I bought some studio equipment because I wanted to be making music every day instead of being limited to one session a week.

I never had any grand plan to do stuff on my own, it was very much a side project to begin with. I didn't know if it would just be pre-production that would end up being used on 2 Bad Mice material or how it would work out. There is a certain element of compromise when you work as a group, and it was nice not to have to do that, although there are positives with having different creative minds and different ideas. We were fairly democratic, so if two of us liked something it would generally stay unless the other person really hated it.

LTJ Bukem was a big source of inspiration around that time. When he did Music that was the big turning point for me. I'd always liked that kind of sound as I was heavily into Detroit techno like the early Transmat stuff and labels like Nu Groove which often had those nice pads and chords. It had a very mature, grown-up sound to it. It was more refined than everything that had come before it, which was generally quite raw and naive sounding.

Music was a super slick, dreamy, absolutely unique piece at the time, and it blew my mind. I first heard Tayla play it on dubplate at The Sanctuary in Milton Keynes. I was out non-stop back then; week in week out we'd be at the bigger events in London, at least once a week without fail, at places like Roller Express and AWOL at the Paradise Club, plus Rage at Heaven every Thursday.

The Helicopter Tune was the first Deep Blue release to see the light of day. I had made two or three tracks on my own before this, but that was mainly me finding my way around new equipment. We would do a lot of chopping up of breaks and play them on the keyboard. Some people would cut up breaks and programme them in a sequencer, but we would cut them up a little bit and play them on the keyboard. The Helicopter Tune switches between the Blowfly break and another break taken from a record called Wind It Up by Konspiracy, which was on Shut Up & Dance.

I had no idea where the Blowfly sample was from until a few years later. I took it from a sample CD. It was off Zero G

73

Volume 2 which I had borrowed from Rob's studio. At the time with 2 Bad Mice, finding breakbeats was a big thing for us but we didn't really have any of the source records. Simon was really into hip hop in the mid-80s, so the breaks we sampled were either from those records without any idea of where they originally came from, or the early sample CDs.

I finished The Helicopter Tune in less than a day. I had recorded it to DAT and was just about to post it to Grooverider when I thought to myself that it needed an intro as it came in a bit too quickly. I came across a preset on the Yamaha DX100 keyboard called 'helicopter', and I pressed that key for 15 seconds, adjusted the modulation and thought that's it, and then sent it to Grooverider. At that point, it was still called Fantasy, which is why the two tracks on the other side of the record are Fantasy #2 and #3. I liked it when I finished it, and I thought I had made a good tune, but I had no idea it would be as successful as it was. I think you trust your own judgement as much as you can, and it can be difficult to be objective about your own stuff, but there are times when you can sit back and know something is definitely quite good. The rush to get it on a DAT and in the post that day was me trying to instil some self-discipline and not ruin it or overcook it.

It became popular very quickly. Someone told me the first weekend Grooverider had it he was playing at Sunday Roast or Jungle Fever, and apparently, it got rewound five times. Before 1993 there hadn't really been a culture of rewinds at raves. No one was stopping records and rewinding them – they'd have thought you were crazy. It was around that time it became a thing. I asked Groove to give it to Fabio and Randall, and then everyone wanted it. It snowballed from there. I hadn't realised the extent of how much sharing went on at the time, but it was still kept within a reasonably close-knit circle. People sharing those dubs down at Music House was pretty much the best form of promotion you could get.

It really worked in a club. 2 Bad Mice had been quite big, but it was certainly very satisfying to see the reactions to my solo work. It was a good feeling to see it take off and have that impact as it was not contrived at all. I had got a royalty cheque, I bought a sampler, and this was the result; it was unexpected.

It was at the point where the intelligent style and the jungle/jump-up style were separating a bit and The Helicopter Tune straddled both scenes. It worked in an LTJ Bukem set or in a Jumping Jack Frost or Gachet set. It was all more luck than judgement though, it wasn't intended in that way. I played it to Bukem, and he said he'd like to put it out on Good Looking, but it was always a given it would come out on Moving Shadow.

The period from dubplate to test press could vary, but by that time we had learnt how to keep the momentum going if a tune had a real buzz. If you left it too long, you'd lose out. It was made around October 1993, and I remember doing a few PAs performing it over Christmas and New Year, and then it came out in April 1994. As it started to get bigger everyone was calling it the helicopter tune, so the name evolved from that. It made more sense to change it from Fantasy and make it easier for people buying it in the shops, which was good business sense.

Moving Shadow was run properly. Rob had spreadsheets with the key dates for every release and he would

have a meltdown if labels weren't printed by a certain date and that kind of thing. John Knight at SRD had encouraged him to be that organised. I seem to recall the original pressing was 20,000 copies and that sold out within the first two weeks. As a comparison, the average Moving Shadow release back then would probably sell around 3 or 4,000. I'm sure Blackmarket Records ordered 200 on the day of release. They sold out and had to reorder more the next day. I think if you add in the repress and the remixes in the years that followed, in total it probably sold between 50 to 60,000 copies.

"We never thought beyond going raving the next week and wanting to make another tune."

The Rufige Kru remix came about as Goldie had started talking to Rob about engineering Timeless. This was before he had his deal with FFRR and he came down to the Shadow studios to do a session and see if Rob could interpret his ideas. We already knew Goldie from going to Rage. He had made Terminator and hooked us up with test presses, so we had a burgeoning relationship. We were looking for remixes and we either asked him, or he asked to do it. He had a case full of DATs from sessions with all sorts of stuff. He'd sit there with a portable DAT machine and his headphones on getting bits for tunes, so I think the remix came out of that.

There's no way I would have thought people would still be asking me about The Helicopter Tune and playing it over 25 years later. I didn't imagine it getting played six months later. We never thought beyond going raving the next week and wanting to make another tune. There was no real precedent for longevity other than maybe something like Strings Of Life, which you could still play years later. Songs from that era were the closest we had to a benchmark. I was 21-years-old when I made it, and you aren't thinking like that. It's astonishing it has that impact, and it still gets played and the youngsters in the crowd know it. I think if something is made with integrity you've got a better chance of standing the test of time.

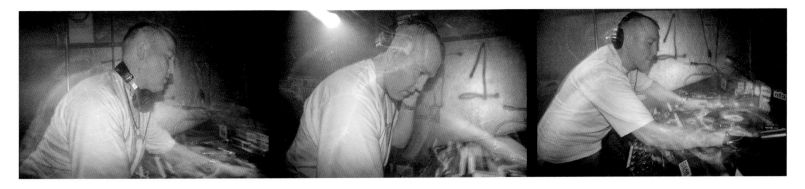

Rob Playford at the Winter Music Conference in Miami (1997)

LEVITICUS
THE BURIAL (PHILLY BLUNT, 1994)

Already a headlining DJ at the acid house raves of the late-80s, Jumpin Jack Frost is one of the original junglists. His production CV is relatively small, but not many artists can claim to have something as huge as The Burial in their catalogue. Drawing on his background of reggae and rare groove, The Burial was one of the biggest tunes of the jungle explosion of 1994, gaining popularity outside of the scene and dominating sound systems at Notting Hill Carnival that year. Originally coming out on Frost and Bryan Gee's Philly Blunt label, the demand for the record was such that it ended up getting licensed by Pete Tong for a mainstream release on FFRR the following year. Twenty-five years later, the "big, bad and heavy" track still rocks crowds...

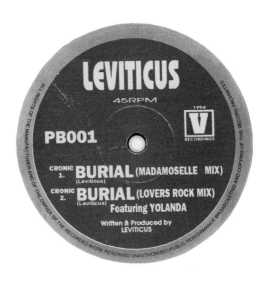

Jumpin Jack Frost: I'm a huge rare groove fan, and I grew up with that kind of music during my childhood. I used to go to the rare groove parties like Funky Express and Funkadelic. I'd also go to Soul II Soul every Sunday at the Africa Centre. Mademoiselle by Foxy was one of my favourite records at that time, it had such an uplifting vibe to it, and everybody loved it; it was a classic and I wanted to sample it. The Jigsy King and Tony Curtis tune My Sound A Murder was one of my favourite reggae bashment records and I loved the power of that "big bad and heavy" line. At the time, I didn't have a clear idea of what I wanted to do with them, but I knew I wanted to use them on a record.

Around this time I'd actually just been arrested for possession of a firearm. The police had come to my house and found a 9mm with 24 rounds of ammunition, and I was in deep shit. They were trying to get me to grass on the network of people that I'd got it from, but I was thinking 'fuck that'. I needed something to channel my energy into, so I decided to start making some records. I'd made some

tunes before that with DJ SS and I found that when I was in the studio I could leave my problems at the door.

I went to Dillinja's house with the two records, and that was it. We got a beat running and sampled the Mademoiselle "oooh" part first and then started playing the bass off the same record. I think sometimes the best records make themselves; I'm not a particularly prolific producer but I find sometimes the best records come together just like that, and that's what happened with The Burial, it just made itself. I was the producer and Dillinja was the engineer. Obviously, he's very technical and had a huge influence on the sound of the record. He's a genius. We come from the same area and had known him since he was a kid as his family was involved with sound systems around Balham. He had started making music and put out Lionheart so I'd been keeping an eye on him as a future prospect.

After hearing it 100 times while we were making it, I thought it was good but I didn't quite know if it was good enough to start playing to the boys. First of all, I made a dubplate with my name in it so I could test it playing it out; I

think I played it at Roast and everyone went nuts. It got a rewind straight away, and people were running up to the decks asking what it was. I started giving it out to DJs like Grooverider, Micky Finn, Kenny Ken, Randall and Fabio. It just blew up, and the hype got so big; it became apparent quite quickly to Bryan and I that we had a very big tune on our hands. It was flattering but quite overwhelming as I'd never had a record people wanted so much. I'd had tunes out, and people had played them but nothing where my phone rang so much and I was getting calls from people outside of the scene with r&b and hip hop DJs ringing me for it, reggae DJs ringing me, house DJs... it just went right across the board, it didn't matter. I think it was the anthem of Notting Hill Carnival that year.

"I played it at Roast and everyone went nuts. It got a rewind straight away."

We had V Recordings but it didn't really suit that sound, so we started up Philly Blunt to put it out. Then we decided to get some more tunes for the label, so we had Firefox's Warning and Dillinja went in with Gangsta, which were both big tunes too. We licensed The Burial to loads of compilation albums and took it as far as we could. Then London Records wanted to sign it and we passed it on to them. My manager at the time was Simon Gough who did all the Reprazent stuff with Roni and worked with Rebel MC back in the day and he was pretty experienced with these things. Part of the deal was that I had complete control so I chose the remixes and had last say on the artwork. I was happy with what London Records did as we'd already sold so many copies that anything they did was a bonus. In my world, everyone who wanted it already had it, so I was just grateful it was being taken to another audience. Off the back of that, I signed a publishing deal with EMI, so the track was licensed to London

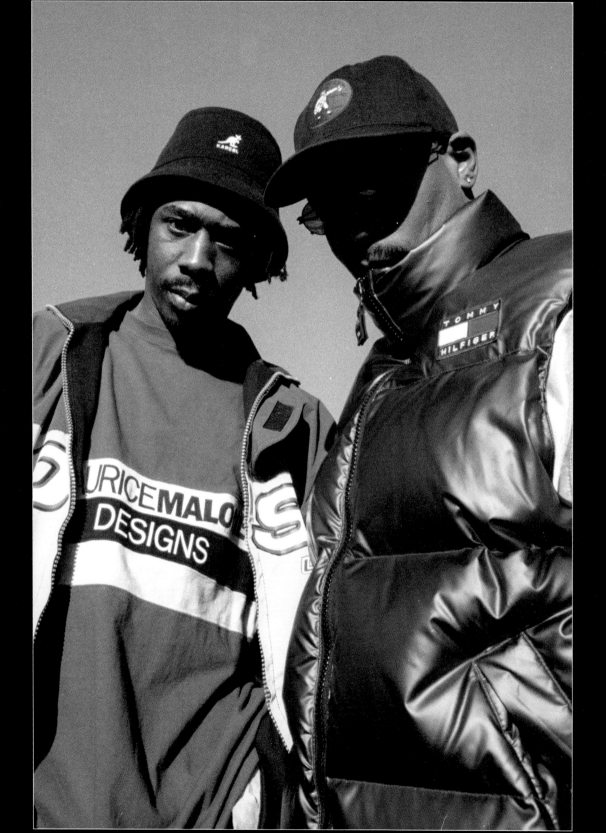

Bryan Gee and Jumpin Jack Frost
Brixton (1996)

for a period of time and then it reverted back to me. I did quite a lot of remixes under the Leviticus name and kept that same style for those mixes but I didn't feel the need to do another single at the time as I was busy DJing and our labels were doing well.

I think I started seeing that the tune had some longevity when I saw the reactions at carnival that year. I saw the magnitude of it and how it had crossed over and introduced a lot of people to jungle. It's a feel-good tune, and people always have time to feel good.

Bryan Gee: I remember Frost saying he was going round to Dillinja's to make a tune and he was going to sample Mademoiselle by a group called Foxy, which was a very big rare groove track. Everyone played it; you had Family Function, Soul II Soul, Shake N Fingerpop and sounds like Funkadelic and Maze who would play that kind of stuff. I didn't know about the Jigsy King part at the time but when he came back and played me the record we just instantly knew it was a hit. Frost's inspiration to use those samples was a perfect marriage with Dillinja's sound and his big bad and heavy bass.

I took it to the distributor, and they were like: "Nah, I don't think so". I don't think they understood it. I told them trust me, this is smashing up the place, this tune is going off. We released it and it was the first time we'd gone into jungle. With Philly Blunt, we wanted to do something that reflected the sound of the streets. Roni did Warning, Dillinja did Gangsta and Ray Keith did Girls Dem Want It, and they were tracks that had more of a street identity, with the reggae and hip hop elements. V Recordings is more universal so I don't like to restrict the styles, it's just good tunes. Straight-up beats and good vibes, tunes we liked regardless of genre. Later on, we did everything from the Brazilian stuff like Sambassim to Funktion by Ed Rush.

If you're talking top ten jungle tracks then The Burial it has got to be in there. You can play it to anyone outside of the jungle scene and they know it. It's a great track and brings back great memories.

M-BEAT FT. GENERAL LEVY
INCREDIBLE (RENK, 1994)

Since 1992 Marlon 'M-Beat' Hart had been crafting an abundance of raw, sample-heavy jungle for his father Junior's Renk Records label. General Levy was a prominent name in UK reggae, having been signed by Pete Tong's FFRR after releases on Fashion Records and Tim Westwood's Justice imprint amongst others. The collaboration between the pair resulted in jungle's first big crossover success story, with Levy reworking the vocals from his song Mad Them.

A venture into the mainstream for such an underground genre was not without controversy, however, and Incredible finding its way onto MTV and Top Of The Pops divided opinion. A now-infamous interview with The Face magazine saw Levy make some comments about his standing and influence in the jungle scene which were not appreciated by some of the more established DJs and producers and ultimately resulted in the record being blacklisted and ultimately affected the momentum Marlon had built up with his previous releases.

Although it never won the purists over, today Incredible can be looked at as an entry point to jungle for a generation. Alongside UK Apachi and Shy FX's Original Nuttah, it was responsible for a slew of compilation albums hitting the high street and evokes a nostalgic feeling for a generation of teenagers. By the mid-2000's you were as likely to dance to it at a wedding reception as you would be hearing David Rodigan or Heartless Crew play it. With Marlon not wishing to be interviewed, Renk's Junior Hart and label A&R and producer Steve B run us through the track's inception and impact

Junior Hart: Renk's approach was to come from a different angle than what was happening with the music, which

was mostly samples and high pitched vocals. I was from a sound system background and wanted Renk to go into heavy basslines and tough grooves with proper vocals which was unheard of in the hardcore scene. Everybody was still sampling from records and couldn't afford live vocals at the time. Renk was quietly changing the scene as we had already worked with artists like Ratpack in 1992 with a hardcore track called Looking Out My Window. That was the start of Renk recording vocals so our artists could perform live. That was how I saw the future of jungle.

Steve B: I started at Renk in late 91/92. I'd known Junior before he started Renk, we'd put out stuff by Michael King who ended up doing some big speed garage tunes years later. Marlon [M-Beat] was making tunes that were getting noticed, so he became a focus of the label. Junior and Marlon came from the reggae sound system background, so having live vocalists wasn't a massive departure from what they already knew. Junior looked at things a certain way

and was always thinking of the bigger picture, wanting to do live shows with singers.

Junior: Marlon is my son, and we decided to focus on the ragga vibes and capture the reggae market as well as the emerging jungle market. Sly Dunbar [of Sly & Robbie] is my cousin, so I had access to studios in Jamaica and vocals from Jamaican artists. I wanted Renk to have a distinctive sound and be the number one jungle label. I had no idea things would get so massive, but I remember saying to Marlon that if we worked hard, we could get the label established within three years, and we did.

Steve: Marlon was just churning tracks out, from Booyaka up to Incredible he was really prolific. He would use the studio during the day, and Junior would get other producers in at night. I was brought in to work the distribution and then ended up doing mastering, press, sending DJs tunes, whatever needed doing basically.

Junior: Incredible was a carefully crafted piece of work. Marlon did the backing track and had tried it with vocals from Shabba Ranks, Super Cat and Chaka Demus, which I had got from Jamaica, but every time he played me the demos it wasn't juicing me. I knew it needed a live vocal so I started to look for a UK DJ who could ride the riddim. I tried Tippa Irie but he couldn't cut it, and I also tried Smiley Culture, but that didn't work out either.

A few months later, my cousin Sly was working at Fashion Records. I ended up talking to John who owned the label, and he suggested I listen to a few of his artists and played me a few tracks produced by Gussie P. I heard a General Levy track called Heat and instantly loved his vibe. His voice was raspy and he could chat fast. John gave me his contact details, so I called him. It was about 10pm and by midnight I was at Levy's house chatting to him and outlining my plans to blow up on the jungle scene.

I left him with the backing track and he agreed to come to the studio the following week to demo the track. We met

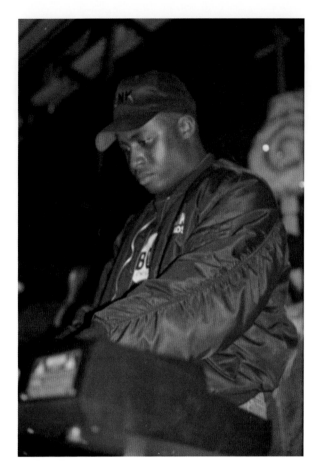

M-Beat performing at Thunder & Joy (1994)

up at Vons Studios [in Holloway, North London] to hear what he had come up with. When he opened with 'Well big up all junglist massive!' we knew he was the one. We did a rough mix of the track that night as I wanted to give a dubplate to David Rodigan. He was on the Kiss at the time and they were based over the road from Vons. We went to Kiss the next day and gave Rodigan the special and he dropped it on his Drive Time show. London went mad and the Kiss switchboard was jammed by people wanting it played again and it was requested for the rest of the week. Steve: I vaguely remember it being Easter Weekend and we took it to Music House to get it cut. We gave it to Devious D and Micky Finn and Frost were there begging us for a copy but Junior was saying no! I'd seen Frost earlier that week and he'd mentioned us distributing Leviticus for him, which

we had heard on dubplate and knew it would be big, so I was trying to get Junior to give Frost a copy of Incredible so he'd give us The Burial. On Tuesday the phones lit up. Devious told me he'd done a one hour set and played Incredible for about 40 minutes. People were going bananas and reaching over the decks to rewind it, so we knew something was afoot, but no one could've imagined the scale it reached. At the time you didn't get those full vocal tracks. There were things like Universal Love by 4 Hero, and Let Me Be Your Fantasy, but that was singing. Everything else was samples and snippets of vocals. On Incredible, Levy did the vocals from start to finish. I knew a guy called Vinnie who worked at SOUR, and he played me a test press of Original Nuttah. This was just after Incredible. I thought it was good, but the vocals were too much, I said the same thing to Vinnie, which was that I'd play the instrumental!

We knew something was afoot, but no one could've imagined the scale it reached."

Junior: There were only a few DJs I would give exclusives to, like Rodigan, Devious D, Micky Finn, Jack Frost and Nicky Blackmarket, as well as John Peel at Radio 1. There was also Big Al Mayfield who played a major part in breaking Incredible in the mainstream clubs. Those were my boys, and we'd work closely with them, feeding them Renk dubplates.

I wanted to try and convert the reggae DJs to jungle so I went to Jamaica and pressed up 7" records because reggae DJs wouldn't buy or play 12"s like the jungle crowd would. We needed to give it to them on a format they were used to. Incredible was the only jungle tune to be pressed on 7" when most underground releases were on 12" or 10" vinyl. The first release went to number 39 in the charts, and then I pulled it and set another release date. It was bussing up mainstream radio and clubs but nobody could buy it. This strategy created more buzz on the record. Tower Records in Piccadilly Circus was bombarded with people wanting it.

Steve: We put it out and deleted it, which built it up more. That was the version with the grey sleeve, then it came out again with the remixes in the blue sleeve, and there's a yellow sleeve as well – the Jungle Steppers mix – which not a lot of people know about. We didn't really do the dubplate thing. I remember early on, Junior saying to me that we needed to get the power away from the DJs because if they didn't play a record, we were fucked. He wanted to do videos, and get on TV, and was talking about the internet. Later down the line, I could see he had a point. He'd try all sorts of things and was quite ahead of his time. People like Danny Donnelly and Rob Playford, they had the tunes but also brought the business acumen to the table, and Junior had that too. He was always trying to go the live route because there was more money in it, and it takes the music to a different level if you can recreate it in a live setting. We did a concert in '94 in Walthamstow, and the strapline was 'the first jungle concert ever'. It was crazy, people were trying to kick the doors in to get inside. We even did a concert at Camden Palace with a full orchestra at one point.

Junior: I had approached Pete Tong as he had signed General Levy to London Records, and they didn't know what to do with him, so he hadn't done much until he featured on Incredible. I asked if he wanted to put Incredible out and give it a major label push. He said let's see how it goes, and then they might consider taking it on. I told him to give me a deal now or to forget it. He declined, and I marketed the track through Renk. I had to borrow money and almost lost my house trying to finance the track with the costs of making a video and pressing the vinyl, but I believed in the product and eventually signed a distribution deal with SRD, and that helped to ease the pressure a little. We shipped 40,000 copies in pre-sales and eventually sold around 60,000, but after marketing and the costs for shelf space that the mainstream shops charged and distribution we just

about broke even but it was tough going. The re-release in September 1994 entered the UK national chart at number 11 and went up to number seven and was featured on Top Of The Pops. Pete Tong came back to me wanting the track, and I told him to fuck off. He tried to muscle in, but I just looked at them as jokers. The rest is history.

Steve: We had been part of the scene since the acid house days, and there was no mainstream radio support and no magazine backing. I remember when DJ Magazine and Mixmag wouldn't come near us as they weren't interested. Every year they'd say it was dead, but it kept going and the

General Levy with dancers, South East London (1999)

parties were massive. The music was being played at places like Dreamscape and World Dance. If you listen to tapes from '94, people like Grooverider were playing Incredible. It was the biggest thing out with no mainstream help, so we were wary when the majors came sniffing around.

Mixmag did an issue with Levy, DJ Ron, Frost and Rebel MC on the cover and not long after that The Face interview came out, and it went a bit wrong. I think there was some confusion as to whether he said "I run jungle" or "I'm bigging up jungle". He swears he didn't say what he was quoted as saying; I think he did but didn't mean it as it was taken. Dancehall and reggae artists are quite bragga-docious, and they'll say that they're the best MC or what-ever. The jungle DJs looked at it as someone who had just turned up claiming to be the biggest thing and they took umbrage and weren't having it. That's when the jungle committee happened and all the rest of it. We were just lucky that the tune was already out there and as much as they tried to lock it off they couldn't.

Marlon used to go to a lot of raves and knew all those boys but then the boycott happened, he had some dis-agreements with Junior about the direction of things and ended up leaving the label. He got a deal with XL Record-ings and recorded an album that never came out, which he still has the masters for. Then he got a deal with Jazzie B and did some remixes for Soul II Soul. I think he was a bit affected by the boycott, but he was changing musically as well and going more into song-based tracks like Sweet Love, which he had actually made before Incredible, and that charted when it was re-released. He also made a jun-gle version of Free by Denise Williams and did Morning Will Come with Junior Giscombe. The boycott had hap-pened and Marlon was making all this musical stuff, and people didn't take to it, so he just stopped making music.

Junior: I am still amazed at that track to this day. We did a major deal with Honda for their worldwide advertising campaign, so it's still making money. Truly Incredible.

RENEGADE
TERRORIST (MOVING SHADOW, 1994)

Ray Keith has more classics and anthems to his name than most. Terrorist is perhaps the biggest of them all, with its distinctive piano opening, rumbling bass and rampaging drums, it was many a DJ's choice for an opening tune throughout 1994. It was also arguably the track that made the Amen breakbeat a cornerstone of drum n bass for years to come, and another iconic release on Rob Play-ford's Moving Shadow label.

Ray Keith: I made Terrorist in 1993, just before I was going to go and play out and Nookie engineered the track for me. We met through a mutual friend of ours called Pedro, who had done some stuff on Nookie's Daddy Armshouse label.

Nookie: Pedro worked with me at Red Records, and he knew Ray from City Sounds so he introduced us. We both have a Mauritian family background, and we connected and decided to work together. He wanted me to engineer for him and came round with the samples he wanted to use.

Ray: I had got kind of pissed off as everyone was just sampling reggae tunes and just ripping the fuck out of them, so I thought, I'm going to do something and show everyone what my interpretation of jungle is, which is dub, and that's how Terrorist came about. There are three main influences in there: Smith & Mighty, Kevin Saunderson and Derrick May. Derrick is a good friend of mine, and when I listened to Strings Of Life, I wanted to make something like that, which really stood the test of time. As this was my version of dub reggae, I was also inspired by Bob Marley and Studio 1. I'm an 80s baby so when I was growing up, electronic music was artists like Depeche Mode, Kraftwerk, Paul Hardcastle, Gary Numan and John Foxx. I'm still very

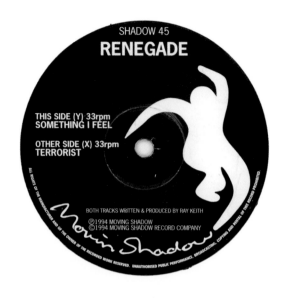

much into that stuff, and it's the blueprint of what we do today.

Nookie: I was still living at my parents' house at the time and there was an extension out back that I used for my studio, which is where we made Terrorist. I had my Dad's old Sony hi-fi speakers in there, and the bassline was so heavy it blew one of the speakers so my Dad wasn't too happy! Ray wanted the piano off the Japan record re-played rather than sampled so I recreated it.

Ray: I heard the Japan track [1980's Nightporter] and thought the piano was unbelievable. We replayed it in the studio so I wouldn't get fucked for sampling it, as I previously had problems when I did News At 10 (Ray's 1992 release on Absolute 2 that made use of the theme from the ITV programme) and didn't want to get caught out again. I reworked the Amen break from King Of The Beats by Mantronix, creating my own interpretation of it. He had

sampled it from the original Winstons track, so there's a lot of musical history going on in Terrorist. It's quite moving that all those people touched my life, and then I was able to take that and pass it on to a new audience, in a new era, with a new culture of jungle/drum n bass. The way I left the breakbeat clean on the track meant that it ended up being sampled by pretty much everybody.

Nookie: I was only there to engineer it, but I helped out and gave my advice on what sounded good. I was just doing it for the love of doing it back then and the buzz of hearing my music played out.

> *"This music was born from the underground. We pushed and pushed, and people started to embrace it."*

Ray: It came out on Moving Shadow as Nookie was already over there and I was mates with 2 Bad Mice. At that time Rob Playford was a very inspirational and influential figure with one of the biggest labels. It would be my first track for a big independent label, and going with them just seemed like a good thing for me to do. The 12" wasn't released until the middle of 1994 but it was getting played off dubplate from around November 1993. I remember dropping it at Orange at The Hippodrome and then later I was standing in the foyer waiting to get paid and could hear Frost playing it, and the place was going crazy. Grooverider, Fabio, Frost and Bryan Gee would be the people that I would give my music to first, as well as Kenny Ken, Randall and Doc Scott. Groove had played my first records back in '92 when I'd done a remix for Orbital, so when the time came I commissioned him to do the remix of Terrorist.

Nookie: I didn't foresee Terrorist being as big as it was. All you can do is write a tune to the best of your ability, and if

Ray Keith in Blackmarket Records, Soho (1997)

you're feeling it then that's what matters. There was no set format, it was quite free as to how ideas were laid down. You had no idea how people would respond to tunes. If we knew how massive it was going to be maybe Ray would've put it out himself rather than on Moving Shadow! That would've been the time to start his own label up. It's all part of that learning curve. Now tunes like that are just accepted as anthems, but we didn't know what would happen back then.

Ray: I guess we were the new kids on the block at the time and it was a new genre. You could compare it to when hip

Ray Keith and Clarky behind the counter in Blackmarket Records (1997)

techno and then the hardcore era. I had remixed Shades of Rhythm and Baby D which were big rave tunes, so it was a natural evolution to get rawer. Tracks like 28 Gun Bad Boy by A Guy Called Gerald were really integral to what we were doing.

I don't consider any one tune in my career as a defining moment, I just look at it as a journey that led me to the next tune, and the next tune after that. I don't look back. I'm learning to appreciate what I've done but I'm always looking forward. Every tune has a different meaning to different people. Terrorist just represented that era at the time: the feeling, the rawness, the independence. It was a hard time in those days but the music brought people together; it was an amazing time for all of us. I can still play Terrorist in a dance today and the crowd still goes nuts.

hop came out in the States. Back then, we were so young we didn't really know what we were doing so we were just living in the moment and it's just lovely to have been part of it. It didn't just suddenly blow up, this music was born from the underground, and there was a lot of hard work going on for a good few years when we were running about doing the grafting. We pushed and pushed, and people started to embrace it. Things began with nights at the smaller underground clubs, and then we got a foothold in bigger venues for nights like Orange and Voodoo Magic. Before that there was AWOL at the Paradise Club, Telepathy at Wax Club on Fridays and I was doing Slime Time on Wednesdays nights. We'd come from house and

Andy C: What a record. Even now, when I play it out, it just goes off! It's a beautiful combination of notes, a perfect EQ of the Amen and the vocal and the other break layered over the top and the bass. The groove is so simple, and there's a beauty in the simplicity. The bit when the female vocal comes in, and the loop on the snare drum comes in over the Amen... oh my god that set me off. I remember being in Wax Club for Telepathy and Brockie dropping it. I can still picture it now: Brockie's playing and Det is dancing sideways onto him with his hands in the air, and the club is going off. It got rewound and what a vibe there was in the club; I got goosebumps. Just thinking about it now makes me feel quite emotional. I don't know if that vibe can ever be recreated.

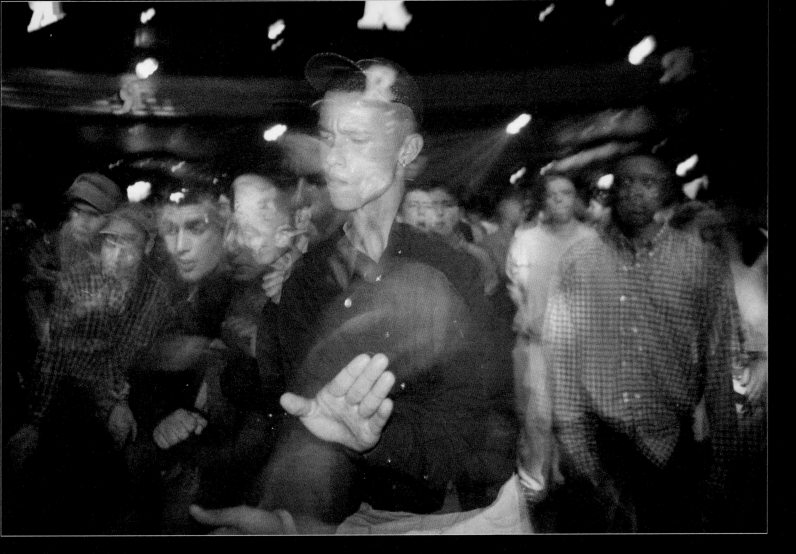

The last Roast event at Stratford Rex,
East London (1997)

THE HOUSE CREW
SUPER HERO (PRODUCTION HOUSE, 1994)

Production House was one of the heavy hitters of the hardcore era, serving up anthems by the likes of Acen and DMS, and holds claim to one of the biggest commercial hits of the time in Baby D's Let Me Be Your Fantasy which went to number one in the national charts when it was re-released in 1994. Floyd Dyce was involved in a lot of the label's productions, and in 1994 as The House Crew, he dropped a monster of a jungle tune in Super Hero.

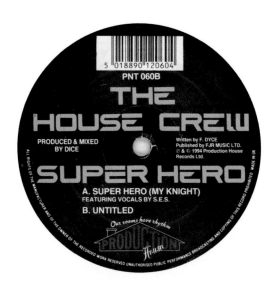

Floyd Dyce: The shift from hardcore to jungle was a natural progression really. Our hardcore tracks had been influenced by reggae, and that became a part of the jungle sound. As far as the increased tempos, it wasn't a case of suddenly one day turning the sequencer up to mega speed. Faster beats were something we had always done. When you look back at things like the tracks I was doing with Acen, they were quite ahead of their time and on the faster side.

We always used different equipment to everyone else. We had a commercial studio so it was more developed and we were probably better equipped than most. When a lot of people were using Ataris, we were using things like the MPC, which was new on the market at the time. The Prodigy and some of the XL Records lot were probably the same. I know Liam Howlett was using the same equipment that Acen was using. When Acen first came to us, he was using the Roland W-30 sampler, and I'd never seen anyone use one of those before. It was a nice bit of kit and Liam used that, so their styles were similar. Acen was into Shut Up & Dance and Liam was influenced by a lot of their stuff. Shut Up & Dance were pioneers for the early jungle sound with the style they were doing.

We were songwriters and constantly looking to have original material, so it was a case of trying to be more creative and trying to make things that weren't going to

get us into trouble sample wise. That being said, Super Hero has a big Buju Banton sample on the track, but we didn't have any comebacks from that. The female vocal was sung by Samantha Scott (credited as SES), who was working with Production House's soul label which was called Special Reserves. The line she sings is from a song I wrote specifically for the track.

There was more to that song than what we used on the final version, but I was getting such a vibe off the Buju sample that I couldn't not use it. We also had the 'must be some kind of superhero' line, which wasn't a sample either, but we'd often do things like that and make them seem as though we'd taken it off a TV programme or another record. Because we were trying to fit all these parts into one track, it became a case of only using part of Samantha's vocal so we could use the Buju Banton bit, so the end result wasn't too song-y, not too ragga and not too hardcore based. We took the strongest elements of each part, so when you listened to it top to bottom, it had quite an impact.

I think the first time Super Hero was played out was at Astoria. I wasn't around on the night but I got some feedback from MC MC, and he told me it got rewound six times; it just went off! That was a good indication it wasn't going to do too badly. I would definitely get a vibe and an energy when making a track, but I could never tell if something would be big. DMS was probably our biggest in-house DJ, and he played all our stuff first, so a lot of the time we'd run things past him to get the DJ angle on it and try to gauge as to whether it was worth continuing with. We really embraced the dubplate thing as it was a good way of hearing what other people were doing and supplying certain DJs. It became a significant part of the culture. Music House became a meeting point for the industry and a good way of keeping your ear to the ground. Most of the big DJs were on our mailing list, like Fabio, Grooverider, Frost and Hype. They all got everything first, and we'd get feedback from them. As we'd become an established label you knew it would get played and not just shoved in the back of their bag. I don't know exactly how many copies Super Hero sold, but we shifted a lot and it was in the club charts. Production House was self-distributed, and I know James and Raymond, who were our guys on the road, were shifting boxes and boxes of the stuff. There was a point where people would buy a release just because it was on Production House.

> *"You don't get a scenario very often where something is so different and new. That era was revolutionary."*

Things were still moving fairly organically, but the success of Baby D did end up taking priority and we were on the road doing more PAs up and down the country. Much more of the creative focus was on that, so it did take time away from the other projects. The House Crew was probably my favourite project to work on though and without the Baby D thing I think I'd definitely have ended up doing more House Crew tracks and making more drum n bass. The way the scene was going was definitely more in line with what I wanted to be doing with the jungle stuff, but the demands were too great as far as Baby D was concerned. Acen was another project that needed more attention, but it became harder for us to get together, and he began to focus more on his own stuff, and I was focusing on Baby D. We'd be going abroad to America and Canada and Europe, so that took up a lot of my time.

When Baby D signed to London, they wanted to use The House Crew's Euphoria for the album which I was really against. I think that was the beginning of fallings out within the setup. I think there were talks of House Crew being signed as a separate act but because Baby D was a priority we had to go with that as working on both at once would've been impossible.

At the time we made music because it was fun and we enjoyed it. We never looked further than the next weekend; it was just about the vibe at the time. It's incredible to think that the records Production House released have made such an impact on a generation and influenced the generations that followed. We still get requests for compilations and remixes, so to think that people still play it 20–25 years later is incredible. We never thought that far ahead so never in my wildest dreams did I expect that.

You don't get a scenario very often where something is so different and new. That era was revolutionary when you think about what was happening socially at the time, and also with the equipment and samplers coming in and people looking back through the music they grew up with and were influenced by and taking bits and pieces from that. That whole movement changed the way DJs were looked at. All of a sudden they were becoming superstars. That way of doing things was totally new and fresh and there hasn't really been that sort of musical revolution since. When you look at modern club music, it's still influenced by what we did back then.

DJ CRYSTL

LET IT ROLL (DEEJAY, 1994)

With his roots in London's hip hop scene as a member of The Brotherhood, DJ Crystl [Dan Chapman] began making moves in the rave world, aligning himself with the Lucky Spin/Deejay Recordings crew. Working alongside engineer Pete Parsons, he conjured up a series of revered tracks such as Warp Drive and Let It Roll. This resulted in a deal with London Records subsidiary Payday which saw him working with rappers from New York, fusing hip hop with drum n bass to great effect. However, it's those early tracks that have him revered by junglists to this day...

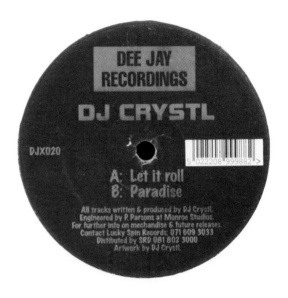

Pete Parsons: Dan was originally the DJ in The Brotherhood, a UK hip hop crew who were using my studio at the time. I was working with them on some demos and recordings, and he knew I was also working on some hardcore stuff with DJ Seduction. This was probably around '92–'93 when hardcore was changing into early jungle. Dan was getting more and more into it as it was more about sampling beats and sounds which was exactly where he was coming from in The Brotherhood, but at much faster tempos obviously.

Crystl: Making the move from hip hop into hardcore and jungle was a natural progression as I was always into the more uptempo hip hop at the time. The early hardcore like Ragga Twins had a very hip hop element, so it felt right to slide across to that genre. I didn't completely leave behind my hip hop roots at all; in fact, I brought them fully across with me. My hardcore productions had hip hop or b-boy elements. I think a lot of people I knew that were hip hop heads at the time also ventured to the dark side and dipped their toes in. As a hip hop producer, it was possibly the most inspirational music being made. Tracks like Rebel

MC's Wickedest Sound, for instance, was such an incredible track and that was a crossover of the two genres.

Around '93 I was playing out at raves, radio stations and clubs as well as producing. I was on Rush FM a lot with Red Ant, MC Fearless, Dicer and all those boys. At the time, I was very inspired by Doc Scott's track Surgery; that was a bad boy tune. I've always liked heavily edited drum patterns, so I guess I just used to go in and just twist up and trigger the drums up. All my music was recorded at Monroe Studios in Holloway Road. I would pretty much have an idea in the morning I was driving to the studio and go straight in and lay it down. Pete and I worked closely together on the vibe, and he played a big role in the engineering, and I also had input. In the early days, I had no clue how to use the equipment, so he basically taught me everything I know.

Pete: Dan always knew exactly what he wanted, he'd have a riff and beat patterns already made up in his head, and

we would vibe with the sounds and beats to get the idea of the track that had already been rolling around his head before he got to the studio. Once we got the basic ideas down, it was again, down to pure vibing it. We would work on some different sections and beat edits as well as other patterns and sounds to get a few mini arrangements together, and then string them together. We hit a flow pretty quickly, and the partnership was very productive right from the beginning.

> "It really went off at AWOL when Gachet dropped it; that's when I knew I had something special."

From what I remember, Let It Roll came from just messing around and vibing. I'd always assign a sample to a single key, but on this track, the snares and claps are plotted across an octave or two, plus I was messing with edits on 32 and 64 beats, and adding delays to other drum sounds as well, this pretty much all came from vibes, which was a big part of how we worked. I think the track was probably done over a few sessions. Dan would have needed to take it away and live with it for a while before finishing it off. With a lot of our tracks then we'd have to have some space between sessions to keep objectivity on the arrangements as they were all

pretty epic tracks, and there's only so much intensity you can take in one session! There were a lot of times when a track would be pretty much done and dusted in one session and then brought back for some minor edits and a mixdown. We had some great sessions, and back in those days, we were knocking them out pretty much on a weekly basis.

Crystl: It was always intended for release on Deejay as the label owners were friends of mine. I made sure the main boys like Grooverider, Fabio and Bukem had it on dubplate but I don't remember where it was played first or who by. I remember Peshay smashing it loads, and the reaction was pretty damn good! It really went off at AWOL when Gachet dropped it; that's when I knew I had something special.

Producing that track along with my other releases led to me getting headhunted by a major label, and the rest was history. To this day I still get a lot of love and interest in all my old stuff I made which is amazing. When I see a post by someone or get an email praising and stating how my music affected their lives, for me, that's priceless.

AK1200

One of the pioneers of drum n bass in the USA, AK1200 gives his perspective of the early days of D&B on the other side of the Atlantic...

AK1200: I'm from Orlando, Florida and I started out playing electro, Miami bass and hip hop; stuff like Dynamix II and Planet Rock. I ran a record store between '91 and '92, and that's when I started paying attention to the hardcore coming out of the UK. I'd call the numbers on the labels and hit up people like Micky Finn and Aphrodite. It got to the point where I knew people and had things sent to me months in advance, so in America, I guess I was the equivalent to someone like Randall in the UK. I was getting dubplates cut. People like Brockie, Hype and Photek were giving me stuff. I had everything from Moving Shadow and Suburban Base too.

Ecstasy was legal over here until about 1990, so everyone in New Orleans, Texas and Florida was doing it back then, and that's when everything started happening like it did in the UK. We went through the whole Balearic summer of love and every phase after that. Sasha was coming here in '88–'89, and we were up to date with dance music as a whole. Florida was big on breakbeat, and we'd have PAs by people like Dream Frequency. When 2 Bad Mice came out with Bombscare and Kicks Like A Mule did The Bouncer, that became the catalyst for the funky breaks scene in Florida. From 1992 onwards there was always somewhere to play. DJ Icey bought 2 Bad Mice, Blame, Rob Playford and MC Flux over to Orlando and they played to about 2,500 people.

I went over to England to play that year too. In 1993 Danny Breaks and I played in Chicago for the first time at a rave called Spank Da Monkey. It was a small scene, and it was super underground, but it picked up in places like Washington DC from '93 onwards, they were really into d&b. New York was good, and so was LA. The more

A copy of AK1200's Junglized newsletter from Summer 1995

culturally diverse cities were into it. Although in the UK it was street music, here in the States it was a more of a white, middle-class audience. The majority of black youth who were open to allowing dance music in their lives did so mostly with Detroit techno, Chicago house, New York garage, or Miami electro. Even when the reggae influence became prevalent in jungle, there were no significant changes in the demographic.

Drum n bass is famously the black sheep of dance music so we'd always be in the smallest room with the shittiest sound system and the least amount of attention to detail. Traditionally the sound systems here were designed for house or techno, so we'd be playing bass-heavy music, but you couldn't feel the bass. There would never be enough

money to do a full-on d&b show. Eventually, you might get one DJ in the main room if they were good enough and two or three in the side room.

As far as big records from that time, Mash Dem Down by Rude N Deadly on No Smoking Records was one that stands out. I remember playing it in DC and seeing people go mental to that. Babylon by Splash, and Oh Gosh on Juice Records were both huge over here. Wishing On A Star on Urban Gorilla was popular. The Desired State remix of Jay Z's Can't Knock The Hustle was big too. Pulp Fiction didn't hit over here like it did in the UK. I liked it personally, but it didn't have the same effect at all; I think it went over people's heads. Something like Peshay's Piano Tune probably had a bigger impact. Things that were deeper didn't tend to go down as well as the tracks that had a more immediate impact. It wasn't until when Reprazent came out with New Forms that people over here got more into that kind of thing.

I had devoted 100% of myself to promoting and representing this music all over North America. DJ Icey ran a little newspaper called US Rave, and I was contributing to that and then started doing reviews for Mixmag Update. The biggest person in the US for d&b would probably have been Dieselboy, and he was reading my reviews to find out what to play. Myself, Dieselboy and Dara, who had come over from Ireland in 1995, were the top three known guys and then there were a few just below us, like RAW from LA and Phantom 45 in Chicago. DJ DB was a big part of it in New York. Each region had someone. Certain places liked it a bit grimier, and others would like it a bit more refined. I pretty much played across the board; what I thought was the best of everything. Whenever something got super popular, I'd move on to something else. Around '97 things got too hard and techy, so I started playing jazzy stuff. Around '99 when everyone was playing Bad Company, I was playing Calibre and EZ Rollers. I'd try to be on top of what I thought was next the whole time; I felt that was sort of my obligation.

I had to work twice as hard for people to relate or take it – and me – seriously. Firstly to be accepted and trusted

as an American representing English music and then, to translate it and properly represent it for an American audience, ultimately helping to open the gates of opportunity for UK artists to come and have an eager crowd waiting for them here. It was a lot of extra work to get people familiar with the music, but eventually, it took off and became really popular. At one time, everyone that came over from the UK wanted to live here. Shy FX lived here for a while. Frost and Bryan Gee had the night at Twilo in New York, and Aphrodite had a residency with me at The Viper Room in LA, which was owned by Johnny Depp.

"You had to be there to witness it, to know what the feeling was and what it was about."

Goldie once said that you have to come from the UK to understand this music. You had to be there to witness it, to know what the feeling was and what it was about. The whole rave movement from hardcore to jungle, there was a point to it all. It wasn't just a case of "this happens to be the vibe", this was where these people were going, and it had nothing to do with mainstream club life. Sometimes people forget that originally this was street music. It might seem odd to hear an American say that, but I can remember witnessing what it was like at Carnival and seeing the stage and getting that vibe. I remember what it was like going to Bar Rumba or to AWOL at Paradise Club.

In the end, the music spoke for itself, and as thankless as it could ever appear to have been, it is something that can never be taken from me. I am the longest-running American drum n bass DJ. I was the first American D&B DJ to play in the UK, and the first to play on pirate radio in the UK. I was the first person to bring Andy C to America. I am the first to do many things, but to still have the impact I have today, is something far beyond any considerations I had when I first became addicted to this music.

CHIMEIRA
DEEPER LIFE (BACK2BASICS, 1994)

Chimeira was comprised of Mark Clements, later of Cause-4Concern, and Tobie Scopes, who would eventually become half of the Serial Killaz. Tobie explains how a night at AWOL sparked a series of events that saw their debut track end up in the record boxes of A-list DJs and kick-start two careers that made an indelible mark on drum n bass..

Tobie: I was at AWOL one night and Micky Finn played Code Red by Congo Natty, which I thought was amazing. I knew that once I had gone up to ask him what it was, I couldn't go back again later if I heard something else; it was an unwritten rule of sorts. Half an hour later he played The Way, so I had to ask my girlfriend to go and ask him what it was, and he told her it was a dubplate from Back2Basics and it wasn't coming out. All the way home, I was thinking about that track and how badly I needed to get a copy of it. The next day I found a number for the Back2Basics record shop and ended up speaking to Jason Ball. He told me the track wouldn't be released because of the sample but suggested I spoke to Taktix, as he made the track. We had a chat, and he said I could come up to Birmingham and cut a dubplate of The Way.

Two days later I got on the train to Birmingham with a big bag of weed and went to the Back2Basics shop. They were nice guys and we ended up listening to tunes all day, and before we realised, it was too late to get the plate cut, and I'd missed my train, so I ended up staying the night at Taktix's place. Jason agreed to give me a DAT to take back to London on the condition that when I'd finished with it I posted it on to someone else, who turned out to be Grooverider, so I actually had it before him! I remember cutting it at Music House when a few big DJs were there, and they were all asking me how I had got hold of it.

I stayed in touch with Back2Basics boys. They came down to play at a club night called Depth that I was running in Chertsey, and I went back up to the shop a few times. Jason suggested I go into the studio, so I asked my mate Mark to come with me; we were both just bedroom DJs at this point. We went through some sample CDs and records in the studio and came across the "deeper..." vocal on the acapella of this house record, which we thought sounded brilliant. We picked out some breakbeats and I took the strings off an obscure jungle white label. It all seemed to fit amazingly and came together in about four hours. A week later Jason called and said he'd played it out, and people loved it.

I was working at Vinyl Frontier in Woking and my boss Joe took a call from someone saying he was Kenny Ken and he was looking for me. At first, I thought it was a wind-up, but it turned out it was actually Kenny, and he was looking for dubplates to play at the Jungle Soundclash. Jason had told him about our track, and he wanted a copy. He called me again two hours later and said he was in Woking. I was only 20 or 21 at the time, and I'm buzzing that this DJ I look up to has come to meet me. Not only that but it turned out he had Randall in the car with him too! I get in the car, and we go to my mum's house to get the DAT. I think we had a cup of tea with my mum and then off they went. I was sitting there wondering what the hell had just happened! It was fucking mad.

I remember being at Voodoo Magic in Leicester Square and I was talking to Dr S Gachet while we were upstairs on the balcony looking down at the crowd, and Andy C came on and played Deeper Life. It was still on dubplate, and this was the first time I'd heard it played out. GQ was on the mic and it got a rewind; the whole thing was fucking amazing. That was when decided I was going headfirst into this.

The name Chimeira comes from Greek mythology. We were sitting around one night, and my girlfriend came up with it. It's an animal with a lion's body and serpent's tail. We thought it sounded good and went with it, but no one could ever say it properly.We put out another track on Back2Basics called Bubbles, and then we started working with Tango. We loved all his early stuff with Ratty and Fallout. He was one of the best producers and engineers ever, an absolute genius. We had a few releases with him on Creative Wax under the name Rising Sons. Around that time Metalheadz wanted to sign something we'd done and Reinforced approached us, but they wanted a four-track EP, and we also spoke to Moving Shadow. The problem was we didn't have our own studio, and we didn't drive, so we could only do something every few months, and then we tended to release our material through whoever we worked with, like Back2Basics or Tango. Eventually, it got to a point where Mark and I were just enjoying DJing really.

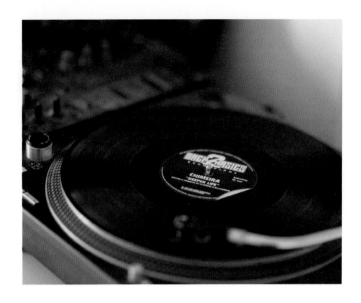

> ## *"It all seemed to fit amazingly and came together in about four hours."*

If you'd had a big tune out, you could swap tracks with other people and get dubs cut and working in a record shop meant I was getting a lot of promos and I would meet promoters like the guys from Slammin Vinyl, and Chris from Fusion who gave me my first big break when he booked me in the jungle room at a Fusion event at Farnborough Rec. I played in between Hype and Frost that night. Around that time Turbo Terry was doing One Nation at The Rhythm Station in Aldershot and made me a resident there. Working in the record shop meant I could sell a lot of tickets, and being local, my friends would come along and support me, which is what the promoters wanted. Working for Phil Wells at Record Basement and Vinyl Distribution in Reading was a massive step up for me, and I started getting a few bookings to play in Europe.

Eventually, I met up with Graham through a mutual friend and that's how Serial Killaz came about. I had the parts for Junglist as Rebel MC wanted me to give them to DJ Hazard so he could remix it for Congo Natty. We were going through the samples, and Graham really wanted to remix it. I didn't want to upset Rebel, but Graham suggested we do it, send it to him, and if he didn't like it, we would delete it. We did the remix and sent it to Hype and Nicky Blackmarket. A couple of weeks later Nicky called me and said he was playing it in every set, and it was smashing it. I explained we weren't meant to do it but asked if he could ring Rebel MC and tell him. Hype also called me to say it was killing it, and he played it on Kiss FM every week for ages.

I had always been into reggae, and ragga jungle was just starting to come back with Shy FX and Chase & Status doing a few tunes, and people like Red Eyes and Benny Page, so we had done it at just the right time. Eventually, Rebel called me after Nicky and Hype had spoken to him, and said he wanted to put it out. Our remix came out on Congo Natty, and it did well. We had a fantastic working relationship with him, and after that, he sent us a DAT with the samples for all his biggest tunes, and we started engineering and producing for him. If Graham hadn't convinced me to do that remix, and without Rebel's approval, we wouldn't be where we are today. It's been a mad journey!

UK APACHI WITH SHY FX
ORIGINAL NUTTAH (SOUR, 1994)

A record that could only have come out of London, UK Apachi's distinctive vocals on the anthemic Original Nuttah came to represent the jungle explosion of '94 perhaps more than any other record. As infectious as M-Beat's Incredible but with more energy and a streetwise edge to it, the track caught fire and hit the national Top 40 in October 1994. The combination of the Goodfellas sample and horns on the intro leading into Shy FX's rapid-fire breakbeats and Apachi's infectious dancehall chat made for an undisputed classic...

UK Apachi: I'm half South African, and my grandmother was Nelson Mandela's first secretary, so from an early age I was around revolutionary people that were involved with the ANC and the anti-apartheid movement, and that influenced me in listening to certain types of music. I was born and raised in London as an only child, and it was quite rough in the streets. There was a lot of National Front things going on, and it wasn't the multi-cultural society we have now, it was very difficult. I was mixing with some white English people, but they didn't really look at you as being proper English, so you'd be almost scared of your identity at that time and wouldn't feel proud of it, so I was still finding myself. The black people were more accepting, though. There were Jamaicans living in my neighbourhood, and I got introduced to reggae. I would hear people like Bob Marley, Papa Michigan and General Smiley, Lone Ranger and all these reggae artists. Bob Marley was a big influence on me because reggae at that time was representing the people and singing about justice and the fight against the system. That connected to me and my South African roots, so I took to reggae, I became friends with some Jamaicans that had come to the UK from Kingston and Spanish Town, and we built up a sound system. We'd used to play a lot of

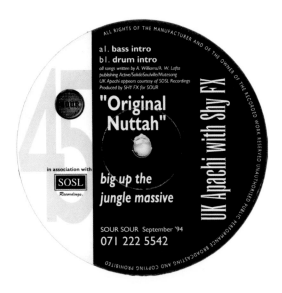

parties and clash each other. I loved the Jamaican culture, and I would walk and talk like a Jamaican, but I was a Jafakean!

I saw reggae as an outlet to connect with the people, so I wanted to released tunes and spread a message. The poll tax was introduced when I was a teenager, so I decided to make a tune called No Poll Tax with a guy called Michael Gordon who had been in a lovers rock group called The Investigators. I didn't expect it to get played on the radio and it actually got banned. This was in 1990, and I didn't think anyone had really heard it, but it was getting played at Carnival by Lord Gelly's Sound, so I would go to Carnival and mash it up and get a good response. Then I did a tune called Bogle Rock which got me on Choice FM so my career was stepping up a bit and I was making a name for myself. A guy called Sam Carroll came along who would end up being my manager, and he introduced me to the jungle scene. I met Potential Bad Boy, and we made a track called Every Man Has A Right which came out on Ibiza

Records. Paul Ibiza was doing a rave at The Rocket on Holloway Road, and it was rammed. We did a PA which went down alright, and I think that's where Shy FX saw me.

Back then jungle producers were mostly sampling and didn't really make tracks with full vocals. Coming from reggae, writing whole songs was what I did. Some producers wanted to get into that and start using live artists. I was sharing a flat with a singer called David Boomah and Sam came to me with a Shy FX track called Gangsta Kid. I listened to it and was singing bits of Original Nuttah in the gaps, as I'd actually written the lyrics about six years earlier. I used to bunk school and invite my friends from the sound system around, and one day we had a video camera, and they filmed me doing a version of Nuttah; this was in the late 80s. My friend Juxci, who ended up having a big record with 2Play called So Confused, said to me that the tune was absolutely mad. I never did a reggae version of it, but when I heard the jungle riddim, I knew it was the right time for it.

I told Sam I wanted to meet Shy and voice the riddim. We met up with Shy and Dave Stone, who ran SOUR; they wanted to do something new, but I wanted to use the Gangsta Kid riddim. They had no idea what I had in mind, but we booked the studio in Victoria, and I went in and did something new, which never got released in the end. Then I asked them to put on Gangsta Kid, and in two takes I banged out Original Nuttah. It was the first time I'd tried singing on a tune as before that I'd just chat or rap, so it sounds like there are two different people on there.

The studio was booked for the whole day, but I was in and out after an hour. I didn't even wait to hear it back because I didn't like to hear myself singing. Sam called me later, and I thought I was in trouble for leaving the studio early. He told me to go back to the studio as they were going mad, and the tune was going to be big. They cut the tune in the next couple of days and gave the dubplate out to the DJs. I didn't go out to the rave that weekend, but I couldn't sleep, I was just playing the record at home and thinking no one was going to like it. I'd made tracks before and they'd never really blown up, but the next day

the phone was ringing off with people telling me it had been getting rewinds everywhere.

Jungle was big by now, and we were doing PAs together. I'm not sure if Shy liked doing them that much as he was just pretending to play the keyboards. He was a very quiet person though so I don't know. We filmed the video in Kings Cross in one day, and Kiss FM put a call out on the radio for people to come down to the shoot. It should've been better really, but they made it quickly just so they had something to put out there. One TV show wouldn't play it because we had rain on the lens.

There was a lot of excitement, but with a hit, there are always issues. The arguments started about who had the rights to the tune and how it would come out. Jungle producers had the artist credit because it was their music, but I came from reggae where the singer was the artist that got credited for the tune, so I wanted it to come out as Original Nuttah by UK Apachi. It was a tune I had written about

Shy FX, London (2002)

UK Apachi, South London (1994)

with music. Shy carried on and put Nuttah on his album. I'm not saying any of this was his fault, but unfortunately, I never released an album, so it ended up looking more like it was his tune than mine, and I'd just done the vocals and vanished.

The whole track was my concept. We didn't write it together; they didn't even want me to use that riddim. Shy did the music first, and then the lyrics were from my ideas, based on things I'd watched growing up like Terminator and Star Wars. It's a wicked tune to perform, and it takes a lot of energy to do it. When I first performed it at Carnival in 1994, we had to stop a few times because people were fighting in the middle. A nuttah wasn't just someone who goes around beating up people though; a nuttah was someone who achieves their goals, that's why there are clips of Nelson Mandela and Martin Luther King in the video.

"It was a multi-cultural thing, and when you went to the raves, you would see people of all colours from different nations jumping up and down together"

myself, and I wanted it for my album, and the follow up was going to be Junglist Girls, which I had done with Soundman. My manager at the time wasn't the best person and made me sign a deal with no representation. I didn't know about the business, and I trusted him, so he ended up acting as the manager, label and publisher. He had the rights to the lot, where obviously he should've just got a percentage.

Shy was signed to SOUR, so they wanted a piece of it too, which is why the record has both SOSL Recordings and SOUR's logo. There were lots of problems. Major labels had seen Incredible and Original Nuttah go into the charts, so they wanted to sign me. Dave Stone wanted to keep the tune to promote his label, so he didn't want to sign it over to anyone unless it was on his terms. My manager wanted things done on his terms, but with all this craziness going on, I became focused on my faith and decided I didn't want anything to do

Original Nuttah was a very British term; you can't get more British than that really. Jungle music was British music, even though it took samples from other styles it originated here I was so happy to be connected to it. It was a multi-cultural thing, and when you went to the raves, you would see people of all colours from different nations jumping up and down together. That was a vibe, and I felt connected to that. It worked really well with my name too; reggae artists had nicknames: Supercat was the Wild Apache or the Don Dada. Apache Indian came out and called himself the Don Raja. I used to call myself Apache Indian, but when he blew up, I decided to call myself UK Apachi, representing the United Kingdom.

Original Nuttah became an anthem; it even gets played at weddings. They did the firework display over the Thames on

New Year's Eve a couple of years ago and played a bit of it, in the middle of Oasis and all that stuff. Lethal B did a cover of it on Radio 1, and it was credited to Shy. Rudimental were on TV performing the song at Glastonbury and didn't say my name, and I'm thinking, are these people for real? Most of the time when they play it on the radio it's now Shy FX featuring UK Apachi. If that was the case, it would've been labelled that way from the beginning. I'm not blaming Shy for it though, and he's a wicked producer. He remixed it in 2001 using his Bambaataa tune, and he got my permission and used the original vocals. That came out as UK Apachi and Shy FX.

I started making music again in 2001 and came back with Badmarsh & Shri and did a cover of Tenor Saw's Signs. The label gave the vocals to Calibre, and he did it using just the reggae vocal, and that got played. When I came back into it, I thought that that the scene hadn't really promoted artists enough, like singers, and got rid of them and they focused on the DJs and producers, and by doing that they ruined the chances of doing what the garage and grime scenes achieved. People like to have a face and personality to go with the music. I understand people didn't want it to become too commercial, but you can have that along with the underground styles. In hip hop, for example, there are mainstream artists, but you have others doing the raw stuff.

I stopped making music again when my mum was ill about twelve years ago. I had got more into my religion again and knew I had to make a decision about what type of person I was. I looked after my mum for a year while she had cancer, and then took on the role of looking after my grandmother. I took a different path and left the scene. I made peace with my ex-manager and the situation with the money and the rights to my music is meant to be getting sorted out, but I'm not sure if I'm too bothered about it at this point in my life. I became a speaker and mentor to Muslim youth, talking to them about living their life in a correct manner and not becoming extremists. People always wanted me to sing something, so I came up with I Was A Nuttah, about my life and where I'm at now. I've left music but would still do something if I felt it would be something positive.

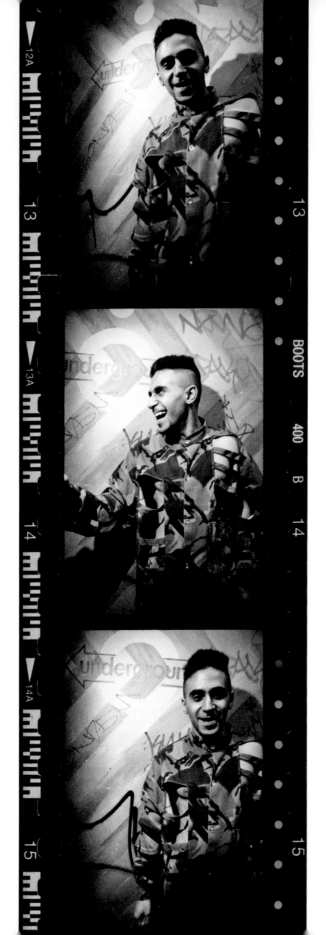

DJ KROME & MR TIME
THE LICENCE (TEARIN VINYL, 1994)

Finding fame on Suburban Base with hardcore anthems such as The Slammer and This Sound Is For The Underground, Krome & Time's combination of killer samples and sharply chopped up breaks made them a favourite amongst A-list DJs and on pirate radio. The launch of their Tearin Vinyl imprint in 1994 saw two particularly mammoth tunes unleashed, both Ganja Man and The Licence were perfect examples of ragga jungle that had crowds calling for the rewind at World Dance, Dreamscape and beyond...

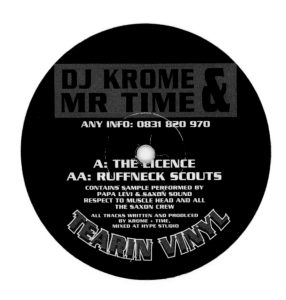

Mr Time: As teenagers, Krome and I were both into dancehall, sound system music and hip hop. We had some decks and a microphone; I used to write lyrics and rap, and Krome was a DJ. We used to take our demos to Trevor Nelson when he worked in a record shop in Hackney, but when we discovered acid house, we dropped everything we were into and gravitated towards that. One weekend back in 1988 I had gone to Camden Palace with a load of friends, and we were wearing trousers, shirts and shoes. We were drinking and ended up in a massive fight; that was a standard night out. Then a few months later, I went back there, and it was a complete transformation. People were wearing trainers and jeans, some were wearing bandanas and white gloves, and I was wondering what the fuck was going on! They were dancing to acid house. We ended up going to Shoom and various other venues, and we couldn't believe what we were hearing. We were so excited about being a part of that, so we just wanted to create something and watch people dance to it and have it move them. We loved raving, and we were in the midst of a revolution that had started in 1988.

Shut Up & Dance were a massive influence, they were the real pioneers of the rave scene when there was the transition from acid house to everything else we know

now. All these genres you have now are little spin-offs of what Shut Up & Dance did in those days. Austin Reynolds engineered our tunes on Suburban Base, and he was also a big inspiration and someone I had massive respect for. DJ Hype was another influence on us, and he made some very unique, individualistic tunes. I met him through Fantasy FM, and he grew up down the road from me in Hackney where I still live now. Brockie grew up around here and the Ragga Twins, Shut Up & Dance, DJ Ron and all the Kool FM lot were from the same area.

Through Hype, we met The Scientist, and he's probably the biggest inspiration for my music. He was an unbelievably talented guy; I always tell people that he should've been bigger than The Prodigy. He was doing amazing things before them, and at a younger age. I spent a lot of time with him in the early days at Kickin Records in Westbourne Park messing around in the studio. We were using 303s, the SH-101 and 102 and all the old analogue equipment. I used to watch Phil [The Scientist] doing his stuff, and he'd show me production

techniques. I actually met Depeche Mode through him as they knew him and admired him. He was a pretty special guy; he's still around and does the sound at Fabric these days.

The Licence came about when I was messing around chopping up beats. What brought it to life was the Papa Levi sample. It comes from a tape of Saxon Sound playing against a sound called Maverick. We had grown up listening to tapes of Saxon and had always wanted to pay homage to them. They would put on dances at Upton House, which was the school we went to in Hackney. We came across the sample, and it speaks for itself really: "do you have a licence to play this?!" The tune comes alive after that. Back then there wasn't much planning that would go into a track, it was just a case of listening, and once you'd done one edit, you could take that section forward and build the track organically. We would arrange the tracks together and both had input into how we wanted the tunes to be structured. I was kind of the engineer and did most of the editing of the drums. I didn't have a clue that it would be such a big tune; it was just done for fun and for love.

Clearing the samples for The Licence was fairly easy. We took a trip to [Saxon Sound owner] Musclehead's house, and he invited us in and showed us all his soundclash trophies. We explained what we'd done and played him the tune. I think we gave him £1,500 or something which was a lot of money, but we were so glad we could do something for him because of all the pleasure we'd had from listening to Saxon over the years. There was a handshake but no contract, and we never heard another thing about it. It was an underground scene and hadn't really gone international at that point, so most of the reggae artists never heard the tunes they were sampled on. We tried to approach the artists if we used them. When we made Studio One Lik we sampled a Jamaican singer called Little John that I admired. I got hold of his number and called him up to ask how much he wanted for using the sample, and he said £10,000!

We made Ganja Man around the same time in 1994. That was written in DJ Hype's house. I was always round there, and he'd gone out and left us in the house and by the time he came back, Ganja Man was finished. The sample on that came from one of Hype's tapes. He had a load of sound system tapes that we'd been sifting through, and we came across that sample, but to this day I don't know what the sound was called or what the tape was. It was an obscure Jamaican sound system. Hype doesn't know and can't find the tape, but I really wanna know what it's from!

Everything we did went straight to Hype. He helped us out a lot back in the day, and we're still good friends now. He broke The Licence as well as Ganja Man, and once he had played it for a while, it filtered out to people like Kenny Ken, Brockie and Jumping Jack Frost. It hit the ground running, and as there were a lot of black people into the jungle scene at the time everyone recognised the sample, and that ended becoming a bit of a quotable line; you still hear people say it now. That combined with the beats, bass and energy of the tune meant it was instantly popular. I remember hearing it at Camden Palace, which was quite special seeing as that was the place where it all started for me. We were in the raves all the time, playing a lot and raving a lot. Life was completely consumed by the rave scene; I lived and breathed it. If I wasn't in a rave, I'd be in the

studio, literally for 15 hours straight sometimes. We had a good run of big tunes, and by that time we had made so many bangers and made a big enough contribution to the music that we could have quite easily just stopped there, so there was no pressure. It was just fun.

The whole process from dubplate to release probably took about three or four months if that. Once we got the masters to Vinyl Distribution, they could have a record on the streets within two weeks. We just wanted to get things out. Tunes picked up momentum really quickly because there were so many raves and DJs were playing everywhere every weekend, sometimes at four or five events in one night; there would be some serious driving going on up and down the country.

There were still negative connotations attached to jungle in the media around the time The Licence came out, so there wasn't any interest from major labels. The whole scene was independent and underground. It wasn't like with bands where you could say: "these guys are the new whoever", it was all so unique and different. There was nothing to compare it to so majors weren't going to take risks with it. A few tunes forced their way onto the charts, but it was still done on an independent level. Around 1996, the majors saw this subculture gaining momentum and realised there was money to be made.

Around '96–'97, the music changed again, and some producers had come out with a new transitional sound that was more progressive. It was an evolution, and more thinking was going into the creative process with the elements and sounds. Once that kicked in and started to gain momentum, the jungle thing started to take a back seat and raves drew a different kind of crowd as well. There'd been a lot of violence at jungle raves, and people like Grooverider made a conscious effort to change the sound. For us, it dipped a bit, and then life kicked in, and my son was born in 1997, so we had to make a decision to either stick with it and struggle to try and build something back up, but we had been in it a long time by then, so it was off to work!

We weren't doing it for money. If we'd have put more effort into the whole thing, we could've carried on and evolved,

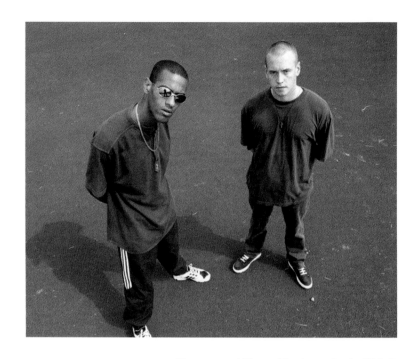

Krome and Time, Finsbury Park (1994)

but the biggest buzz for me was hearing the tunes out and watching people dance to them. I still get a little buzz now if I hear one of our tunes at a festival or on the radio. That's priceless for me. Even in '94–'95, people couldn't believe what was happening, whereas now you go out and the kids take it all for granted. You have to really stand out as there are so many producers and tunes and they're spoilt for choice. We didn't have any template back then so the tunes were more unique and everyone was approaching it from a different angle. If you go to a drum n bass rave now, everything sounds pretty generic, and it's made in a certain format for DJs to play it, so the music becomes more of a platform for the MCs. If you're playing on the main stage, you have to keep within that formula as the kids expect it a certain way and they don't know any different.

I always stayed in touch with music. I still go out now, and I've started going back in the studio. To this day, we feel we made such a contribution at such a crucial time in popular culture. At that time nobody would have envisaged the music still getting airplay today or predicted what it has manifested into.

DRS FT. KENNY KEN

EVERYMAN (RUGGED VINYL, 1994)

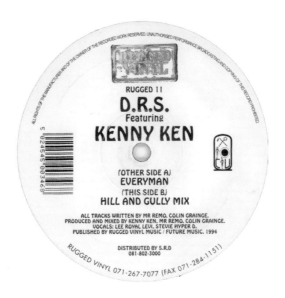

Colin Grainge and Errol Gordon both had both taken steps into the world of dance music in the late-80s and early 90s respectively before collaborating as DRS – Dirty Rotten Scoundrels – for the We Don't G.A.F EP, where they linked up with the esteemed Wishdokta [Grant Nelson] for four tracks of breakbeat hardcore. That was followed up with another collaboration, this time with Jungle Soundclash champion Kenny Ken. The reggae flavoured Everyman was an anthem at raves nationwide, and a VIP mix was subsequently immortalised on the legendary AWOL Live album...

Kenny Ken: Having been around since the early days of the rave scene, I found it quite a natural progression moving from house, to hardcore and then into jungle. There were fresh new sounds appearing daily, and I found myself following the breakbeat stuff. I think it was the reggae influences that attracted me to jungle, but it wasn't just that because there was badass jungle being made that had no reggae influences at all.

Errol Gordon: I came from a reggae background so when I heard hardcore tracks like We Are I.E. I thought to myself that I could really mix where I was coming from with where I was going and try and combine some Studio 1 rhythms with hardcore. I'd been working with Grant Nelson as we were both on Kickin Records and I released a track called Wonderful as Remo Don, which if I remember rightly was the first Studio 1 hardcore record. I'm not sure Kickin did as much as they could to promote it, as they had people like Hype and Wishdokta who seemed to get the majority of the promotion, or that's how I felt at the time. I saw that people liked the idea of mixing reggae and hardcore,

but I decided that the next track I did I needed to get one of the DJs from the scene involved to give it a bit more of a punch.

Kenny: I wasn't as serious about production back then as I am now. The idea for Everyman came from Errol. He had been making me some wicked dubplates, and I was always testing out his new beats. I used to like testing new tunes at Roast and AWOL.

Errol: At the time, I was going to Roast at Linford Film Studios. I met Kenny there, and one night he played Wonderful, so I thought I like this guy! I approached him and told him I had a track I was working on and asked if he'd like to come into the studio with me and maybe do a remix and put his name on it.

Kenny: DRS was Errol, Colin Grainge and Earl Blackwood.

Kenny Ken, London
(1997)

Errol: We also called ourselves Rough Tempo. Colin was amazing at getting on the computer and the sampler and creating sounds. Earl was the guy that played the instruments because everything we did was played from scratch. The only samples were the breakbeats. Everything else was guitars, bass or sometimes keyboards. The vocal on Everyman was sung by a guy called Lee Royal. I had a party at my house one day, and I was playing some tracks I'd put together. We were listening to this riddim, and he started singing Everyman over it. I went into the studio, put a bit of drum n bass together, and called Earl over. Once we created the track and got Lee to sing it, that's when we called Kenny to sweeten it up. He came and sat in on the session, and I played him what I had, and he put a few ideas in and gave me a really good Amen sample which we didn't have, and it developed from there.

> *"I saw that people liked the idea of mixing reggae and hardcore."*

Kenny: We got the OK from Errol Dunkley's label to re-sing the vocal [from 1977's A Little Way Different] with no problems. We asked Stevie Hyper D to do a bit on there too; he loved it and was straight in there.

Errol: Stevie and I used to MC together way back in 1990 at a night called Still Buzzing which was in Shepherds Bush, so we were quite close. I was meant to do more stuff with him, but it just didn't happen. I toned his voice down an octave to make it sound deeper so when people heard it, they couldn't tell it was him straight away. I regret it now, but at the time I thought it was the right thing to do.

Kenny: We didn't think we had a big track on our hands, we were just stoked about making a good tune. I can't remember which other DJs we gave it to first, but we got good feedback. The first time I played it out, the reaction was nuts!

Errol: We did a PA at Bagleys that got a really good reaction, but again, I'm not sure that the promotion was as good as it could have been. Rugged Vinyl tried to push it at Kiss FM, and it was almost one of their big playlisted tracks, but then it didn't quite make the cut. By that time I'd left Kickin Records, and I wondered if I stayed there if it would've got more promotion, but we'll never know. Rugged Vinyl did a pretty decent job of pushing it though, and Kenny did a lot of work to promote it too.

Kenny: It had a great impact on my career. It made those who didn't know Kenny Ken know me.

Errol: After we made Everyman I had started an album. I wanted to make a reggae jungle album with live vocals, and it took me about two years to get about nine tracks that in my eyes were fabulous. Some of them are better than Everyman. I got to the point where I was starting to do the final mixes, and around that time all the DJs got together and decided they weren't going to play vocal tracks anymore because it was bringing the wrong crowd into the raves. I've got a stack of unreleased tunes that I made after Everyman. I gave out a load of dubplates, but the DJs weren't playing them, so it disheartened me. They didn't want to play vocal jungle anymore, which made me really angry. I got pissed off, and I started making house music.

When Kenny was doing his 25th-anniversary rave, and there were a lot of people online mentioning Everyman. There were people from the reggae scene saying that was the tune that made them love jungle. I didn't realise it had that effect because I'd walked away from the scene, so I'm really happy it had that impact on everybody, but I'm sorry I wasn't there to feel it.

DEAD DRED

DRED BASS (MOVING SHADOW, 1994)

Birmingham's Back2Basics label had fast become a major player in the jungle movement, partly due to the massive The Way by DJ Taktix taking the scene by storm over the course of '93 and '94. Label boss Jason Ball went into the studio with local DJs Asend [Lee Smith] and Ultravibe [Warren Smith – no relation] and the result was the ground-breaking Dred Bass. Released on Moving Shadow and one of the label's biggest singles, the track's huge bass with a crowd-stopping vocal followed by gunshots triggering the rapid fire breaks made it an immediate anthem and its influence could be seen in British dance music for years to come.

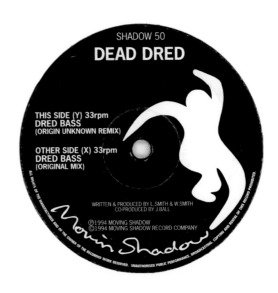

Lee Smith: I was into electro in the 80s, and then from 1987, I was into house music and the rave scene. Before I made music, I was going out all over the West Midlands; I was always a raver. I wanted to get some decks and learn to mix, and I also wanted to make a tune, but at that point, the equipment was so expensive, so I thought it was one of those things that was never going to happen.

I never really pushed myself with the music thing, but when jungle came along things took off for me as a DJ and producer. There was a shop down the road from where I lived called Back2Basics, which was run by Jason Ball. He had put a few tunes out and had a studio with an Akai 3000 sampler. Warren and I spoke to him, and he said for £10 an hour we could go into the studio. We thought we'd take some samples down and have a bit of a smoke and mess around, but we didn't really expect anything to come of it. We went in there, and Jason engineered for us as he knew how to use the equipment. We said we wanted to use an Amen beat and some strings with this vocal we had and that became What Kind Of World which was our first track. It actually ended up getting played quite a lot on dubplate so Jason put it out and it sold quite well. Jason

then said he wanted us to do another track for him, but we didn't need to pay for the studio this time, and that was when we made Dred Bass.

We had heard a tune on Moving Shadow, and halfway through it, there was a bit of a reversed bass. We liked that and decided to do a tune where the whole bassline was in reverse. We tried that and put the gunshots in. There was this sample CD called X-Static Goldmine that we used. Quite a few DJs had a copy; Andy C took his sample for Cool Down from it. I remember him telling me he'd heard the Dred Bass sample but overlooked it. The majority of the track took four hours, it was a bit of a laugh really.

The next day we were in the shop playing a tape of the track, and Kenny Ken was in there. DJs like him and Micky Finn would often stop by when they were in the Birmingham area. He heard us playing Dred Bass and said he needed to take a copy so he could play it. We rushed back to the studio and quickly mixed it down and gave it to him. Within a few days, people were calling up asking about "that gunshot tune".

Kenny Ken and Micky Finn supported us from day one. Kenny played it on Kiss FM within a few days of getting it, and then I think Micky phoned us asking for it. Rob Playford heard it at AWOL, and he phoned Jason saying he wanted to sign it. Jason told him it was us and that he thought we'd love to be on Moving Shadow. I think maybe he regrets that now! Looking back I wish I'd put Dred Bass out on my own label and got 100% of the royalties but at the time Moving Shadow was a big label and we wanted to be on it. At least we can say we've been there and been part of that.

We made Dred Bass around March, and it came out in September, so it was on dubplate for a while. Rob wanted to leave it for as long as possible and then Andy C did the remix which extended things for a bit longer before it came out. The original promo had a different b-side called Running In The Family which sounds quite rough if you listen to it now. Then it got promoed again with the Origin Unknown remix. Rob Playford and Andy C had come up to Birmingham for a night at the Que Club. We were sitting in the studio playing some new tunes, and it was suggested that Andy do a remix for us. We didn't hear that played out until Andy played it at The Equinox in Leicester Square. I wasn't sure if I liked it or not but all the DJs seemed to play it and it became big in its own right. I think he did a good job with it considering it was a big tune anyway. It gave the track life for a few more months.

Back then it was unusual for a jungle tune to have a video, but it got played on Pete Tong's show a few times, and I think MTV phoned Moving Shadow and said they wanted a video for it, so they suddenly had to do a video out of nowhere. They shot it in London, and we couldn't make it, which I regret now as it was played quite a bit on MTV. Goldie ended up being in it, it's just some computer graphics and shots of Goldie's teeth really, so some people thought it was his tune!

Looking back now, it seems like a bit of a dream. Everything was right – the right sounds, the gunshots. It came out at the right time. The one person I met who didn't like it much was Tango. He used to live with a female DJ called

Fallout, and we were at their place one night, and he said: "not being funny Lee but I don't actually like it!". I was fed up with people telling me they loved it, so it was nice for someone to have an honest opinion. I don't know for sure, but I think it sold around 60,000 copies on 12" and it charted just outside the Top 40. There was no real expectation back then, the hope was that someone would buy it and you didn't lose any money putting it out that would be good enough.

"Within a few days, people were calling up asking about "that gunshot tune"."

Apart from Dred Bass and What Kind Of World, Warren and I kind of went our separate ways. I wanted to get a label going and push things as far as I could. Moving Shadow owned the artist name Dead Dred so legally we couldn't use it for release on any other label so to get around it Jason, and I ended up using Dred Bass as our artist name instead.

In some way, I regret the success of Dred Bass because we went straight to the top, really quickly, and there's nowhere to go after that as artists. You're never gonna beat that tune again, and everyone wants more of the same, so after that, it's just downhill! It was good while it lasted; I started my own label, Second Movement, and got lots of DJ work and went all over the world but I kind of wish it had taken a bit more time to get there, with a few other tunes first.

Andy C: I'm good friends with Rob Playford, and we were out raving at AWOL one night. We were in the middle of the dancefloor when Kenny Ken dropped Dred Bass. It got a million rewinds, and you could see people wondering what the hell it was. During the week Rob calls me and says: "guess what I've just signed to Moving Shadow?". We drove up to Wednesbury near Birmingham and hung out with the guys, and Rob asked if I wanted to remix it. That's one of those crazy vibes seeing a tune like that get born.

J MAJIK
YOUR SOUND (METALHEADZ, 1995)

Although many of the genre's big names had roots in dance music well before jungle came along, J Majik represented a newer generation of producers. Growing up as a teenager in London in the early 90s, he immersed himself in the music and set about making his mark at an early age. Taking some guidance from a few trailblazing artists, his own Infrared label would go onto to be hugely successful in its own right. He also made up part of the original Metalheadz crew, and Your Sound remains one of the storied label's high points...

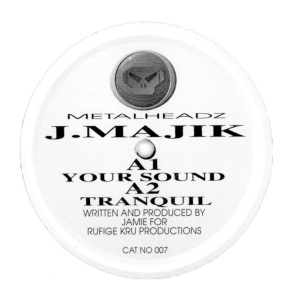

J Majik: I made my first track at 13-years-old. I had some cool people around me that helped me; I grew up with Lemon D, although he is a bit older than me, and my first release was on Planet Earth, which was his label. This was around '92–'93, and I had a track called The Choice, which has the "six million ways to die" vocal in it which got used again two years later. I was known as Dexxtrous to begin with, although there was the other Dextrous who I honestly did not know about and I'm sure he didn't know about me either. I was 13 when I came up with the name, which meant using both hands on the turntables, so it was inevitable someone else would pick the same name. It got confusing, so I changed my name when I made Your Sound. I wanted to create a new identity for the Metalheadz stuff, and it was Goldie that came up with the name J Majik for me.

I do not believe I was any more talented than anyone else making music at the time. A lot of it comes down to what you tune into and the music around you, as that is subconsciously a huge part of the music you make your-self. I was lucky that I met Lemon D at an early age, and that was through going to record shops and spending my pocket money at places like Lucky Spin and Blackmarket. I would wash cars so I could buy two white labels at the weekend. It was like an addiction. You would be trying to get that record before someone else and would get to know people at the shop so they would put things aside for you. It was all part of the excitement.

My older sister worked at a camera company called Sammy's in London. She told me there was a guy she worked with who liked the same noisy music as me and that he had a record label. I did not think anything of it, but then she said he had got me a jacket from the label and there were only 10 of them made. It was a Reinforced jacket. She said the guy's name was Mark, but I did not know who that was. I went up to her work one day after school to thank him for the jacket and realised it was Mark Mac. At the time, I was buying 4 Hero records and the early Manix stuff. Mark and Dego were two of the nicest people you could meet in the scene at the time. I was only 13, but they were excited that I was into their sound, and they gave my sister some records for me. They would let me come up to their studio in Dollis Hill, and I just sat there in this tiny cramped room watching



them make tunes. I started to learn which keyboards had certain sounds. You could not ask for better schooling at that time, and their influence was a major part of me getting into that sound and is why maybe my early stuff had a similar vibe to what they were doing with Reinforced.

I made Your Sound at the end of '93. I gave it to Grooverider, who played it at Lazerdrome and it got rewound three times. Goldie heard it and told me he wanted it for Metalheadz. At the time I'd just made the track and there wasn't any foresight in terms of wanting it to be on a certain label. There was no expectation of your track getting released back then; you were just excited to hear it being played in a club. It was the seventh release on Metalheadz, and it didn't come out until 1995, but in those days tracks could be on dubplate for six months to a year before they came out and Your Sound was on plate for at least a year. Goldie had scheduled the releases before the label even started as he had got a crew of producers together. It was a very organic movement; my social circle at the time was Photek, Source Direct, Peshay, Kemistry and Storm. I was friends with everyone that played at Metalheadz.

There was a time when Peshay had been off the scene for a while as he had been ill, and he had a comeback set at Blue Note. We were all really tight so myself, Photek and Source Direct each gave him some exclusive tunes, just because that excitement of hearing your track being played in that club was like nothing else. You could go to Metalheadz on a Sunday and there were people from all walks of life, there was no colour or religion, just everyone together enjoying themselves. There was no snobbery in the music because it was all new and the scene was not divided so you would hear a Bukem tune in there, or something more jungle sounding. It encompassed everything.

We called it drum n bass, some people called it jungle, but whatever it was called, there was no formula to the music. We had punk, and that was a British sound, but there had not been anything like that since. It had spawned from the rave sound and got to a place where David Bowie and Bjork were coming to the club and sweating like everyone else. There wasn't that media coolness around the early dance music – it had just been in warehouses or fields – but now it was coming out of that.

I was offered deals by a few major labels and turned them down. I was lucky that I'd seen my peers do it before me, and some of them ended up with their hands tied. You can end up in situations where you cannot put music out unless the label likes it, so maybe two years after you sign with them you have not released anything. Maybe you were driving around in a Ferrari in the meantime, but when you get a deal like that from a label it's a loan, and I think a lot of people didn't understand that at the time. The problem with labels is you have A&R people involved, and so there is one person that can decide whether anyone gets to hear your music and that is not right. We are not making pop tunes to sell loads and unless you're doing that it's difficult to work with a major label.

Drum n bass is experimental music, or it should be anyway. I listen to all sorts of music, so I can appreciate a good tune from any genre. With my early stuff, it was a case of being influenced by the sounds that people around me

Metalheadz Sunday Sessions at the Blue Note, Hoxton (1995)

were making. You make music you want to impress your peers with. When your peer group changes or you are exposed to different styles, you are going to create different kinds of music. As a producer, it's natural that you want to try other things.

> "You could go to Metalheadz on a Sunday and there were people from all walks of life."

I still love jungle, liquid, some jump-up and neurofunk; I still love the whole of the scene, but I'm not part of a particular camp so I'm not defined by one specific style. I made the Full Circle album in 2019 which was a retrospective look at the music I was making in the mid-90s and I just put it out there as a personal record, but it got a really good response, and I've ended up getting exposure from it so it went so much further than I imagined, but now I'm conscious of not being pigeonholed in that bracket.

When I made Spaced Invader I wasn't looking to make a house/drum n bass record, it happened organically. I was listening to a lot of house music and early garage at the time. I love breakdowns, and if it can get the hairs on your arms to stand up, that's what it's about to me; I want to feel goosebumps. I had just done Love Is Not A Game on Defected and I went to see Simon Dunmore, who gave me a CDR of the Hatiras track. I played it so many times and thought it was wicked. I decided to try and make a small loop of one of the sounds from it. When I chopped it up and sped it up it worked at 170 bpm, then I added the breakdown but never thought it would get released. I played it to Andy C down the phone and he immediately sent a cab over to get the DAT so he could get a dubplate cut. It got so big that Simon approached me, and we put it out on Defected.

As a producer, it can get to a point where you're making loads of tunes, but you can't release too many at once. So many producers made more tracks than they could release at the time and ended up sitting on things that might've been bigger than the ones that actually came out, but they moved on and the sound moved on. For example, most of the records that came out in the shops in '95 were more than likely made at the beginning of 94. There were so many tracks from that golden era that never got released.

I run a label called Deep Jungle with one of my best friends Lee, who released music on Lucky Spin and Moving Shadow as DJ Harmony. We release tracks from the 90s that never came out at the time. I've been a record collector for years and have a massive catalogue of dubplates. Lee had been posting unreleased tracks on Soundcloud and people would contact him offering money for them, but they weren't for sale. People were saying it was unfair he was keeping hold of them, and he was even getting threats at one point! We thought why not put some of them out, even if they only sold 100 copies we would just need to cover our costs. Once it's pressed up, then it's there forever. It's not throwaway like the digital thing, I think it's much more meaningful when you can hold a piece of vinyl. If you buy a record, you'll listen to it fifty times or more, especially back in the old days when people didn't have lots of money. If you bought vinyl it was something that was precious.

There was a label called Deep Jungle that put out one DJ Harmony record in 1994, and we liked the name as it summed up the sound we were going for – it's deep and its jungle. We then spoke to some of the original guys like Dillinja, Adam F and Redlight and started putting together a list of potential tracks. The longer it's gone on it's become a really credible label so now artists are approaching us. We put out Sovereign Melody by Dillinja with a limited edition of 50 copies on coloured vinyl, and they sold out in 30 seconds. There's a real buzz with collectors for things that they have been after for years. It's not something we're doing to get bookings off; it's just there as a label and the most we do of each release is 500 copies as we want to keep it credible and cool. We could easily have done 1000 copies of a few of them but what keeps it exciting is that when you get one of the records, you feel special.

PESHAY

PIANO TUNE/VOCAL TUNE (GOOD LOOKING, 1995)

One of the more versatile talents to emerge from the hardcore era, Peshay has proven himself able to turn his hand to a variety of styles without sacrificing the quality that saw releases on Reinforced and Metalheadz earn him an album deal with Island Records. Having already collaborated with Good Looking boss LTJ Bukem for the 1994 release 19.5, he stepped up again with the landmark Piano Tune 12". Backed with the equally amazing Vocal Tune on the b-side, it signalled a new direction for drum n bass, both in terms of production quality and style...

Peshay: You could hear the sounds and tempo gradually changing. Things had started with the straight four to the floor drums in the late-80s, and then people started to incorporate breaks into that structure, and then it got called jungle techno. Then the more reggae based jungle vibes came in and then it became drum n bass. In the rave days of the early 90s, it was 130–140bpm, and people were speeding up breakbeats and old hip hop records and putting the rave riffs in there so it sounded more manic and everyone was going nuts. As it moved to 155bpm and then to 170, you could do stuff at half tempo, so it didn't sound as hectic. It was a time of experimentation, and the sound developed and became more professional sounding. The music was new to us, and people were trying new ideas, and as the producers got better technically, the sound started to become more polished. By polished I don't mean sounding cleaner, just sounding better. For example, Dillinja's stuff sounds grimey, but it still has that soul. That's what makes him so special and is why his tracks still sound good today. There are more advanced studio techniques these days, and things might sound better sonically but it doesn't necessarily make for

a better tune. If the idea isn't there it doesn't matter what equipment you have.

I was working in different studios with different engineers. I did a few things with Dave Charlesworth and Bay B Kane and ended up releasing tracks on Reinforced, Good Looking and Metalheadz. I was listening to a lot of different music. House was a big thing for me. I've always loved house from the mid-80s onwards, but I was also listening to funk, disco, jazz, everything really. People seemed to have a much wider range of influences back then. My favourite eras for music are the 70s, 80s and 90s.

The inspiration for my tunes came from everything that was happening at the time. The Piano Tune is an atmospheric breakbeat track and comes from pure rave culture. The Vocal Tune is based purely on a house vibe. When I listen to it now, it might be dated in places, but it still has that soul and still stands up as a piece of music. They were both made in late 1993 and were on dubplate for well over a year, but when the 12" was released in 1995, the wait

hadn't done the record any harm. Both the tracks were made specifically for release on Good Looking so when I made it I gave it to Bukem, and he played it on dubplate for ages before it came out. There was that culture at the time where people would hold onto tracks for a while before they came out, if they put them out at all. There were two sides of the argument: some said you should put things out sooner and not make people wait, and others thought you should hold out longer and build the buzz. There's no right or wrong.

When you make a tune, you can make something that sounds good to your ears, and that's all you have to go on. It's only when you start playing it to other people and playing it out that you start thinking hold on a minute, this is quite a big tune. Before long everyone's asking you for it, so that tells its own story. Once you've got that buzz and you have people going mad when you play it out then you know. I didn't know it would blow up as it did. Every situation is different though, you can only make something to the best of your ability and if people like it, then great. The first time I played Miles From Home out was in Bristol, and everyone went nuts, then certain people kept asking me for it, and before long I heard it everywhere.

In the early days, I'd give Danny (LTJ Bukem) the tunes first as I was doing things for Good Looking, or if it was something for Metalheadz obviously Goldie would get it first. I'd also give tracks to Bryan Gee and Frost, Randall, Doc Scott and Kemistry & Storm. A mixture of people really, but Fabio and Grooverider would usually have everything I did first. I always liked the mixture of what they do; their background is soul and funk and the Detroit scene and with that history comes an appreciation of different styles of music that maybe other people wouldn't necessarily be into. I think the reason drum n bass blew up was that it's not just one sound. That's what made Metalheadz a special label: it didn't deal with one sound, it dealt with good sounds, and that's why it's still going strong today.

I've still got thousands of flyers of places I played from 1991 onwards. There were so many good clubs and raves

Peshay DJing at the Blue Note, Hoxton (1996)

back in the day like Dreamscape and Living Dream, and Rezerection in Newcastle to name a few, but Metalheadz at The Blue Note in Hoxton Square was the most special of all time. It was phenomenal. All the producers like Dillinja and Photek would be there, and everyone would bounce ideas off each other. Anyone who was anyone would come down there, and you heard things that you would not hear anywhere else. The crowd was so open, so it didn't matter what it was; you could play a jazzy thing or harder stuff, it didn't matter; there was just an appreciation for good music.

There was a time when I'd been ill and hadn't played anywhere for 18 months. Goldie had asked me to play at Metalheadz, but I didn't know if I would be able to. He said if you're well enough, we would love you to do it, if not we understand. The night worked out great, and I did a good set. It's a shame there's no recording of it as it would be great to hear it again. I've played thousands of raves around the world in front of thousands of people, but I'll never forget that night. Sometimes playing to 300 people can be better than playing to 30,000. People didn't know at the time, but I was on so many painkillers that night. I felt a bit numb while I was playing. Fabio saying it was the best set

Peshay at Metalheadz Sunday Sessions (1996)

he ever heard made it more special because when you get recognition from your peers like that, it doesn't give me a big head, but it means a lot when it comes from someone who's been around and knows the score. It's a good feeling to know you're doing something people appreciate; that was one of the most special nights in my life.

> *"It was a time of experimentation, and the sound developed and became more professional sounding."*

James Lavelle signed me to Mo Wax off the strength of a few tracks, The Piano Tune being one of them. He just told me to do my thing. I would've done the Miles From Home album even if I was releasing it on my own so I didn't make it in that style because it was for Mo Wax, I just did what I wanted to do. With an album, you want to showcase a bit about your personality. It had been completed for a year before it came out, but because Mo Wax became part of A&M/Polygram which then became part of Universal, there was a lot of contractual issues, and it was eventually released in 1999. Myself, DJ Shadow, Kirk DeGiorgio and someone else, I forget who, were the only Mo Wax artists kept on after Universal took over. I ended up working with Ross Allen at Island Blue which was cool as he's a guy that knows about a lot of good music and he liked the album. There was no pressure to make my music more commercial sounding, and I didn't change my sound because I was signed to major. Remember, when Mo Wax initially signed

me, they were backed by a major, but they were still an independent label. I still listen to the album sometimes, and it still sounds decent. If the product is good, it will stand the test of time.

Back then, the whole scene was still so new. Then everyone started going international and travelling to America and all over Europe because it was an emerging sound that everybody was loving. The gigs were going through the roof. We'd be coming back from Australia and then go off somewhere else. Promoters came in from around the world, and you could see drum n bass was blowing up, but no one knew where it would go or how long it would last. Everyone was just doing their thing. It was a great time to be involved because there was that excitement you get when something is fresh and new. It's been a fantastic journey, and it's gone super quick – so many great memories.

Fabio: I knew Peshay and Bukem played me The Vocal Tune way before it came out. He said: "you need to hear this track, he's done something you won't believe". He played it to me, but he didn't give it to me and said he wanted to lock it off for a bit. I was thinking: you can't play me that and not give it to me, you're taking the piss mate! I got it about two months later, and it was just killing it. Even now it still gives you goosebumps, along with Horizons and Music; it's on that level. It's an incredible tune, and a game-changer as it bought the house flavour to drum n bass. The Masters At Work sample gives it that feel and we were huge fans of them. You have to remember that before hardcore, we were house DJs. That's our roots in dance music. It still gets played now and it will get rewound. It's just an absolutely amazing tune.

STORM

If you were looking for a DJ whose career ran parallel with the twists and turns of drum n bass as it flourished throughout the nineties and beyond, then Storm would be a good example. As part of a duo alongside Kemistry, who sadly passed away following a road accident in 1999, they gained popularity off the back of slots on pirate stations Touchdown and Defection FM. They would eventually be involved in some key moments in the drum n bass story, most significantly being resident DJs at nights like Speed and Metalheadz, and running Goldie's label of the same name in its early years...

Storm: I had been DJing since '92 and Kemistry and I had residencies at Lazerdrome and Innovation, so we had those two regular things and were out and about doing raves like Desire. Around '94 we noticed that things were changing and some DJs were getting moved into the second room, so there would be a jungle room and a drum n bass room. We were a bit miffed we were being put in room two, but when jungle took on more of a hip hop influence it didn't really appeal to me and Kemistry. We didn't want to play a tune that was talking going on a drive-by because that wasn't what we were about. When jungle became a bit more aggressive, some people did migrate towards drum n bass. The mood changed in the clubs; someone got stabbed at Lazerdrome and places close down when things like that happen. It wasn't all jungle's fault, but as the lyrics became more aggressive, it attracted a different crowd and you could feel the change, and you could smell it too. Things were being smoked in our clubs that maybe we didn't understand. It was interesting to see and feel that change at somewhere like Lazerdrome where we had been for years. All of a sudden there would be a situation where you might bump into someone, and there would be attitude whereas before people would just say sorry.

So, we were still playing basslines, but maybe it had a bit more music, fewer lyrics, and the dark sound had come into it too. You could call it d&b or jungle, but we felt we were all junglists. I think it was down to the promoters really. I suppose Speed came off the back of that; we wanted this version of drum n bass that we were playing – which we didn't think was that different – on the main dancefloor. We had met Leo, who was the promoter, at Record Basement in Reading and he wanted us at this night he was doing. He had approached Fabio and LTJ Bukem too. It was difficult to begin with because he didn't have loads of money so we pretty much all played for nothing when Speed started. I think they needed £300 to put the night on so Kemi and I decided to phone 150 producers and get them in at £2 a time! That meant it was mainly producers that first night – Alex Reece and Wax Doctor were down there, and we met Photek in there. He put us in touch with people like Digital and Source Direct. I think the DJs on the first night were Bukem and Nicky Blackmarket, which is something that always surprises people when I tell them!

Sarah Sandy from Groove Connection got involved and helped put a structure in place, so Bukem would play last, Fabio in the middle and then the warm-up would be the residents who were DJ Lee, Doc Scott, Kemistry and Storm; that never really changed. Having a hero like Doc Scott warming up was insane. We could contact emerging producers and tell them we were playing their music and they would come down. The first time I met Marcus Intalex face to face was at Speed. I think a lot of people migrated there because it was something different, there was a more musical slant to it, but I still played records like Roll On and Cool Down, and Kemi would play Ja No Yah Big by Dillinja.

We could be doing Speed on Wednesday, Bar Rumba on Thursday and then Metalheadz at the weekend. Some records would get played everywhere, or you might

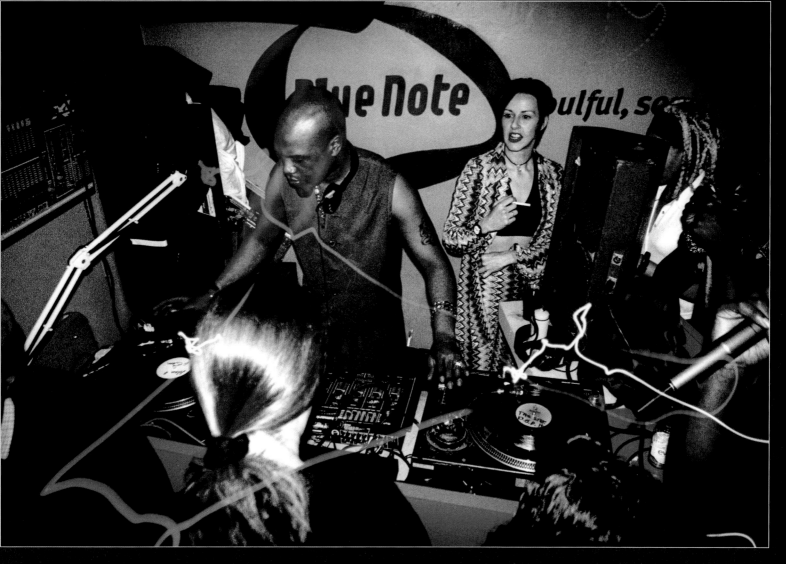

Storm in the booth with Grooverider at the Blue Note (1995)

bring in different records for certain nights, and that's why back then you could have someone like Nicky Blackmarket at Speed playing an amazing set. That is the art of DJing, where you're able to do different things. We might do Telepathy at Wax Club, which was a really tough jungle club and then do Speed in the West End. There were so many releases and styles back then so you could do that. There were events in Germany, France and Switzerland and what's now called drum n bass was really coming through at that point. People like Gilles

Peterson were starting to play it, and it was interesting to see the way those kinds of DJs approached the music. At one time Sven Vath was playing some of our stuff, and Photek was really cool, so lots of DJs from other genres were playing his music. I remember King Britt coming to our house with Dego from 4Hero. I gave him the latest Hidden Agenda record, and he put it on the deck and switched it to 33. He told us to make sure we always pressed the vinyl at 45 otherwise he wouldn't be able to slow it down!

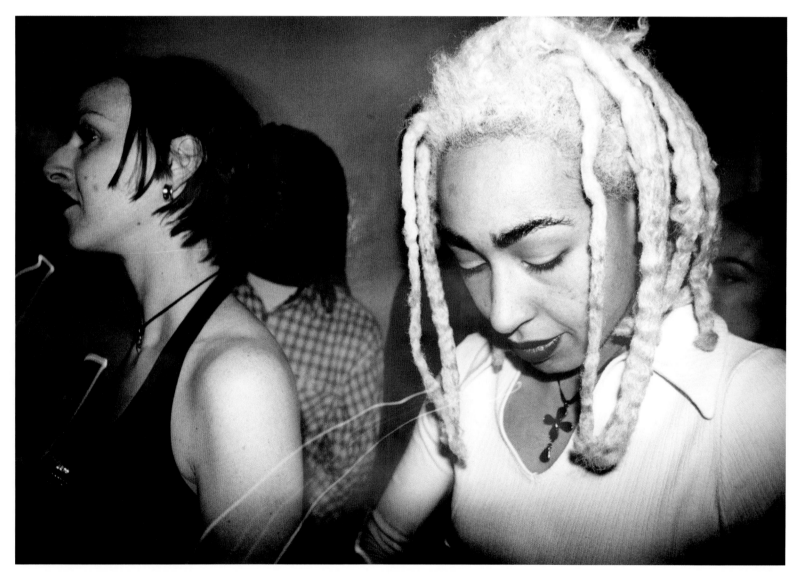

Kemistry and Storm at Metalheadz (1995)

Metalheadz came about after Goldie had put a few tunes out and decided he was in a position to start a label. He wasn't looking at it as a longevity thing, it was something he was doing out of respect, and he wanted to involve producers that had inspired him, like Wax Doctor, Alex Reece and Peshay. Dillinja was hot and Goldie had to have him on the label, and J Majik was making his name on Lemon D's Planet Earth label. Doc Scott was a silent partner in the beginning when they put out the first release, which was Rider's Ghost and Drumz, which had been around on dubplate for about 18 months, and then we put out the Peshay 12" [Psychosis/Represent] which was very different.

The first few releases didn't sell that well, perhaps because Goldie didn't have as much time to promote them as he would've liked. He had been signed and needed to make an album, so Kemi and I took on the running of the label. We came in around the fifth and sixth releases which were Your Sound and The Angels Fell, so you couldn't go wrong with that. We were lucky to be on board at that time as everybody played those tunes, so that introduced more people to the label. A lot of the artists were quite young, and Kemi and I became the aunties of the crew. It was very much the artists' label, and we'd have meetings with everyone at Goldie's flat and discuss who had releases coming up and what order they should go in and share ideas. Sales picked up and we started doing the Blue Note, so we had a vehicle to promote our sound. We would have our trainspotters down the front, and you would see people writing things down, heads rotating trying to read what was on the dubplate while it was playing!

We had a mailing list of about 250 people, with an A, B and C list and then an overseas list. People in different countries would help me out, like Pressure in New Zealand who would make sure DJs in that part of the world received releases, and someone in Japan would do the same there. When we played abroad, we would find out who the main DJs and radio stations were in each country and build our network. Goldie had Kemi and I do the promotion for Timeless so we were given London Records' mailing list and that meant we could contact all sorts of people. Other d&b artists had been signed to major labels there was a bit of a backlash where some DJs weren't getting sent the music, so Goldie wanted us involved to make sure the right people on the underground were serviced first and when that was sorted we could take it to radio and the media.

Metalheadz was a lifestyle label, right down to the logo which might be one of the best ever. When Goldie signed his deal with London he gave them Metalheads (with an 's') and a different logo design, and we kept the other logo and remained Metalheadz (with a 'z'.) I don't think most people noticed and just thought we were some huge label! I get asked what a typical Metalheadz track is and you can't put your finger on it, but it has a lot of drama. All the initial releases were dramatic in different ways. People think of it as a dark label, but it wasn't. Alex Reece did Basic Principles which was a beautiful piece of music, and then followed it with Pulp Fiction which is unique, and a total classic, but really came out of the blue. Adam F had Metropolis which was a naughty, dirty, hard track. It was all quite different. Source Direct and Photek came along, and Hidden Agenda. The first ten releases are ridiculous, even up to the 20th or 30th. I was there up until To Shape The Future came out, and when I look at the catalogue from my time there I just think "wow"!

P-FUNK
P-FUNK ERA (FRONTLINE, 1995)

With a simple but highly effective marriage of rolling beats, r&b melodies and b-boy attitude, Pascal's P-Funk Era is one of the seminal tracks of the golden era. As the influence of hip hop became more prevalent in the music, this combination of a militant KRS One vocal snippet dovetailing with the calming vibes of the Mary J Blige sample would keep dance floors bubbling whenever it emerged in the mix through a sea of crashing Amen breaks and snare rolls. It's as good an example of a pure 'roller' as you'll find. It's also an important part of the lineage that lead to Pascal signing a deal with a major label as part of the Ganja Kru and setting up the legendary True Playaz imprint which would be reborn in 2007 as Playaz Recordings, and now serves a whole new generation of DJs and ravers.

Pascal: I started Frontline in 1994 just as an outlet for my music and stuff I was doing with friends. Before that, I had a label called Face Records, where the tunes were a lot darker. After I set up Frontline, I helped Hype with Ganja Records as he wanted his own label too. Zinc was giving Hype lots of tracks, and Hype would suggest what he could change so he'd go back and do this and that to them. I didn't have many dealings with Zinc in the early days, but I'd see him at the Kiss FM studios and stuff like that. Hype told me he had this track he wanted to release which was Super Sharp Shooter, and it was around then that the Ganja Kru started. In the early days of Frontline, the tracks would always be me and someone else, and then Zinc started giving me music under the name Dope Skillz. Later on, my own productions slowed down to the point where I wasn't doing much and then it was a case of getting demos from other people and listening for things I

liked and wanted to release. There wasn't much thought process involved other than if I liked it I'd put it out.

When I made P-Funk Era, I was living at my mum's. I was listening to Fabio on the radio, and he played a Doc Scott tune called Far Away. I remember hearing that, and it had the Lyn Collins break in it, and I thought I need to do a tune just like that and keep it real clean and simple. Back in the day, I was strictly a hip hop boy, so making tunes with hip hop samples was just natural for me. I thought of the Mary J Blige sample but other than that there was no plan involved. I literally just turned on my computer, and it took me an hour from start to finish. I just rolled it out that night: just one break and a simple 808 bassline. A lot of my tracks back then wouldn't take me long to do at all. I'd go to the studio on a vibe, knock something out in a few hours, and that's it. If people were into it, great. If not, I'd move on to the next one. It didn't bother me. Frontline had been set up as a hobby really, so if people liked the music, great. If not, it was no big

deal. For me, it was about enjoying the whole process of making music.

At first, I didn't see P-Funk Era as being something special, and I took it to Hype to see what he thought. I would always take things to him first, and most of the time he'd just say it was alright, but if my memory serves me right, I think he quite liked P-Funk Era straight away, which was quite unusual for him at the time. My tunes always used to have to grow on him, so that he liked one of them immediately for once was a big surprise, but other than that I didn't really think about it too much.

Hype used to say things like "you should be doing more of these" but it wasn't like that for me. I couldn't just go back and do another one on the same tip. For me, it's about the vibe. If I wanted to a dark and moody track next that's what I'd do. Certain producers would have a sound, and they'd keep going with that sound as long as they could until they felt the need to change it, which is cool because they would get an identity and a vibe, but I could never do that. I couldn't get my head around that. That was a personal thing.

Pascal, London (1997)

For me, it was about enjoying the whole process of making music."

I'd been DJing since I was 14, but in the early days I wasn't actually playing out. I just gave Hype everything. It's always nice when you're in a rave, and someone drops your track, and I used to get excited if I heard it out, but P-Funk Era wasn't one of those ones that the DJ dropped and the crowd went mad. It was just a real minimal roller that people would just nod and bob along to. It was only after a long period of time once people recognised it and remembered it that you'd start to see a good reaction off it. Maybe that helped its shelf life as it wasn't a "quick fix", it was more of a grower. I think those more minimal tracks

can have more longevity because they're not in a particular style of the moment. They can just keep being played year after year, and it's still just got that rolling vibe.

Zinc wanted to do his own mix of the track, so I gave him the parts, but I didn't want any remixes of it to be released at the time. I'd made tracks before like Johnny Jungle, and there were about 20 remixes of that, and it gets to the point where enough is enough. Moving Fusion did a remix years later because I used to start my sets with a mix of one of their tunes and P-Funk Era and it would smash the place down. I told them if they were going to do a remix I wanted it to capture that vibe, and take it completely away from the original and that was the closest they could get to it.

I did do a VIP mix, and then I did a different VIP for Randall, which is the one on the AWOL Live album. I remember being at Ministry Of Sound when he played it. It was nuts. We were all in Ministry, the place was jammed, and he dropped it, and I just remember all the girls singing the Mary J Blige part and all the guys were doing the KRS One bit. The hairs on my arms were going mad! I was just going "oh my god!". That was probably one of the highlights of my career.

SOUND OF THE FUTURE

THE LIGHTER (FORMATION, 1995)

DJ SS' Formation Records and its various sub-labels maintained a prolific rate of releases from day one, with a steady stream of in-demand 12"s from 1991 onwards. Many were by SS himself using a plethora of aliases, but also included tracks and remixes by the likes of Carl Cox, Roni Size and Jumpin' Jack Frost. Using his 5HQ record shop as a base, SS and Formation also played a key part in the careers of future stars such as John B, Twisted Individual and Matrix. In 1995, The Lighter by Sound of The Future (another SS pseudonym) emerged as one of the anthems of the year with an instantly recognisable piano intro tearing up dancefloors across the country...

DJ SS: I started out as a scratch DJ for this band, and one day I went to this guys house for rehearsals. He pressed this button on his Atari, and the music started. I couldn't believe it. I decided that was for me, so I got a little computer and never looked back. I was still learning when I put out my first EP. If you listen to it now, you can hear a few bum notes in there because I didn't know how to delete them properly! That was what made the music what it was, though, it was just vibes.

I made Lighter in 1994, just thinking I'd try it out in my sets to begin with. I'd been working on the track that would end up being the other mix of Lighter, with the reverse vocal, for a while. That came about from spinning a record back while I was DJing, and I thought it sounded good. I had spent weeks on it as that was intended to be the main track. I was also working on a downtempo project with another producer. We were jamming in the studio, and the piano player started playing Love Story. At the time, I didn't know that's what it was, but I recognised it from somewhere; I asked him to do it while I put some beats behind it and decided to record it. You can listen to the original Love Story and tell that we

replayed it for Lighter. The notes and chords are slightly different, which meant we didn't have any problems with the publishing. We weren't trying to do a revamp of Love Story; it was just a different interpretation of it.

Back then, people sampled anything and everything, and that's why the music became so popular. We were just looking for clever samples, and there were things that sounded good that maybe you couldn't get permission to use, but if it was played backwards, it wouldn't be recognisable. It was all about finding sounds and samples; we took all sorts of styles and added beats and bass. At the time, it was about making tracks catchy with vocals and hooks. That's why jungle was so massive: it had something you could remember.

I used loads of aliases on my records back then because I had so much music to release. I was constantly in the studio and was always trying to outdo myself. If you only make a tune once or twice a year, you hear things differently but being in the studio 24/7 I could listen and tell what was missing or what was needed. We'd built

a proper studio that had everything in place, the room was perfect, and Formation was a bit ahead of the game as far as sound quality went. It was a similar thing with Moving Shadow; sonically their stuff just sounded better. Other people were making tunes in bedroom studios or in a little room somewhere. Dillinja was way ahead of the game, he had a vibe, and he had the sound we all wanted. He was the first one to make that distorted thing sound good. Shy FX always had a vibe too; there were a few people but not loads.

There was a core of about 30 producers that were doing good stuff constantly around that time. There was a bit more quality control back then, and it was more organic. You had to have a studio and a mixing desk and a sampler, you couldn't just have it all on one computer. Anyone spending that time and money and then pressing it up had to spend a bank of change. You couldn't press up a "maybe" ting because it might not work, so there was more control, and that made it easier for people to digest. I would give tracks to the DJs and let them have it for two or three months on dubplate, and it would come out whenever it came out. We promoted it and promoted it and caught a vibe, and a few DJs having something as an exclusive is what built the hype. People were more patient then, but these days it's the "now, now" generation and you can get everything on your phone so as soon as they hear it, they want it the next day.

DJ SS in Miami (1997)

"I was constantly in the studio and was always trying to outdo myself."

We had a few conversations with major labels back then, but we already had the whole thing down from start to finish, from the studio to the shop floor, from production to the sales stage. The studio was above the record shop, so we were dealing with the punters every day. When it was pressed, we'd be the first ones to have it, and we could see their response. That's how we gauged it, and that was a wicked tool to have. We had it all, so we wouldn't have really gained much from a major label. If I'd have done that I'd have been tied into a deal and maybe still stuck in something now. I could've signed my life away, but I had good people around me, and we built the foundations. If you have that, then you'll always be able to progress. I'd make tunes and bring other artists in, and my partner would take care of the business. I'd come up with a concept for something, and he'd put it together. We were trying to innovate and do different things, like setting up the World Of Drum & Bass events.

I didn't even contemplate Lighter being as big as it was, but people were into it straight away. I got the dubplate cut at Music House, and me and Grooverider were the only ones that had it. Groove had a big response to it and was telling me it was the one. I've done better tunes for sure, but it's my biggest and most popular. I think it sold around 23–25,000, but with represses and digital, it must be way more. Ministry Of Sound licensed it recently, and 25 years later it's still getting played by jungle DJs, grime DJs and garage DJs, and you can't really say more than that.

ALEX REECE

PULP FICTION (METALHEADZ, 1995)

Making a name for himself around 1992–93 with a prolific output under a variety of names on various labels, Alex Reece became part of the original Metalheadz crew on its inception in 1994 and his second release on the label – the iconic Pulp Fiction – would completely change the drum n bass landscape. It was credited as creating the 2-step style that would become standard across the genre for the rest of the decade and beyond. An innovative, minimal record that managed to be a guaranteed floor filler when the use of manic chopped-up breaks and ragga vocals was at its peak, Pulp Fiction's warm bassline and jazzy horn sample was nothing short of a game-changer. Sporadic releases aside, Alex is all but completely detached from the music industry these days, and I wasn't able to make contact with him for an interview. A record of Pulp Fiction's stature couldn't be omitted from this book, however, so it's left to others to comment on its impact...

Phil Wells: There was such a variety of sounds within the drum n bass formula. The records got bigger and bigger, and the record that took it to another level was Alex Reece's Pulp Fiction. For years people found d&b difficult to dance to because there was no 4/4 beat to it. Alex put it back in but used a snare where there'd usually be a kick drum. I knew Alex from when he first started as a trainee engineer at Basement Records; he was a lovely guy and extremely talented. His techno stuff was amazing, his drum n bass was brilliant. Him and Wax Doctor were like brothers, glued to each other. That period when they were at R&S Records resulted in some astonishing pieces of music; amazing records. Pulp Fiction was a pivotal tune, like Demons Theme, Valley Of The Shadows or Doc Scott's Shadowboxing, certain records that were just outstanding

and had a massive influence on the scene. Every year you had one or two tunes that come along and change everything, and Pulp Fiction was one of them.

Fabio: A game-changer. The most minimal tune you'd find. Jungle had loads of samples and noises, layered breaks. Pulp Fiction was the first minimal tune. There's nothing to that tune, no big breakdown. Its drums and a bass. No strings or pads. That track is dear to my heart, and I was going to put it out. Alex Reece brought it to me at Speed, and I played it and thought it was amazing. Creative Source hadn't started yet, and I was thinking about making it the first tune, but the process of starting the label took so long that Alex ended up taking it to Goldie. Goldie heard it and said: "I'm having that". Alex had given me a tape at first and then gave me a DAT, so I cut it. The first time it got played I was doing a set at Voodoo Magic at Leicester Square, I went on after DJ Ron who absolutely smashed it. I had decided to play a liquid set.

Anyway, I looked behind me, and Micky Finn, Ron, GQ, all of those guys were there, and I was dying; my set was not happening. The crowd weren't into the tunes at all, and I was thinking, oh my god, I'm dying on my feet here. I had Pulp Fiction, and I'd never played it out and I was thinking this track is so different, can I pull this off in here? I was playing some Hyper On Experience or Flytronix tune and people were starting to leave, and I was thinking this is a disaster. I put it on, and the whole place stopped and just erupted about a minute into the tune, and it got rewound seven times. No joke. Micky Finn rewound it, GQ rewound it, Ron rewound it. No one could believe what they were hearing. You can play it now and it doesn't sound out-dated, you can play it anywhere and it's possibly the only tune you can do that with, where you can play it anywhere at any time and it will work because it's unique. It doesn't start with a break it starts with a bass. It's just this rolling, dark, minimal tune. It saved my night; I'd never played a set where I just wanted the ground to come and swallow me up and that tune dragged me out of a hole. After that, everyone was on Alex. The next day he must've got 200 phone calls. Goldie took the tune and the rest is history. I even named the track, it was untitled when he gave it to me; I was really into Tarantino films and suggested he called it Pulp Fiction. Alex thought it was a bit weird but I said trust me, call it Pulp Fiction. He went along with it. That tune was a big moment for me.

Getting that reaction and that many rewinds on a new tune won't happen to a DJ many times in their career. The only time that's happened to me was with Strings Of Life back in the acid house days when no one was really playing it. It just destroyed the place.

Goldie: I definitely took it from Fabio. I heard him play it and thought that's got to be on Headz, and Fabio was cool with it. No other label deserved it at the time, to be honest. Was there anyone else who was worthy enough? Think about what Metalheadz had already put out by then;

you never knew what was coming next. Pulp Fiction was the beginning of 2-step drum n bass. It could be played anywhere in any part of the scene. I saw that crossover potential straight away and knew it would be huge. I went to Alex and said this record is ridiculous, I've got to put it out on Metalheadz.

> *"Every year you had one or two tunes that come along and change everything, and Pulp Fiction was one of them."*

Alex's downfall was his manager. I felt these outside people coming into the scene were taking shit from it that they didn't deserve. Around that time everyone was being snatched up by major labels, so Lemon D and Wax Doctor were on R&S, and Dillinja was on London Records. I told him he should've signed with Metalheadz and then licensed his album to them, instead of signing directly with London, where his record got stuck in their pipeline. I advised all of them not to do it. I told Alex it would be the end for him if he did this. He did the Model 500 remix and a few other things, and then any remix he could possibly get, but there was no artist development, and he crashed. Wax Doctor ended up doing kind of the same thing, but he stayed faithful to Metalheadz, and Alex did to a certain degree. There were stories that I beat him up and took Pulp Fiction from him. The best one I heard was that I drove to his house in a rage, put a gun to his head and demanded that the DATs were handed over. I thank Alex for his contribution to the art with that track though. It was a massive contribution, and I think he could've gone on to do greater things. His manager fucked his head up, and he should never have happened like that, but he was young, and maybe he didn't know any better. It's a shame as he was a phenomenal artist, really outside of the box.

URBAN SHAKEDOWN
SOME JUSTICE 95 (URBAN SHAKEDOWN/PWL, 1995)

A headline name in the rave scene since its inception, Micky Finn was combining breakbeats with heavy bass as far back as 1991 when he dropped She's Breakin Up under the alias Bitin' Back. His first release with Aphrodite and Claudio Giussani, aka Urban Shakedown, was Some Justice, a record which would reach 23 in the national charts when it was re-released in 1992 at the peak of hardcore's commercial popularity. Further dubplate-only mixes followed in 1993 and 1994 until in 1995 it was given a full makeover with monstrous bassline and ragga vocals courtesy of D.Bo General. The sample from Someday by Ce Ce Rogers was retained from the original mix, and a new anthem was born...

Micky: The original version of Some Justice will always have a special place in my heart. It was quite groundbreaking as in 1991 no one was doing breaks like that. We decided to cut them up and make our own drum patterns. The pitched up bassline had never been done before. Back in '91, we made quite a few breakthroughs.

Aphrodite: I learnt an interesting lesson very early on with Some Justice. At the time there seemed to be a race to have certain equipment and a specific sampler, a big mixing desk and all that. We produced Some Justice on two humble Commodore Amigas that had been linked together by a manual click track that I speeded up and slowed down to get it in time, but once they were in time, you could set the two off together. The sound was in 8-bit, and we mixed it down in Carl Cox's front room, using his DJ mixer with an aural exciter. That track ended up becoming huge. It was one of the first hardcore tracks to conquer the charts. It wasn't as big as Baby D or The

Prodigy, but it was up there. That taught me that it's not how you make the tunes; it's how they sound in the end.

Micky: I met Gavin [Aphrodite] in City Sounds when he was a computer programmer wanting to get into making music. Him and Claudio were already an outfit, and he was playing something to Ray Keith, who worked in the shop. Ray wasn't into it, but I heard something I liked and got chatting to him. I lived in Brockley at that time, and Gavin was in Eltham, so we were both in South London. I took the Run DMC, and Ce Ce Rogers records round to his place, and the rest is history. It was Urban Shakedown featuring Micky Finn, and we went from there. Off the back of the popularity of Some Justice, we signed a deal with Pete Waterman's PWL label in 1993. I had a brilliant relationship with Pete, a lot of people probably wondered why I was working with him but he's a very cool dude. He let us run the label and didn't try and stamp his mainstream machine all over it so I can't knock him. It's ok

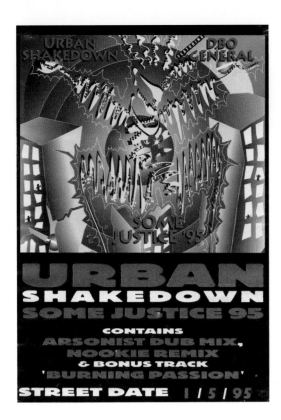

arsonist, Gavin was his lawyer, and my daughter played the witness.

The track came out during the days of AWOL, which was an absolutely unbelievable time. Originally Swan-E and Trevor Fung had been part of the team, and there was a good collective of people. By '95 it was me, Kenny Ken, Darren Jay, Dr S Gachet and Randall and we were all doing well in the jungle scene. We did the Red Eye Sessions that went on until one in the afternoon. It was a weekly event, and all the DJs would come down after they had played their sets elsewhere. People liked it because it was a safe event and we had a good sound system. I would come out of Music House at 6am after cutting dubs all night, and that was a regular thing because you knew the sound system at the club would back you up. I'd say it was the most upfront club in the country by far; you couldn't touch it. The AWOL Live album was the first thing that Ministry Of Sound released; they didn't even have a label set up at the time. We recorded it live at Ministry, and each of the DJs did three tunes each. I mixed it down, and I've still got the DAT at home. I had to do a bit of editing on a certain person clanging their mix a bit, but we got rid of that! It was a brilliant night. That whole era was just so special.

"It's your canvas, go and paint on it; there are no boundaries or rules books for this thing."

I'm quite a simple person: does it work on the dance-floor? Yes? Then we've done our job. Call me cheesy, but I like the sing-along tunes that are in your head the next day like Warhead, Ready Or Not, Arsonist, or Fire. It seems like those sort of tunes don't exist anymore. Nowadays, I see too many people stroking their chins worried about what other apps the producers are using.

All through the 90s when Gavin and I were doing all those remixes we knew it wasn't everyone's cup of tea,

getting into major label deals as long as you can keep artistic control and they don't try and turn you into Wham or something.

Arsonist already existed as a dubplate track in its own right. It had that big Dead Dred style bassline which was the flavour at that time. We loved a good bassline and spent a lot of time working on them. D.Bo General was a friend of L Double, who I'm good friends with since way back in the Unique 3 days. They're both from Huddersfield and D.Bo was from a reggae sound system background. We asked him to voice specials for Grooverider, Kenny Ken, SS and Darren Jay so we knew they'd play it as it had their name in it and it went down a storm. Listening to it now I think the original Arsonist was better and that the original Some Justice was better, but that was just a personal thing; I don't think they work together that well. For personal reasons, the tune was dedicated to my brother as at the time he had received a prison sentence. We made a video for it too, which was a bit of fun. I was dressed up as a judge, D.Bo was the

but do you care? You should do what you want to do, not what someone else expects you to do. It's your canvas, go and paint on it; there are no boundaries or rules books for this thing. Those people that try and segregate and pigeonhole things can ruin a scene. One night of the same genre can bore the tits off people. I think you should hear different stuff in one night, like what you'd hear Hype play in a set – bit of dark, bit of jump-up, a bit of Wilkinson.

When the reggae jungle and the vocal tunes got phased out, I found I wasn't into the real heavy, dark side of things like the No U Turn stuff. I'm not knocking people but it wasn't for me, it was too dark. I thought it was all a bit mechanical. Just lashing Amen breaks for the sake of it. For a while, it seemed like a competition of who could do what to the sounds, and I wasn't in it for that. We were still shifting ridiculous amounts though, and when Bad Ass came out, we sold over 50,000 copies. I came from a background of hip hop, jazz-funk, rare groove so you can understand why our stuff had that vibe. A lot of people have said to me that it wasn't until they heard our kind of drum n bass that they got into it. Rhythm and basslines are the most important things for me, and when the dark tunes got a bit funkier again, then it had me. Ed and Optical started doing things like Watermelon, and I was into it.

I've been in the game 30 years now, and I am one of the fortunate ones to be blessed with witnessing this whole thing from 1987 with the acid house parties and ecstasy arriving on these shores. I saw the whole explosion. I came from a criminal background so I knew that once I'd broken that chain, this was for me. This is what I wanted to do. I've never had a job so it was either this or going back on that stupid path. I didn't have a great childhood; I did some stupid shit and ended up in prison but I turned it around. You know what they say: find a job you love and you'll never do another day's work in your life. It's not been hard work for me, I've loved it.

Micky Finn at Jungle Fever, Roller Express
(May 1994)

T POWER VS MK ULTRA
MUTANT JAZZ (SOUR, 1995)

With its chilled, downtempo intro and a sample of proto-rappers The Last Poets, T Power & MK Ultra's Mutant Jazz was already a very distinctive track. DJ Trace's radical remix took it in a completely different direction and laid out the template for the tech-step sound that would figure heavily for the rest of the decade...

T Power: I'd be lying if I said I could remember exactly how Mutant Jazz came about. It was just another track in a queue of tracks I was making at the time, but it seemed to stand out more than the others. I was starting to reach a point where I could achieve the sound I wanted, but everything didn't fully mesh until I did the Self Evident Truth album in 1995, and then it all spewed out in one go. After years of having technical hurdles or maybe not having enough musical know-how, all those barriers lifted at the same time. I put Liberation on the B-side of Mutant Jazz which was me really getting into the abstract side of the music, where the drums are quite different, and everything has lots of panning and delays. There were other people doing that like the early Metalheadz stuff with J Majik, Peshay and Photek, and then Dillinja started to take hold of the reins, and I think that was when Metalheadz started to really get its identity as we know it now.

I had started off releasing music as part of Bass Selective on DJ Only Records, and then started doing stuff as T Power on Soapbar Records. DJ Only became SOUR, and I ended up there as a solo artist. I think I'd probably started playing them my more stripped back stuff, as I had started to progress my sound from the early material on Soapbar, and then I started to develop a slight ambient tinge to it.

There was definitely a period where we were starting to strip back the music, and the silly pianos and sped up vocals were starting to fall by the wayside. During that time there was no template for what drum n bass was supposed to sound like so there was more room for creativity at that point. I think my first track for them was Lipsing Jam Ring, followed by Elemental and then Mutant Jazz. Everything kind of fell into place and the label was starting to get more involved in the scene, so it wasn't unusual to see Grooverider or Swift at the offices on a Friday looking for dubplates. The artists people really wanted music from were Shy FX and Potential Bad Boy, in terms of people at the label that were doing stuff that the DJs cutting dubs would actually want to spend money on.

SOUR offered the remix of Mutant Jazz to DJ Trace, and he came back with Rollers Instinct which completely changed drum n bass and defined the sound for the rest of the decade, and that was really where drum n bass stayed until the noughties. I did not know what to expect when he was asked to do the remix. Obviously, I liked it, it was a great remix, and he had put a lot of effort into it. There was nothing to not like. It really changed everything. It

probably defined Trace's career, and that remix is in a lot of people's top drum n bass tracks of all time. There were two remixes. I'm not sure why as the first was so strong, but it was done for a flat fee, so maybe there was a feeling that as it had been so big, there should be an opportunity for Trace to collect publishing off a second mix.

"You had to be there to witness it, to know what the feeling was and what it was about."

SOUR saw the market for what I was doing. The guys that ran the label had been around the industry for so long that they knew all the angles. They did try to try a few things to replicate the success Shy had with Original Nuttah, but they knew it would've been very limiting in terms of what they were trying to do with the label if they allowed it to be solely defined by the ragga side of things. Even in the early days, there were indications that was going to be an issue. Whether we like it or not, it changed the whole vibe at the parties, and not for the better. It became dangerous for DJs to go out and play their sets. That was something I had left behind in my hip hop days. I cut my teeth on funk, soul and hip hop before dance music even happened. I watched Juan Atkins as Cybotron turn electro into Detroit techno, This Brutal House by Nitro Deluxe came out on what was fundamentally an electro label, and that really changed things. I watched all of that happen, so by the time we get to jungle, I did not have the stomach to be stuck in a potentially life-changing situation. This is music.

SOUR did manage to get a massive deal with Avex Trax in Japan off the back of mine and Shy's releases alone and my album was one of the things that anchored that deal, but they weren't expecting Waveforms as the second album, they were expecting Self Evident Truth part two. I could have probably sold a ton of those if I had done it, but that wasn't me. My problem was that I moved too fast for a fan base that was very genre centric. I had gone beyond being a b-boy, so

I was listening to ambient, techno, broken beat, everything. I used to go to Dingwalls every Sunday and watch Gilles Peterson play. I was taking my influences from the outside rather than having an insular view. In turn, DJs from outside the immediate drum n bass scene would play my stuff, for example, Mixmaster Morris was a huge fan and championed my music in those days. The scene was ready for someone to blow up, and I don't think there was a better choice than Roni at that time. In terms of something that could work outside of a club, and work on stage, they made that work really well.

Drum n bass became too fractured, and sub-genres appeared, and you ended up with all these pockets and cliques that didn't really communicate with each other. Even into the noughties, it was like that. There were people in the industry that would be at different nights, but you wouldn't see the same punters. It was Dogs On Acid vs Drum & Bass Arena!

I think it was the case that d&b producers were looked down upon to begin with, especially by the house music scene; there was some elitism there. Ironically, as it turned out, d&b ended up proving to be one of the most technically challenging forms of dance music to produce. Even though I have fallen in and out of love with the format, the tempo is so restrictive that you really have to know what you're doing. If your production is loose with d&b, you do not stand a chance. Guys like TeeBee, Calyx and Noisia are absolutely at the top of their game on the technical side of things. Regardless of whether you like their music, they are absolute dons at what they do. It's a tricky form of music to do well and takes hours of hard work to perfect it. Back in the day, we would have killed to be able to get the level of depth and control in the music that Breakage has now. His take on jungle is fucking ridiculous frankly! I have had the pleasure of mastering a couple of things for him, and they're jaw-dropping. Everything he has to do to achieve that level of volume and still get that clarity is quite remarkable.

I completely detached myself from d&b and did the Chocolate Weazel album [Ninja Tune, 1997]. I tried to get back into it doing by nu-skool breaks, but it didn't take me long

to decide that I didn't want to be DJing to kids for the rest of my life. I took a break and around that time me and Shy reconnected and ended up sharing a studio from around '98 onwards. He had so much unfinished material that I just ended up helping him for five years. It was three years before he dropped anything serious on me and Shake Ur Body came about, which was refreshing for me as it was a hell of a lot of fun to work on music like that. You know what the elements of the tune are doing, and where it's going to start, and finish and you know what you're trying to achieve. After years of trying to reinvent myself at every given opportunity, it was nice to have a clear brief of what to do. We worked with a lot of vocalists, so I got very good at recording vocals and mixing them down. It was a good learning period and a lot of fun.

After we got the first dubplate of Shake Ur Body back, I was pretty much in tears. It was so bad and Shy was almost ready to scrap the project, I said no because the tune was sick, but it was just on a poor quality dubplate. We got some decent dubs cut, and I was right! It wasn't met without resistance, but I think everybody understood that the scene really needed some help at that point. It really needed to attract girls because it had become a sausage fest. We bought the girls back and turned it into a party again. There was us, and Marky did LK and Uncut had Midnight which was huge. That probably helped pave the way for Pendulum to come and do what they did and take it up to another level.

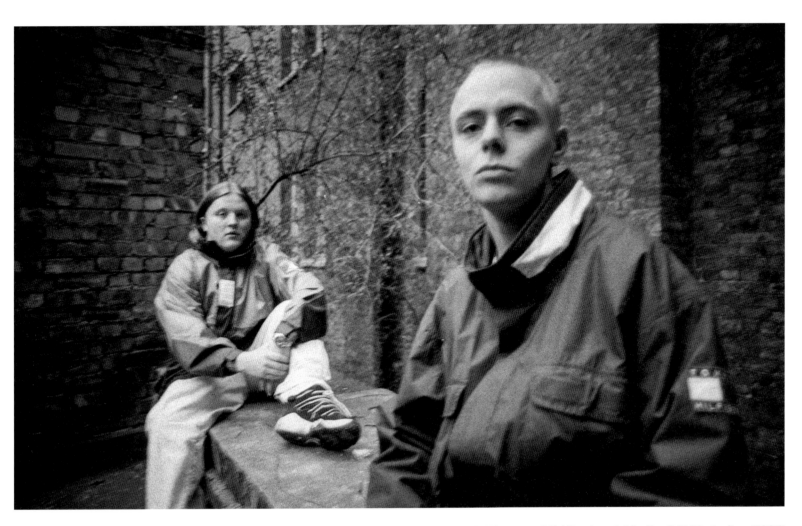

DJ Trace and Ed Rush outside the SOUR studios (1995)

SHIMON & ANDY C
QUEST/NIGHT FLIGHT (RAM RECORDS, 1996)

Shimon is an original part of the Ram Records crew. Having debuted on the label in 1994, he would link up with school friend and label boss Andy C in 1996 for one of the best A/B-side combinations to ever hit the shelves. Quest and Night Flight both became ubiquitous at raves from the second half of '96 onwards and would still regularly feature in Andy's trademark high octane sets well into the next decade...

Shimon: The first time I went into the studio was with Ant Miles, and I worked with him on the first record I released, which was The Predator on Ram. Once I had a taste for it was my first taste of it, I told myself I didn't want to put out anything else until it was 100% me. I got my head down, bought a sampler, read the manual and mucked around with it until I knew what was going on. Andy and Ant helped me out a bit and showed me some stuff, but I'm mainly self-taught.

Quest was the next thing I did. I had been working on a few tracks and Andy would listen to what I was doing. He came over while I was making Quest and we decided to finish it together. The same thing happened with Night Flight. Andy was good at structuring things; I think he got that skill from DJing, so knew where to drop things and how to lay out the intro. I would do more of the writing, and maybe Ant would mix it down for us if we were working together. We all contributed to all aspects of the tunes but generally, I would write the track, and Andy would structure it. I didn't even have proper studio monitors back then, I was using hi-fi speakers. I knew what I liked and what I wanted to hear though and it seemed to work. That was as much of a plan as I had.

Andy started playing both tracks out on dubplate, they began to catch on, and everyone was playing both tracks

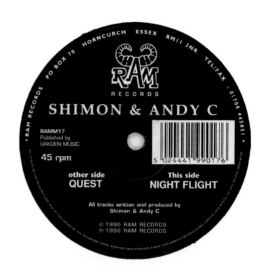

quite a lot. I couldn't believe it; it's a crazy feeling to have your first tracks be that successful and seeing everyone going crazy to these tunes you made. To begin with, I remember Andy saying it could do really well and we might be able to do 3,000 copies on vinyl, so I thought that would be amazing! It took on a life of its own and ended up far exceeding my expectations.

> *"I've always wanted whatever I'm making to be completely different from my last tune. I think sometimes that's been to my detriment, but that's what I have to do to stay fresh."*

Usually, I find that the good tracks are the ones that are nailed the first time, so with Quest or Night Flight the first and only versions were the ones on the 12". Ant did a

VIP mix of Quest for the Speed Of Sound album but apart from that, there were no other mixes until the Ram 25th Anniversary album in 2018 when I remixed Night Flight and Bladerunner remixed Quest. Those old tunes don't need anything crazy doing to them or they start to lose what made them good in the first place. Bladerunner just fattened it up which is good as it means you can play it alongside newer stuff with the modern mixdowns and it won't sound too weak.

I was definitely influenced by people like DJ Die and Alex Reece. Pulp Fiction was a big tune for me. That was a real turning point in drum n bass and a big influence on my work as I liked the way Alex stripped back the beats. I wanted to make stuff with a bit more space, not too crazy, more rolling and bouncy. I guess that was my sound.

Seeing how crowds react to certain tunes definitely helps the production process as you know what you needed to do when you got in the studio. In the early days, I was going to raves like Elevation and Life Utopia. As it switched from hardcore into drum n bass and the sound

got a bit darker I would be at AWOL or Lazerdrome, or out wherever Andy was playing. Later on, Ram got their residency at The End so I'd be playing there. I would be out from Thursday to Sunday. There was a friendly rivalry between producers, so you would go to Music House and see Bad Company or Ed Rush and Optical checking out each other's tunes.

Some people have their own specific sound and push that, and I think to an extent that's a good thing to do, but I've always wanted whatever I'm making to be completely different from my last tune. I think sometimes that's been to my detriment, but that's what I have to do to stay fresh.

I think that where we are now is one of my favourite times for d&b. It's the most organic its sounded for a while, like how it used to sound back in the day but with modern mixdowns and there's some good stuff about. Those older tracks from the 90s might not sound as heavy and have a bit less bass than the current stuff, but I think they were more distinctive. I still play Quest and Night Flight now, but at the time obviously, I had no idea they would end up as big they became. Certain tunes stand the test of time, a bit of it is nostalgia, but it's also that they just hit the right spot.

distributed by SRD 0181 802 3000

RAMM 14
ORIGIN UNKNOWN
'Truly One' b/w
'Mission Control'
available now
RAMM 15
Stakka & K.Tee
'Danger Zone' b/w
'Hear Say
available 15th jan
RAMM 16
ORIGIN UNKNOWN
'Valley of the Shadows'
b/w 'Awake '96 Remix'
available jan / feb
RAMM 13R
Desired State
'Goes Around Remix' b/w
'Here and Now Remix'
available early feb

tel/fax 01708 445851

ADMM 10
JOINT VENTURE
'Sunrise' b/w 'Take Away'
available now
ADMM 11
CONCEPT 2
'Life Line' b/w
'Soon Come'
available 8th jan
ADMM 12
INTERRORGATOR
'Break War' b/w
'Circles'
available jan 25
ADMM 13
Liftin' Spirits
'Cup-a-Cha' b/w
'Music Lover'
available late 5th feb
ADMM 9R
STAKKA & K.TEE
'Rugged'n'Raw' (Splash Remix)
'Bad Influence' Remix
available late jan

DJ HYPE

PEACE LOVE & UNITY (TRUE PLAYAZ, 1996)

Widely considered to be one of the best DJs around, DJ Hype's status as a key figure in British dance music is undeniable. Coming up with Shut Up & Dance and playing on Fantasy FM in the early 90s, he went on to release era-defining tracks on Kickin, Suburban Base and his own Ganja Records. In 1996 he launched True Playaz with Peace Love & Unity, which featured the soulful vocals of MC Fats riding a rumbling bassline...

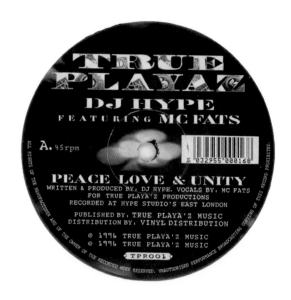

Hype: When people talk about the history of drum n bass, they might not go back further than Goldie, but the scene wouldn't exist the way it does without Shut Up & Dance. If you speak to anyone that was producing jungle in the early days, they would all mention them, but when you read the magazines, they hardly get a look-in. Our culture wasn't part of the mainstream at all, we made it out of nothing; we didn't learn it at school, and weren't taught it in any way. We nicked some wood and built our own speakers, and I've still got them now. There was no rave scene – we had blues and shebeens, then the warehouse thing came along after that. I'm very proud to have been a part of that, and I love the fact that I have this history; it was the time of reggae and early hip-hop, but I was DJing before hip-hop came along. I started with one deck, so there was no mixing.

The standard of the equipment didn't come into it. I had a sampler keyboard that was basically a toy; it was about £70, and it had a feature on it where you could record into it for two seconds. Before I had my own studio, I would have to use one with an engineer and they would be trying to tell me what I should and shouldn't do, but they didn't understand it because they were older and used to working on rock music. I used to play for Orange at The Rocket, and the promoter was Chris Paul. He used to make poppy dance

music. He had a rave project called Isotonik, but he'd been around before that; he was from the disco era. He had a studio so I would go there. I did stuff for Strictly Underground and Kickin Records, where I was the A&R man / in-house producer. Shut Up & Dance recommended me to them, but at that time I was winging it and didn't really know what I was doing at first. I was given a bag of demo tapes to go through, and I picked out The Scientist's tape which I think [Kickin label owner] Peter Harris was already aware of and although I didn't like his stuff I thought that maybe if me and him got together we could do something.

It was at Kickin that I did The Bee and The Exorcist, which was actually a track that I made on my own as a demo when I was on Fantasy FM. I'm not a keyboard or synth player, so I hooked up with The Scientist, and I brought him that track, and we worked on it as a joint project, which was a success. He was different to me, a very pure techno kind of writer, but it wouldn't have come out the way it did if either of us had made it by ourselves. I wasn't looking to be

an artist, and I never wanted to be the superstar out front. I wanted to be this cool producer and DJ, so we used The Scientist's name because he was going to do the PAs on his keyboard and I would be credited as the producer, but I didn't understand that side of the music industry yet. He would do interviews and get asked about the influences for our tracks, and he would be talking about techno, but he wouldn't mention my input with the breaks and reggae side of things. He would just claim he'd always been into that too and not acknowledge me. He was a very talented guy though, and we worked well together. What we were doing came just after Adamski – and The Scientist had been heavily influenced by him – and Guru Josh. We could've gone on to be like The Prodigy if things had worked out differently.

Suburban Base was the last label I signed to as an artist, and I was initially very happy there, so I wasn't really thinking about having my own label. Then I found I was making more music than I needed and ended up sitting on tracks, so I started Ganja as an outlet for tunes I wasn't releasing on Sub Base. Nowadays everyone wants to market themselves, but If you look at the first Ganja releases, I didn't even put my name to them. I would sell about 2–3000 copies, and the

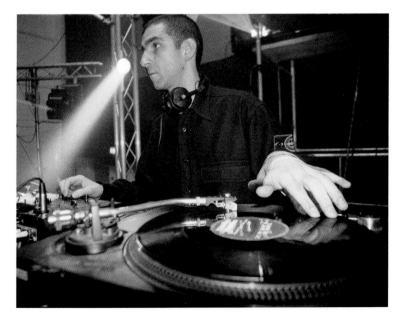

DJ Hype, London (1995)

distributor would say they could re-press it, but I wanted it to have that feeling of being something cool, and that it wasn't a record that was easy to get hold of. It's a bit like me having a dubplate of a track that everyone wants, but you have to come and listen to me play if you want to hear it. People started loving the stuff on Ganja, and I was a bit disillusioned with other labels releasing my tracks. Looking back, I can see that those labels did a lot for me, but at the time, I felt unappreciated and thought that I wasn't getting the right money while they built their empires. I didn't understand contracts, and a two grand advance to someone like me was like a million pounds, but a few years later when you've had some success, you start to think you're getting knocked.

When I write music, I don't have a picture in my head before I start, so I don't know if it will be mellow or hard. Things would never come out the way I went in to make it. I'll be in the studio, not even writing, just jamming. I might get a few beats up, and something will start to take shape organically, and then I build from that. When I would get remix requests people would say they wanted a certain style, but I'd tell them if they wanted it done this way or that way they should make it themselves; I don't know what I'm going to do. Pascal made a track called Gone Are The Days which was a very mellow, liquid-y track. I was supposed to do the dance floor banger mix, and I ended up doing a nine-minute roll out because that's what came out.

I knew Fats from DeUnderground Records in Forest Gate; I'd go and hang out there to get vibes. Randall would be there, and Mikey, Cool Hand Flex and Uncle 22. Fats was a mate of theirs, and he worked as a distributor in a van. I got friendly with him, and as he could sing, I suggested we did a tune together.

I was living in Edmonton at the time and had a studio in the house. There were no windows in the room as I didn't want anyone looking in. This was Edmonton during the crack era, and the house backed onto an estate, so I didn't want people seeing the equipment and breaking in. Fats came over, but the thing is he's not a writer, he won't come with a verse and chorus or whatever, he just makes it up as he goes along,

DJ Hype
(1997)

and he won't re-voice anything so you can't get him to do it again. If you're a good producer with a decent ear, you can pick out the parts that will work, so I think that maybe anyone else that works with him accepts what he's done, and then they take it away and work with it as best they can. I'll be on at him, and I work him quite hard in the studio.

On that day I didn't like what he was coming up with so while he was jamming I wrote down something as a suggestion, which was the "peace, love and unity" part. He emulated that and I then I think he added "the world would be a better place..." lyrics and that was it. I think Peace, Love & Unity was the first track I made with an Akai S3000. I had gone from a 1000 to a 3000. It was quite an easy track to make, not something that I struggled with.

> *"Peace Love & Unity was a success and a great start for the label. We did about 30,000 copies and it kept selling; good songs will do that even after the initial buzz wears off."*

Peace Love & Unity was a success and a great start for the label. We did about 30,000 copies and it kept selling; good songs will do that even after the initial buzz wears off. Original sounding tracks are timeless, and they don't go out of fashion. I like the label to have a steady flow of releases, but they don't have to come out the second they're made; if the track is unique, you don't need to rush putting it out. If something is a genuine hit then bringing it out quickly or leaving it on dubplate won't affect it. Now with the internet, everyone can find out about a tune quite quickly, but we didn't have that back then. There was no Annie Mac or Radio 1 playlisting it – they didn't support it at all. The hits from that era were genuine underground hits. When I did Closer To God that was on dub for about two years, Super Sharp Shooter was on dub for a while too. I've got DJ Hazard tracks that I've been sitting on for years, but I could



release one now, and it would be the biggest thing out.

I had met Pascal through Sponge as they produced together under the name Johnny Jungle. He was doing Face Records, and we would help each other out, then we decided to do something together. I had also become friends with Zinc. He came to see me at DeUnderground and would ask me for advice on his tracks; it went both ways though, and I learnt from him too. He'd been producing for a while by then, and he probably had more faith in me and trusted my judgement more than I did! He lived near me, and we started to work together more and more.

Major record companies were offering me deals as a solo artist. XL, FFRR and a couple of others wanted me, but I didn't want to sign exclusively to them, and I didn't want to be a pop star, but I thought I could use them to get a deal for all of us which is how the Ganja Kru came about. I'd used the name before but not with the intention of it being a real crew. I decided to stop doing Ganja Records; it was growing, but that hadn't been the original plan for it, so I hadn't set it up with barcodes or anything. Pascal and I spoke about joining forces and doing something properly and setting up a label and production team. I thought we should include Zinc as me and him were tight at the time. We started True Playaz at the same time as we signed our non-exclusive major deal, so in my head, I had one foot in the underground and one foot in the mainstream. The agreement with the major was that we could release projects as a team, but at the same time, I would be allowed to run my label. Our intention with True Playaz was to put out good music and work as individual artists away from the major label deal, we didn't plan on signing other artists at first, and it worked very well. Zinc parted company with us many moons ago, and Pascal and I have carried it on since around 2004.

I come from a very poor and humble place. This music came from the creativity of living in Hackney with no computers, no clubs, no parents that dropped you off everywhere. We lived on the streets. Where I grew up, everyone ended up being on drugs, mad, dead, in prison. The only people that did well were people like me that got into music.

RONI SIZE/REPRAZENT
TRUST ME (TALKIN LOUD, 1996)

With a prolific output since his emergence on the scene in 1993, Roni Size took things to the next level in 1997 when his New Forms album won the coveted Mercury Music Prize. The ground-breaking project was a critical and commercial success and contained acclaimed tracks such as Brown Paper Bag and Heroes. Its release was preceded in late 1996 with the Reasons For Sharing EP, which contained an addictive jazzy roller called Trust Me, which had been tearing up dancefloors on dubplate and would go on to be a fixture in DJs boxes for years to come...

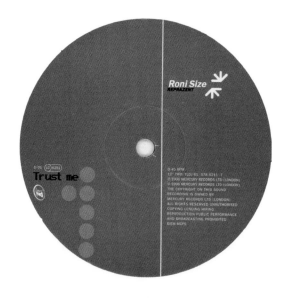

Roni Size: Back in the day, we were in the studio as much as possible. We didn't have much equipment at the time so myself, Krust, Die and Suv were using Smith & Mighty's studio; Tricky and Flynn & Flora would be in there as well. We did that until we could afford to build our own studio, Studio Drum, which we all shared. It was in a small room in an office block. We bought some S760 samplers, some Tannoy speakers and we would play the music so loud bits would fall out of the ceiling. We ended up having a time restriction where we could only make noise between 8pm and 7am, when the people next door came into work.

Weekends we would usually be driving around the country DJing. Friday or Saturday we would go to London and go around the record shops. There was Blackmarket, Lucky Spin and Horace in Camden Market as well as a few others. You would see everyone out and about trying to get the white labels first. We would take our own white labels up and do a bit of swapping and trading. Ray Keith and Nicky Blackmarket were like the A&R men of drum n bass and jungle. You had to get to Blackmarket on a Saturday morning, and it was like being in a club. You could pick up records without even knowing who they were by; there were no preconceptions about certain artists. Those were really good memorable times.

We were all competitive, but it was a friendly competition. Moving Shadow had set the standard with production, especially with Foul Play. There were people like Rap and Aston, Wax Doctor, Dillinja, 4 Hero, Zinc and Adam F. Then there was Gwange who was on Legend Records; I used to love what he did, he was a bad boy!

I was putting out a lot of music on V Recordings and Full Cycle but being a part of a major label was really different. Gilles Peterson and Paul Martin from Talkin Loud had picked up on the jazzier side of what I was doing. They found it more palatable [than some other styles of drum & bass] and it was something they could latch on to, and because of that, I got a record deal. When they signed me, I vowed I wouldn't do it unless I could bring my crew with me. Krust and I got deals, and then we managed to get everyone else on retainers. I used to get asked why my name was at the top, that was because it was my deal, but

I wasn't going to do it without Krust, Die, Onallee and Si John. That they all agreed to be involved made it a beautiful thing.

With New Forms, I tried to show the whole spectrum of the music. Reasons For Sharing was like me saying, this is for everyone and this is the reason we're sharing it. You had Share The Fall on there and Sounds Fresh, which Kenny Dope still plays to this day, Down and Trust Me. It came in a plastic sleeve and cost a fortune to put out. I had gone in saying: I want to do this, I want to do that!. Trust Me was made up from samples but I can't remember where I took them from. Record companies would just give us loads of vinyl, so we would go home and sample the fuck out of them. The drums and the drop were all me though. I included it as a DJ tool on the EP.

Playing it live was great. We would play Trust Me, and you could tell there were people that didn't know it was a Roni Size tune! There were people who loved what I did for the Kool FM crowd and people who loved what I did with Reprazent, so there were two sides of Roni. Some artists don't have to worry about trying to please both sides of the coin, whereas I had to juggle it a bit, but it's something that I managed to do. People used to hate me [for the Reprazent material] but then find out I did Trust Me and tracks like Warning and the Dope Dragon stuff and they hadn't known that was me. We used aliases because we had too much music to put out and because it was fun.

Trust Me came back into the world around 2010 when Andy C started playing it. He can find an old gem and revitalise it, and then everyone starts playing it. I started playing it again because Andy was playing it! Shy FX dropped it at the Red Bull Soundclash in 2014; it bust up the dance, and he won the clash.

It was made in about an hour, what tune starts like that though? A couple of stabs and then it drops. On the original version, the sample is slightly out of time, but it still works though. It was like that in the old school days; you had to get the tune done before the electric meter ran out! The number of tunes we lost because we didn't have

money for the meter. Back then it could take 30 minutes to save a tune on a floppy disk, so we would leave it, go out and hope that it would still be there when we got back and that the electric hadn't run out. We benefited from not being able to tweak things. You would have just one version on DAT, unlike now where you can have different versions saved. Using the old mixing desks, as soon as you moved something, it was lost, unlike now where you can hit recall.

"Playing it live was great. We would play Trust Me, and you could tell there were people that didn't know it was a Roni Size tune!"

Most of our tracks would be on dubplate for quite a long time. That was something that only a privileged amount of people got, and no matter what you did, you were not going to get it! We had so much music coming out that we had to try and schedule it all in. Bryan Gee had enough already, he had more than he needed! Not just from me but from Krust and Die, and people like Adam F, Dillinja and Optical. Some of it still hasn't come out. We had a residency at The End, and if you were going to test any tunes out, you would do it down there. The system in there... oh my god. If you had fillings and they weren't put in properly, you'd be looking on the floor for them. The End was a great club with a great vibe, and that was the testing ground. You could really test it there and get a real response. The End and Movement at Bar Rumba were the spots.

It was at a time when I was just rolling out tunes. I would never really rate any of my tracks though. Some of them would get put on DAT, and I would just give them to Bryan Gee or Frost or someone, and they'd play it and get a crowd response. It's Jazzy was in the bin; it wasn't going to be released, but Bryan Gee picked it out. What happened was that Alex Reece had made Pulp Fiction and everyone was going crazy over it; it was great but simple, and that was what Alex Reece did, so I thought I'd do my own version. I was all about the drums, the bass and the energy so I found these wicked pianos and got that bassline, rinsed out that bass and put some breaks in there and rolled it out and thought: that's how it should've sounded, to my ears.

Bryan Gee: Trust Me was the one that got away as far as I am concerned; I wanted that tune so much, it was V all over! Roni was doing his first album for Talkin Loud, and he had to give them his best tunes for a project like that. I'm glad he did, but It was bittersweet for me; Roni was our biggest artist, and I was happy that he got his major-label deal, but at the same time I knew it would prevent us getting music from him. I had to look at the bigger picture as I knew Talkin Loud would put money behind him and push the music to a place that V couldn't, so if they could open those doors, then we could follow them.

He won the Mercury Prize with that album and reached people all over the world. Brown Paper Bag and Western were great but Trust Me was for the junglists. It's a fun, feel-good track and everyone was into it straight away. It's so simple, and as soon as people hear that bass, they go crazy; it's the kind of bass I associate with a tune like Circles because it just sticks in your head. DJs like Andy C, Friction and Marky still use it in their mixes now. It's probably one of Roni's biggest dancefloor tracks, and it's a classic.

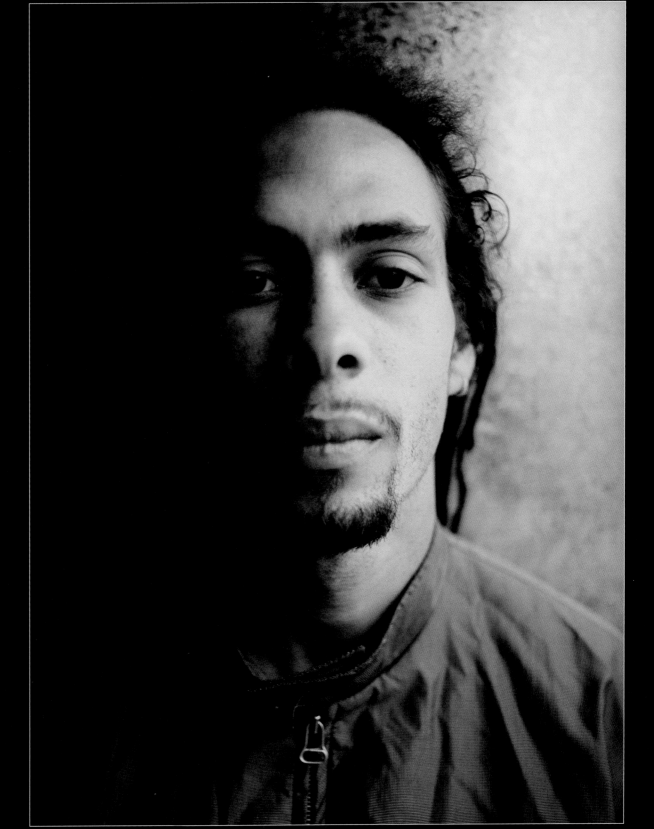

Roni Size, Bristol (1997)

MICKY FINN & APHRODITE
BAD ASS (URBAN TAKEOVER, 1996)

Having dropped one of the biggest rave anthems of the early 90s with Some Justice, Aphrodite had cemented his status with a string of consistently quality releases on his own Aphrodite Recordings, as well as the massive Calling All The People as A-Zone on White House Records. Towards the end of 1996, a new track with long term collaborator Micky Finn began circulating on dubplate. Bad Ass quickly gained anthem status by the time it hit shops as the first release on the duo's new Urban Takeover label and proved to be a perfect opening track for DJs, with the sampled film dialogue acting as a call to arms for ravers to "control the night"...

Aphrodite: I was a huge fan of electro in the 80s. I still collect the 12"s from the Streetsounds Electro series now. I was using electro samples and suitable hip-hop ones that I liked. The tempos worked well, but there weren't that many producers doing it.

Around '92–'94 there was a kind of north-south split, where we all loved our breakbeat down in London, and they all loved their trance and progressive house up north. 1993 was a bit of a transitional time. There was also this weird thing where the DJs that had been playing the same stuff in '91–'92 had separated and there was this divide between happy hardcore and jungle. You would see it at places like World Dance, where you would have a happy hardcore DJ and then a jungle DJ. The tracks LTJ Bukem was doing and those types of records came along and changed everything for me. I was totally skint and made Calling All The People [as A-Zone], and that got me £500 to survive. That tune went off, and from there I made more and more, all with a bit of a reggae influence. Things like We Enter, Big Booyaa and Mash Up Ya Know, and my Aphrodite Recordings label kicked off. Around '95–'96 I changed my style a bit, and my beats became more based around the kick and the snare, rather than having a crazy breakbeat going on. I made a track called Tower Bass which had that hip hop style intro, and everyone loved that.

People were learning who I was, so my DJ bookings were picking up at the time. I didn't have a copy of Quest by Andy C and Shimon to play so I went in the studio and made my own version. The bass on Quest was subtle, but you could hear it well on a big system, my take on it just had a more in-your-face bass sound, and that was the first mix of Bad Ass. I played the dubplate that weekend and it didn't work. I got no reaction at all so I didn't play it again. I played it to Micky and he was all over it so I gave him my dubplate. He went off and played it, and he got rewinds every time!

My dubplate version had no vocal sample, but it did still have that reggae twang noise. We went into the studio and found some vocals; I think Micky had the film that we took the speech from and turned it into a proper track. Although a lot of my tunes are easy to mix, which was something I did

consciously, when I mixed down Bad Ass I forgot to shorten or increase the chords in the intro, so if you mix it from the beginning it doesn't come in on time, you can only mix it from when the first beat comes in. Totally my fault but it was too late by the time I realised, and I couldn't change it!

Bad Ass did really well, so we used it as the springboard to start a new label which was Urban Takeover. We were in touch with Mulder from Bristol who had some really good stuff and we had other demo tapes coming through. Natural Born Chillers were in a studio half a mile from our office, and Rock The Funky Beats [the second release on Urban Takeover] ended up being signed by East West, who had previously commissioned us for the Yazz remix [Abandon Me] which remains my favourite remix that I've done. Around the same time, I put out some other bits on my own label that did pretty well like King Of The Beats and Dub Moods. The UK was a really big market for vinyl then; Dub Moods sold about 25,000 copies, and Bad Ass was about double that.

I didn't expect them to sell as much as it did, especially over such a long period of time. That's always been the case with virtually all my releases though; they have never been big sellers when they come out, but three years later people are still buying them. In some cases, I was still repressing tracks five to ten years later. I notice when I DJ that I can drop one of my own tracks that is years old and it still works, but I can't necessarily do that with some other producers.

I had records like Stalker which was used in the record shop scene in Human Traffic which exposed me to new audiences that might not usually be into drum n bass. Still, I found that UK promoters would often play safe and book the same people every year, and some wouldn't be prepared to take a chance. We're very influenced by the media in the UK and there's always a yearning to get the latest thing but in other countries, people weren't reading the British press. I was never part of that One Nation scene, but I started getting offers to play abroad and people in some countries might not know Grooverider for example, but they would've heard of Roni Size and Aphrodite.

> *"I played the dubplate that weekend and it didn't work. I got no reaction at all so I didn't play it again."*

In the early 2000s, there were a few years where I only had one or two gigs a year in the UK but I was playing at least twice a weekend somewhere around the world, like the Czech Republic or Italy. I did a track called Ganja Man that went crazy in Russia so I was over there a lot. There was a weird thing in Spain where people liked my records played at 33rpm instead of 45, which is bizarre. King Of The Beats and the Jungle Brothers remix got me into the USA and at one stage half my time was spent over there, sometimes doing two or three weekends a month. Wherever I was going, DJ Zinc seemed to be going as well. I'd be abroad and ask who else they had coming out and it would invariably be the same few people like Roni Size and Bukem.

Between 1988 and 1994, it seemed that every year had a defining sound or a new genre that would emerge. Based on that, back in the 90s, you wouldn't have thought that drum n bass would last long; jungle didn't last long and hardcore was only around for about two years, but from 1996 to now, drum n bass is still here. The levels of production have improved, but I get promos through now that pretty much sound like what we were doing in 1995. The style is still there, which is amazing.

DJ FLIGHT

DJ Flight's teen years coincided with the birth of drum n bass. Here, she speaks about her early raving experiences and the events that would lead to her residencies with Metalheadz and Swerve, and an acclaimed show on BBC 1Xtra.

DJ Flight: My mum was a big reggae fan, and my dad was into soul. I was into a lot of hip hop growing up too, so I guess it was the black music influence that drew me to jungle. I was into breakbeat and hardcore from early on, and I got heavily into it at secondary school. I used to listen to Steve Jackson on Kiss FM and liked what he was playing, and my friends would bring in tapes of the pirate stations that they would get from their older brothers. As I got older, I started listening to pirate radio and going out to under 18s nights. There was one in Streatham on a Sunday called Club 2000, and I saw SL2 there when I was about 14. One week Praga Khan was supposed to do a live PA, but they missed their flight and got Aphex Twin to fill in; I've never seen a dance floor clear so quickly! It was absolutely packed, but it was so banging and hard that the dance floor just parted!

The first big rave I went to was the last Elevation at Crystal Palace when I was 16, and then I was going to things like Orange, Desire and Innovation. I liked the big raves but found myself enjoying the smaller events more. Moondance organised a London club tour where they did events at places like Camden Palace and SW1, and that was the first time I saw Kemistry and Storm DJing. They came on after DJ Rap, but I didn't know who they were; I'd seen their names on flyers but didn't know what they looked like, they played their set and blew my mind as it was so different from everybody else. I thought bloody hell, these women are amazing, the fact they were women was inspiring to me. If you see someone that looks like you doing something you believe that maybe you could do it too. While I was watching them one of the guys I was with said

to me "that'll be you in a few years". It hadn't even entered my mind before that to learn how to mix, even though I'd been around guys that were doing it. That was in '95, and I started buying records the year after. I knew tunes off tapes and pirate radio, but I didn't always know what they were called. The first records I bought were Jonny L's Tychonic Cycle and Doc Scott's remix of Miracle by Olive, from Wax City in Croydon.

> *"Blue Note felt special at the time; it was so small it felt like you were in on a secret."*

One of the big records for me was Optical's Shape The Future with Raging Calm on the other side. It sounded so alien and different to everything else that was around at the time. Kemi used to play Raging Calm a lot. To me, it's the perfect mix of rough and smooth, light and dark, anger and joy. Other huge tunes from that time for me would be Metropolis by Adam F, Unofficial Ghost by Doc Scott, Photek's Rings Around Saturn. Future Unknown by DJ Krust on Talkin Loud too. I bloody love that tune! The Bristol guys were killing it with their releases on V, Full Cycle and Chronic.

From seeing Kemistry and Storm at Innovation, I followed them to Metalheadz at the Blue Note. I later found out from Jayne [Storm] that they used to call me their number one fan! Blue Note felt special at the time; it was so small it felt like you were in on a secret and something a little bit exclusive, but without being elitist. It got to a point there would be a massive queue going down one side of Hoxton Square, and it was hard to get in. Luckily by that point, we'd been going long enough to know the people on the door and they would let us in. It was exciting, and it

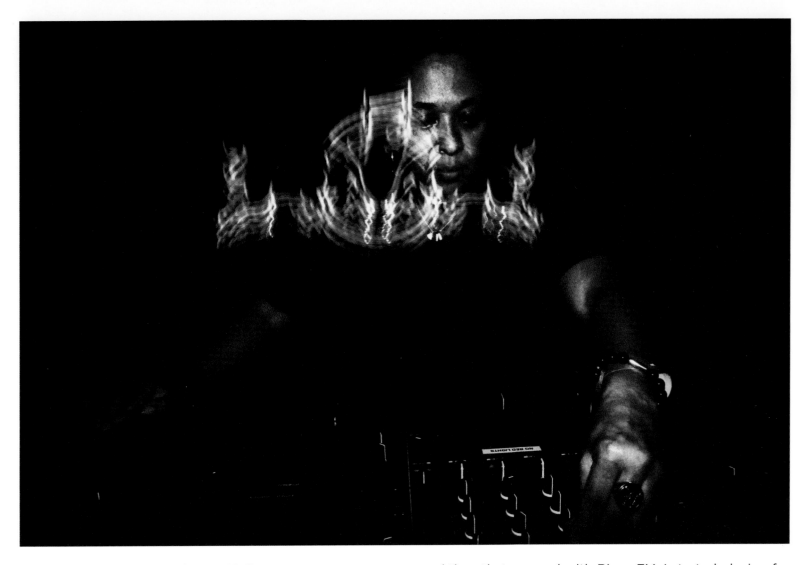

DJ Flight at Egg London (February 2019)

would be packed every week. You were guaranteed to hear excellent music that was fresh and new, and there was a wicked Eskimo Noise sound system. The vibe was kind of electric in there.

When I started mixing, I used to give Kemistry & Storm my mixtapes for their feedback, and they were really supportive and mentored me. Kemi told me she liked the way I put tunes together so I thought that with their seal of approval I must be doing something right. After Kemi passed, Jayne gave me her decks, and that was the first set I owned. I started doing pirate radio, and Flex FM was the first station I played on, then Pressure FM with Stamina and then that merged with Rinse FM. I started playing for Metalheadz in '99 and then Swerve from 2000 onwards. I'd tailor my sets to the different nights, and I'd always play a mix of stuff. I liked the smoother stuff like Hidden Agenda; they're one of my all-time favourite producers. I met Calibre quite early on, and he'd let me cut tunes. I loved J Majik's Repertoire and that kind of sound and things on Good Looking and their sub-labels. Personally, I don't like a lot of the more mainstream stuff, but it's understandable that it's been so successful because there have always been huge dance tracks getting in the charts. The backlash to it was a bit silly as it's always been there. It's been interesting to see the different styles pop up over the years and to see how the music has grown.

NASTY HABITS
SHADOW BOXING (31 RECORDS, 1996)

Doc Scott is one of the d&b originators, with a résumé that predates jungle and takes in the legendary Eclipse club in Coventry and residencies at Speed and Metalheadz. His releases on Reinforced and Absolute 2 were some of the key 12"s of the era and remain in demand to this day. Having initially launched his revered 31 Records imprint in 1994 with a track under the name Octave One, the follow-up wouldn't appear until 1996 when Scott resurrected his Nasty Habits alias and unleashed the legendary Shadow Boxing...

Doc Scott: Shadow Boxing was a kind of a rough idea, and it wasn't really meant to come out. I always made these kinds of experimental, loop type things, just for dubplates really. Over the years I have found that sometimes your biggest or most popular tunes are the ones you think the least of, or at least felt that way when you made it, and that's the case with this track.

Me and Goldie had these conversations about what we called ghost loops, where you would be humming a tune or a riff of something that you'd heard that night, or maybe even something you hadn't actually heard; it might've been two tunes were in the mix that made a new loop. I had been playing out one night, and I think I'd stuck around and caught Grooverider playing. I was driving home, and I was humming something. I had an idea and wanted to make a tune that people would be humming after they'd been out or when they woke up in the morning. It had to be something simple, which is why Shadow Boxing is repetitive in that way. I think I had the drums and the breaks already done as I had been playing around with them on another tune. I sampled a Reese bassline from a DJ Trace tune and messed around with it for a couple of hours and made it as big and long and huge as I could, with shit loads of reverb,

and I played three or four notes for the riff. All the mixes you hear on the track are live. I had a loop going and the fade in and the sweeps is me just muting things on the desk. I did two takes and thought the second one sounded alright and was what I was trying to achieve.

It was very inspired by techno as I'm a big fan, and Kevin Saunderson and Richie Hawtin would make tunes very similar in their approach with one riff that would drift in and out of the track. Shadow Boxing is basically a techno tune at 170bpm in my mind. It's influenced by those minimal tracks in the way it changes but it's essentially a loop, so the trick is to try and make it interesting enough for seven or eight minutes, so it doesn't get boring. There were a few things I did around that time that never saw the light of day but sometimes you just throw something in, and it all comes together and just sounds right. I think the Wu Tang kung fu samples in there grabbed people's attention and it caught on.

I gave it to Grooverider on dubplate, and then I went to Japan for a couple of weeks. This would be late '95 or

early '96. When you went to Japan back then, you were off the grid. Their mobile phone network was different to ours, so your phone wouldn't work and calling home from the hotel was super expensive, so I would get there, call my wife to let her know I'd arrived and that would be it for the duration of the stay.

I remember getting back after ten days or so and turning on my phone when I got to Heathrow, and it was full of messages. Groove had been playing it and freaking everybody out. That really caught me off guard. When you write a tune, you're on the other side, so you don't get to experience what others feel when they hear it for the first time; sometimes I envy that. Some people have got a lot out of Shadow Boxing; I have had people tell me it was the tune that got them into d&b. To me, it was just a loop that I threw together and did not think that much of to be honest, so it is beyond humbling. If you write a song and anyone gets anything out of it, that is an amazing thing. The fact that so many people apparently got so much out of this means more than anything really. Maybe it sent them in a certain direction musically, or it just cemented their love for drum n bass.

Around that time, I was surrounded by assassins. Guys like Goldie, Source Direct, Peshay, Lemon D, Wax Doctor and Alex Reece. I was always jealous of people like Photek and Dillinja; they were like ninjas to me, and I was this dude that was struggling to keep up. I thought that if I could try and keep pace with them, then I would be alright. I wanted to make a tune that was so simple to show that you didn't need to be a whizz kid in the studio. I sometimes found being in the studio a slog, but some producers can do thirty hours straight and churn out five tunes. I used to hang around with Total Science, and they would blow me away with their work ethic and how quickly they could turn stuff around. That said, the amount of time it takes to make a tune is immaterial really, whether it's six hours or six months it just comes down to whether you like it and is it any good, and that's all subjective anyway.

Whereas the original version of Shadow Boxing was one that crept up on you, the remix I released in 1997 was designed to be the complete opposite, and more in-your-face. I made a couple of versions and played them at Metalheadz when it was at Leisure Lounge, which was this huge venue with an enormous sound system. That was a big factor in how I approached making that remix. It sounded good on dubplate and worked well, but I think everything did in there because the sound system was so big and aggressive. I remember being in Dillinja's studio once and looking at his DAT machine and the LEDs weren't moving, and there was definitely a bit of his influence in that remix, with me trying to run everything into the red; I brick-walled it.

I never professed to be the greatest or the most technical producer at the time. I was a believer in less-is-more,

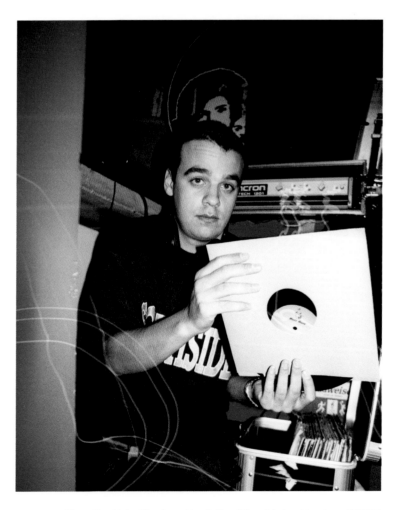

Doc Scott in the booth at the Blue Note, Hoxton (1995)

but as I didn't see myself as being technically gifted in the studio, if I could get away with doing less and use my musical knowledge rather than my technical abilities in the studio, then that would be an easier deal for me. I would make tracks with a certain night, venue or DJ in mind. I think with Shadow Boxing, Grooverider was in the back of my mind because he was the only person I gave it to initially, as I figured it would be up his street. My benchmark to gauge a tune was to give it to those kinds of people. Give it to Groove, Fabio, Bryan Gee and Goldie, and if they gave me the thumbs up then I knew the tune was alright. For me, personally, that was all I needed. If it got to a point where it was viable to press it on vinyl and people bought it that was a bonus as far as I was concerned.

I only ever wanted to be a DJ, but I kind of stumbled into making music for a period in the 90s and made a few tunes and some of them were well received. I got to the end of the decade and thought: what just happened then?! It's all a blur looking back on it. We went from raving – pretty big raves too – which was very much a UK thing, to sometimes going over to Europe, and then by the end of the decade it was worldwide and it was everywhere. That explosion from '95 to '99 was insane; it was all 100 miles an hour, and it was a fun time. By the early 2000s, I found it difficult to write music, but it was easy for me to walk away from because I didn't

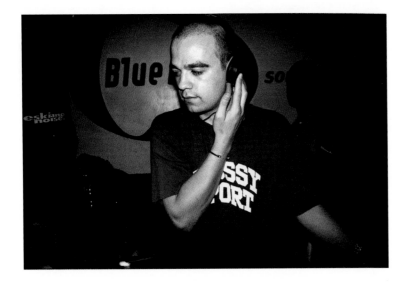

consider myself to be a full-time producer. If I couldn't write something I was happy with it was easy for me to walk away from it and just concentrate on DJing and running the label.

"Shadow Boxing is basically a techno tune at 170bpm in my mind."

I had the idea of starting up 31 Records to put out a couple of things myself, but I mainly wanted to concentrate on putting out other people's tracks as that was more interesting to me. I was fortunate that I was friends with people like Total Science, Ed Rush, Optical, Dom & Roland and Digital, and I thought they were making amazing music. I think I was a bit lucky, to be honest, but I will say that I think I know what a good tune is; I love A&R work and DJing and picking out what I think is good. Right place, right time comes into it too, and I think if Shadow Boxing had come out two years earlier or two years later it might've been a different story. You need that element of luck with the right tune. For example, when Marcus Intalex released How You Make Me Feel, it was huge because everything at that time was hard and aggressive and he came along with a tune that was soulful and had vocals.

In those days you could have an air of mystery about things. DJs would be playing a track on dubplate, but people didn't know what it was. That was the beauty of dubplate culture in that period where you could really build things up. Give it to a few select DJs that you knew were playing at all the places you wanted it to be heard, and you could keep it secret or anonymous for a few weeks or months if you wanted to. The internet was in its infancy, and everything was word-of-mouth so you could grow things through the network. I kind of miss those days. There are pros and cons to everyone knowing everything now; It's cool that you can go online and find out pretty much anything, but I think sometimes part of the fun of music is not knowing. I used to stay up late listening to John Peel

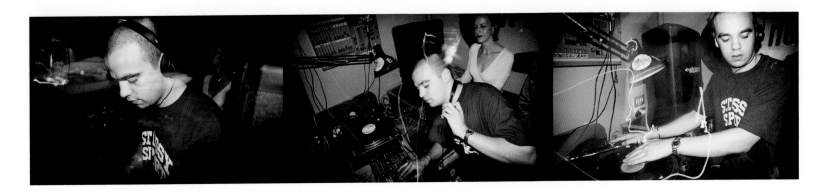

and other people on the radio and then spending Saturday afternoon in a record shop in Birmingham spending whatever money I had on records. Things change for better or worse, but a bit of mystery can be good.

I think what makes drum n bass so special is that it runs itself. We have had these spikes in popularity over the years. There was the mid-90s period when Roni won the Mercury award, and Goldie did Timeless and everyone was trying to sign everybody. When the major labels moved on to what they saw as the next trendy fad, we just kept putting on our own events for our crowd, and we took it around the world. In '96–'97 I was going to Japan, Australia, New Zealand and I went to America for the first time. The music went global and became much bigger than just a London thing or a UK thing, and then it belonged to everybody. I thought that was a beautiful time as you had the influence of producers from Europe and other countries and it expanded in different directions. In some ways, you could say it kind of diluted the scene because we ended up with multiple sub-genres, but I think it needed to do that to find itself. I would say in the last decade I don't think it's ever been better or stronger than it is now, particularly in the last five years. It's so strong and so well supported around the world and it's self-sufficient.

This music has an amazing ability to appeal to young people which is fantastic, so the next generation keeps coming through, and I'm amazed by some of the things I hear today because it's difficult to make something original. Drum n bass is nearly 30 years old but when people can still reinvent what's been done or be inspired by an old DJ Die tune or something and put a fresh twist on it with modern production techniques, then that's amazing. The younger artists are also aware of the people that helped build this thing in the first place and respect that, which is a beautiful thing. There is a lot more unity in d&b now, whereas in the past that wasn't always the case. As we get older, we get a bit mellower, and we had a couple of people in the scene pass away over the last few years, and that puts things into perspective. I have seen the scene come together like never before during the last five years. I know this scene can support itself without major labels or the media pushing it. It was born in the UK and given to the world, and now it runs itself and looks after itself and regulates itself. Every now and again there is a kink in the armour, and it sorts itself out.

I get why people have a favourite era, but I don't think you should pit them against each other and compare the 90s to the present day. Back then, none of the things that people like Roni, Krust, Dillinja and Goldie were doing had ever been done before. Even now I can dig out an old Dillinja tune that might be 25 years old and still sounds incredible because it represents a moment in time that can't ever be reproduced. Hearing the music in the environment it was designed to be played in and also having that collective experience when you hear a brand new tune, or a remix or a VIP or whatever and you hear it with 100 or 300 other people and you all react at the same time. Those moments are what it is all about for me.

MAMPI SWIFT

THE ONE (CHARGE, 1997)

With a catalogue of 12"s to his name for the likes of Sub-urban Base, Frontline and Trouble On Vinyl, Mampi Swift launched Charge Recordings in 1997 as a platform for his brand of tough, stripped-back drum n bass. Simple and effective seemed to be the key and the third release was just that. With its distinctive build-up and drop into a heavy bassline, The One proved to be a massive track that cemented Swift's status in the game...

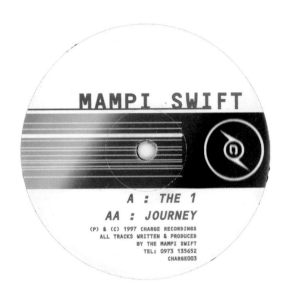

Mampi Swift: I was playing on Kool FM from about 1993 onwards. Kool is responsible for quite a lot of things in this scene, with Jungle Fever and all the rest of it. I was also working in Lucky Spin around the same time, which I thought was a great way to be around the music I was interested in. I was still a youngster, and it played a very prominent part in my life when I was growing up. I worked at Unity later on, but Lucky Spin was more significant in terms of my career. I met a lot of people there, a lot of the big DJs, and the Lucky Spin shop was next door to Monroe Studios, which is where Pete Parsons worked. He was working with DJ Trace, DJ Crystl and basically anything that came out on Lucky Spin or Deejay Recordings. Pete was the first engineer I ever had, and the person who taught me how to use the equipment. This was around '94–'95. I didn't have a clue how to make music, I just knew how I wanted it to sound. I learnt how to programme music and everything else from him.

I was chipping away, not really knowing what I was doing. I had a dream of what I wanted to do, but I didn't have a vision for my career, I was just doing my thing, being in the right place at the right time. By '95 I was doing stuff for Suburban Base and starting to develop my sound and learn a bit more.

Growing up, I had never had music lessons. It's only now I'm older that I understand that this is what I was meant to do. It's a bit of a shame I didn't start earlier, but as far as I'm concerned there's no such thing as coincidence, and everything happens for a reason. I honestly couldn't tell you why or what made me start making my music, I just subconsciously knew it was something that had to be done. I was in Music House one day, and I was sitting next to Rebel MC. He'd been watching my thought process as I was absorbing the music we were listening to, and he asked me if I made music. I said no, not yet. He said: "you need to man, you've got something in you". No word of a lie, that sparked something in me. I can only liken it to that scene in Back To The Future when Marty McFly tells the Black guy he's gonna be mayor!

I didn't really have a particular favourite event or venue when I was DJing; I just needed a crowd. As long as there were people there, I'd make them dance. Atomics in Maidstone around '96–'97 was where I made a name for myself

and got taken seriously as a DJ. That was the spot for me in that period. I remember around '94 I got a call to DJ for Telepathy at the Wax Club in Stratford. That was like the equivalent of The Apollo in Harlem, where the audience is just ruthless. That's where Andy C started making his name. Him and Shabba would be the only white guys in there so you could say it was even tougher for them. They might not have been comfortable, but they would kill it. I wasn't prepared for it in the slightest. I knew I was a good DJ at the time, but I went to The Wax Club and bombed. There were DJs in there laughing at me. I was looking to my side, and they were crying with laughter. It was a very painful experience, but the next time I went to that club, it got so destroyed. I had to show some strength!

> ## "It was the track that meant people took me seriously as a producer and an artist."

My strongest influence was pretty much anything that came out on Reinforced Records between 1991 and 1994, which was just incredible. That label shaped the whole sound of what was getting played in a lot of the raves at the time. A lot of my music is quite dark, and I guess that partly comes from inside but that stuff on Reinforced from that era was also very dark. Some people misconstrue dark as just noisy, but dark is a mood. My other big influence was Pascal. A lot of people might not realise that Pascal is one of the greatest drum n bass producers there's been. If you were to calculate how many big tunes and anthems he wrote, you would be hard pushed to find many people on that level, and it's quite insane what he did as a producer. I was fortunate enough to become friends with him, and he kind of took me under his wing and showed me some stuff. He let me use his studio in his house where I wrote some of my biggest tracks. I've been very much solo in my career from day one, but I've had support from some people and

when I was starting my label the person that helped me the most was Pascal.

Before I set up a label I had been looking around and thinking, Hype's got Ganja and Playaz, and Andy C has Ram, and Grooverider had Prototype, so I thought I need to have something that I can call my home. I didn't quite know what I was doing but that was why I started Charge in 1996.

Now, DJ Zinc used to make tunes with another guy called Swift, and around this time he'd started to die out, but there'd been a bit of competition, and he was calling me out on pirate radio for a battle! I wasn't interested in doing that, and then it seemed like he'd disappeared a bit. Then there was a load of us in Music House, and Super Sharp Shooter came on, and everyone was blown away and asking who made the tune, and the answer at the time was Swift & Zinc. Mark XTC from Manchester turned around to me and said: "Bloody hell Swift mate, you need to step your game up son, this geezer has just blown up!". You have to understand I was a kid at the time, I was 19-years-old, and I'm thinking that this could destroy me. The next track I made after that was The One. The only person I was ever in competition with is myself, but that whole situation gave me the extra drive to succeed and get my shit together. And then it turned out Super Sharp Shooter wasn't Swift's track at all it was just Zinc on his own!

I made The One in an hour at SOUR Records' studio. It was made purely for dubplate; it wasn't to be released. I had been working in the studio all night long since 8pm, and I had to be out of there by 9am. It got to about 7:45am and I had made a few crap tracks, so I decided to knock up something really simple just to use for a dubplate. I had a load of drums and samples loaded up from the other tracks I'd been working on, it got to 8am, and I thought I should just load them up and get out of there. I put it together and programmed everything. Ed Solo was engineering for me that night, and he woke up at about 8:45am and said it sounded wicked. He went in and turned a few knobs on the compressor to really bring the bass out, and I was out of the studio by 8:55am.

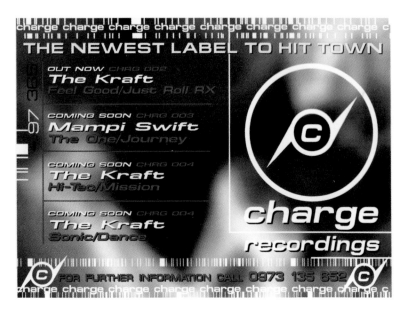

Unless you had your own studio at home, going back to add things or re-doing a track wasn't really an option. You had to finish it in that session because in those days it's not like you could just load up your computer. A week would go by, the mixing desk would've been used another 200 times. The SSL desk I made that track on was the best I've ever used. It just gave it that extra beef and extra fatness which is why The One can still stand alongside other tracks even 21 years later. It was the track that meant people took me seriously as a producer and an artist, but I didn't realise they'd also look at the label seriously, because I was so focused on the music. The pressure came about five or six releases later, I remember Roni Size telling me I was a couple of tracks away from becoming one of the big boys!

Back then, I never really thought about it on a business level, and that's probably the biggest flaw in my career. I could've developed a fantastic business from back then if I had the knowledge, but as I said, everything I do is real and organic, and I was wrapped up in this passion for making music and trying to succeed in that way. I think I can be forgiven for not having that thought process because I

was just a kid really and I got so caught up with DJing and production. RCA tried to sign The One, but I was adamant I needed it for my label, and I stood firm. They wanted me to do an eight-track EP, and I did sign a deal with them, which I'm not sure if I should mention because nothing came of it, but I got paid!

The rave scene hadn't been around long at that time. The summer of love was '88, and people only really got going from about 1992. A lot of people in the scene came from different backgrounds, especially compared to drum n bass nowadays. Some people back then really had no choice and music saved them from being in prison, or having really bad lives and ending up god knows where. We didn't have the knowledge of the industry that we would have 15 years later. A lot of people didn't know how to run a business or know how to pay their artists properly. I'm not one of those guys; I used to actually overpay! I would have artists that had bad experiences and used to go out of my way to assure them, which is a dickhead thing to do. I could not tell you how many copies it sold. Knowing how big that track was and the numbers people were selling back then and the numbers the distributor told me, I feel I was ripped off. It was the third release on Charge, and it sold more than the first two 12"s combined though.

At the time, I didn't know it would be a big tune; no idea at all. I'll never forget how it got named. I went and got the dubplate cut at Music House and Leon, who worked there, heard it and said: "Hey, that's the one you know!". The first time I played it was at One Nation at The Island in Ilford, and it got an instant reload. I gave it out to a few other DJs that day, and I'm proud to say it became an anthem. It was played on Kiss FM during the day which was crazy. I had only been producing for a couple of years at the time, and I had made one of the biggest d&b tracks ever. I can sit here now a bit older and wiser and say that's a pretty bloody remarkable achievement, to do it from scratch by myself in an hour.

DJ KRUST
WARHEAD (V RECORDINGS, 1997)

Drum n bass had always been a genre that didn't sit still for too long, and the producers at the core of the scene were keen to push things forward rather than continue to play safe and milk the same successful formula. One collective that personified this ideology were Bristol's Full Cycle crew, who had perfected their jazz-influenced sound to huge critical acclaim with Roni Size Reprazent's New Forms album. Rather than bask in the glory of awards and glowing reviews in the broadsheets, DJ Krust continued to look ahead and maintain his prolific output from Studio Drum. One of those creations ended up causing mayhem on dancefloors for months to come. With its distinctive intro and infectious anti-hook, Warhead was one of those tracks that found favour with DJs across the board and once the vinyl hit the shelves in that iconic V Recordings sleeve it was a wrap. Krust breaks down the making of a classic...

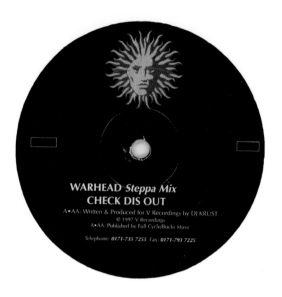

DJ Krust: I remember exactly how I made Warhead. I went to the studio one day, and I heard Roni and Die making this tune called Mad Professor; it was a monster of a tune, and I liked its energy. I had this idea for a tune that I wanted to make. The bassline was in my head – the boom-boom boom-boom boom-boom, and I thought that it would make a good jungle tune. I sat in the studio for two days and went through all my beats and bass sounds. It was started and finished within 48 hours. The infamous intro sound is me touching the audio lead against the socket and getting feedback. I was just changing the leads in the back of something, and when I pressed it, I got that hum and it sounded ridiculous. I recorded it into the sampler and played it back in. I heard rumours about how people were trying all sorts of synths and things trying to figure out how I did it.

What I do when I make music is take a look at what's going on around me at the time and see what's missing, and think about what I need to make my track stand out from everything else. I'd noticed that most tunes had the format of an intro, the drop, then the drums and bass come back in, then it goes along and then drops again; that was a pretty formulaic way of making music. Although I'd never really followed that formula, I thought I could change that style of doing things and take it to another level. It was a case of sitting down and meticulously working all the way through a track almost bar by bar to the end and making it move with the build-up and keeping it interesting enough so that you'd want to listen to the whole eight minutes and not get bored, of essentially what is a monotonous bassline.

The thing most people love about the tune is that there are no breaks in it; once it starts, it plays all the way through, that was the key to the track. The first two minutes of the track is the intro which is the part that's instantly recognisable whenever you play it. I made the intro the hook, made

the riser sound the hook and then made the bassline the hook. There were three factors in creating Warhead. One, I wanted to make a better tune than Roni and Die. Two, I was inspired to make a tune that pushed me as an artist and pushed the scene as a piece of art. Three, to make the ultimate b-boy statement. Just this monotonous sound of drums and bass, with a really authentic attitude, which to me is grounded in being a b-boy.

I liked it, Roni, Die and Suv all liked it, and that was it for a while. It was hard going as it was one of the toughest tunes to break. It took nearly a year before it really took off and I don't think it could happen now, but back then there was the dubplate culture, and we used to have tunes on plate for years. There was a long incubation period, and you wouldn't put a tune out until you knew it was going to have the desired effect. If it didn't have that effect, you'd take it back to the drawing board and make some changes. This is counter-intuitive – and this doesn't apply to all tunes – but if you play something that you know is good and it clears the dancefloor, then that's a good sign. It tells you that the people can't hear what's coming in next and they just stop as it's not the formula they're used to. An experienced DJ will tell you that if people stop dancing it doesn't necessarily mean the tune is crap. Certain tunes like Warhead were just ahead of what was going to happen so as DJs we'd play three or four tunes the crowd knows, and then one that's brand new, so for the first two minutes they'd still be dancing to the last one, and they recognise that it's not the same thing they've heard before. Some people will carry on, but some stop, and then you see this thought process going on while they try to understand the new rhythm.

It's been proven that it can take eight or nine months for people to understand a new concept. If you look into marketing, they have this system where you need to have something presented to you 21 times before you'll buy it, and on the internet, you need to interact with your audience seven times before they trust you. There's a science behind it. When people are unsure, they take a step back, and music is no different. Sometimes it took a year for people

DJ Krust at the Blue Note, Hoxton (1996)

to catch on. With Warhead it slowly built up, and when it got to the apex, I'd never seen anything like it. You'd just play the intro, and the place would go mad. Sometimes you couldn't even get past playing the intro two or three times; you just had to ignore the crowd. I've had four or five reloads on that tune in one night, it's ridiculous.

Andy C and Shimon were hot in the studio at that time, so they were an obvious pick for the remix. I'm not really keen on my stuff being remixed, but I liked their Ram Trilogy mix. I thought it was well done, I really respected what they did and I played it myself. They took the elements of the track and did their thing with it. When it works well, everyone's happy, but it's a fine balance to get something that the label, artist and crowd all like.

I think Warhead was always going to be a V tune as it didn't sound like a Full Cycle tune. At that time I was going through my cinematic phase, what Frost called "the widescreen experience". I'd done the Genetic Manipulation EP, True Stories and Soul In Motion as well as the I Kamanchi stuff with Die but Warhead didn't fit into that at the time. On V Recordings I'd done things like Guess and Not Necessarily A Man, so Warhead fitted in with that sound. It was definitely a slow burner. One thing about Bryan and Frost is that

they do their homework. They're meticulous, and they really schooled us in how to mature a track. We learned so much from them. When they signed us, they were already veteran DJs and known throughout London for DJing that kind of alternative music, so when jungle came out, it was obvious they would be at the forefront. They knew a lot about labels and a lot about DJing and mixing. They taught us a lot about the business before we were allowed to be let loose!

The studio was our 9–5, and then come the weekend I'd jump on the decks for an hour or two and practice with whatever the new tunes were. Most of the time was split between studio, driving around the motorway playing gigs, cutting dubplates, doing remixes and between all of that I'd try and find time to sleep. It was a constant process as we were always working on four or five tunes at the same time. There'd always be loads of ideas about tunes and beats. We were fanatical record collectors and had these big collections. We were constantly touring so we'd be in different countries collecting records, or old drum machines and keyboards. We were always looking for inspiration; something different and something new to inspire the process. It was just juggling – always looking for something to give you the edge and make what you do stand out. We were competitive amongst each other, not just other labels and artists – we were trying to outdo each other. Always trying to find the ultimate break or bassline. It was a good period. It was healthy, and it was new so there weren't so many rules like there are now about production techniques or sounds you could use. It was all jungle; there was no liquid or neuro funk – it was all jungle. If it had strings, in the beginning, it didn't matter; if it was Music Box it didn't matter, if it was Terminator by Goldie it didn't matter – it was all jungle. The only rules were: be original, be authentic and make sure you tear the next DJs head off. It was simple!

Full Cycle had a residency at The End. It was the Bristol sound taking over in the heart of London, and we'd do really interesting and eclectic nights in there. It was a place where people knew they could hear at least two or three hours of brand new music, and we'd work hard to build new sets for that club. It was around the time of the Talkin Loud thing so we could experiment with some of the New Forms material before it came out. It definitely influenced the way we made music for a few years. People would come from different countries to check out that club. I remember seeing some big-name celebrities in there staring at the decks trying to figure out what we were doing. That was a real good time for us, and we got exported around the planet.

"You'd just play the intro, and the place would go mad."

The sound system in The End was ridiculous, so vinyl and dubplates sounded amazing in that club. At that time, there weren't many sound systems that were built for our type of music. Ministry had an amazing system and Womb in Tokyo was incredible, but there weren't many systems in America that could handle jungle frequencies; Twilo was alright, we did a couple of V nights there, but it wasn't really set up for the type of DJing we did. Germany had some great sound systems, especially in Mannheim, which was a stronghold for jungle and they quickly figured out how to get the best out of their sound systems and had some amazing parties. For me, The End was the best in the world for years.

We had made a lot of music for the dancefloor whilst pushing the sound forward so when we got the chance to sign to a major label, we wanted to introduce our music to a wider audience and also show our skill set as producers. We kept the music at 175 bpm but used a lot more live instruments and musicians to add a different dimension. There was no point doing what we did on V or Full Cycle on a major label. Every label we released music on – Dope Dragon, V, Full Cycle – there was a different sound, so we wanted to have a sound for Talkin Loud. We were aiming to make the music sound like hip hop but still be jungle at its core. Once you get into the creative flow, you don't think

about it as much. I don't really make tracks with a specific label in mind, it just needs to sound a certain way, so I'm just making the best piece of music I can. It just comes out however it comes out.

We'd have tunes that didn't fit the album that might be more suitable for Full Cycle or for V Recordings. We used that Talkin Loud platform to experiment and understand the parameters of where it could go and what it could do. We got to go to America and work with Redman and Method Man and met people like KRS One and Zach de La Rocha. We got to sit down with these guys and listen to their ideas about music and production, and it changed what we were aiming for as musicians. You have to understand we used to sit in Roni's house eating jacket potatoes with cheese and fantasise about going to America, or even just being successful DJs. We were hip hop kids that grew up on Wildstyle, so we were b-boys to the core. When we had the opportunity to sign to Def Jam in the US and go to New York, that was more than a dream come true, and then we got to meet Run DMC, Erick Sermon, Redman and Method Man – it was too much!

A problem we did have once the Reprazent album was finished was getting into making music again for the streets. Sometimes you're caught between whatever it is you're trying to achieve and your audience. I get people asking me all the time when am I going to make another Warhead, but that came out 20 years ago. I'm pleased they like it, and it had that effect on them, but we're progressive; we're pioneers, and we're futurists. I'm not trying to make the next Warhead, but I am trying to capture that same energy and innovation because when that came out, there was nothing like it.

Bryan Gee: Krust has always had that deep experimental vibe in his music. Maintain had these crazy high frequencies and every time we'd go to cut the dubplates at Music House it used to blow the heads. I remember Chris at Music House would cuss us; he didn't want to cut Krust tunes

because the heads on the lathe would blow and they cost him a lot of money! That was Krust going further than anyone else. I never heard anyone else make music that blew the heads and you couldn't cut it. Even Soul In Motion, the sound and frequencies were crazy, but they made sense. They told a story.

When he came with Warhead, with that intro, that dirty bass just rising and the high frequencies going along with it. It would be lifting you up, building, building and then bam! Boom-boom boom-boom boom-boom Fuck me, what the fuck is this?!

At that time when we played, people knew they were gonna hear some dirty dubs. The boys were on fire back then, and they had new tunes every week. They wouldn't DJ without making a new tune. They had that friendly competition between them that kept them going, and there was the buzz and excitement going of being able to go out each weekend and drop their new tunes. Everybody knew that with the V and Full Cycle boys, you would hear new tunes. We had MCs like Dynamite and Darrison, and they were family, so they would know you and your set and get the people prepared for any tune that was coming in that the crowd needed to know anything about. Dynamite was one of the best at that – "Yes people, get ready for this one! It's gonna go off!" – he would be letting you know some shit is gonna go down. He's such a good MC for that.

People were always hyped for what we were going to be playing. There was so much we couldn't release everything, but people didn't realise that. You can play everything, but you can't press up and release everything. Some thought we did it on purpose, but it wasn't like that. I couldn't put out a Roni Size tune every week. It was all about timing and letting something breathe when you put it out before the next release came along. What you can't have you always want. People wanted it all, but it wasn't possible. I snapped up Warhead straight away though. It's Krust's biggest seller on V. It flew out of the shops, we probably sold about 10,000 copies of that.

DJ Krust, Bristol (1997)

FRICTION

Friction's relationship with drum n bass began in the 90s during the genre's formative years. Establishing himself as a DJ in his hometown of Brighton, he would go on to not only run one of the biggest labels of the noughties in Shogun Audio, but he also hosted the coveted drum n bass show on Radio 1 for six years, following in the footsteps of Fabio and Grooverider...

Friction: When I was at school, me and my mates would go into the record shops to pick up flyers and get the tape packs for raves like Dreamscape and Helter Skelter and the big jungle events like Jungle Fever. This was the mid-90s and I was 14–15 years old so I couldn't get into any raves back then. Eventually, around 1997 I managed to blag my way into Lazerdrome in Peckham which was pretty full-on and intense but one of those things you had to do to experience the music first hand. DJs would draw for the absolute freshest of the fresh dubplates in there and that's where I got to listen to people like Randall and Gachet; two of my favourite DJ's who used to absolutely smash it in that club.

I loved those early jungle records; I liked the unpredictability of the music and not knowing what was going to happen. I was into all the styles; straight up jungle with the reggae samples or the rare groove type stuff like Tom & Jerry were doing, and I liked the combinations of rare groove with a hefty ragga sample and then a dub break. When it morphed into the tech sound, I could appreciate that too. I just loved drum n bass and all the different influences. I liked rave music, techno, reggae and rare groove so for me that's why jungle and drum n bass enticed me as there are all those different elements, and you'd get the feeling of a wicked drum break and bass. It's just always had that energy for me.

The Tom & Jerry releases – which was the Reinforced guys – those tunes give me that feeling and those memories from back in the day, as well as anything on Good Looking, like Atlantis. The old Metalheadz stuff was like an NBA all-star team with people like Dillinja, Lemon D, and Alex Reece. They were untouchable in those days. Dextrous made some absolutely massive tunes; I loved his stuff. All those tracks had something about them; that feeling of the unexpected and not knowing what was going to come next. That music is timeless. You'd hear a drop and have to hear it again. That's the difference between d&b now, and jungle in the mid-90s was the unpredictability. That's not as apparent now; the production is more hi-tech and focused on the energy and the impact. You don't get rewinds as much these days with everyone slapping walls and demanding to hear the tune again and that's an emotion that I definitely miss. It's a different emotion now, but one I still enjoy.

> *"I liked the unpredictability of the music and not knowing what was going to happen."*

To get a proper taste of things you'd have to go to London but I was living in Brighton, and there was a bit of everything going on there. There was hardcore, and there was drum n bass, and a lot of the events mixed the two but Legends Of The Dark Black was probably the first d&b night, and they'd have Bukem, Randall, Fabio and Grooverider playing there. I was on the periphery of that scene, but I got a set there and then played at a night called Steppaz Convention a few times, that would've been around '97-'98. A local Brighton DJ called Quantum was behind Steppaz Convention with Rok-One and MC Matrix. Skinny was a resident there, and he was producing under the name 175 Crew. I ended up making some tracks with him

as Friction & Nu Balance; we had a release on Trouble On Vinyl and things went from there.

This led to my next phase as DJ and I remember travelling up from Brighton to go to Music House. I'd go up there just to see if I could meet any producers and see if they'd let me cut a dubplate. I'd get paid a tenner at some of these nights in Brighton, but I was still going to spend £35 on a dub. I'd be down on my gig money, but I loved the feeling of having that dubplate. One time I saw Bryan Gee and got talking to him, and he had promos of Warhead and Trouble. I ended up getting a copy of each, and I couldn't believe it. Getting those sort of tunes was like gold dust to me. I used to call up the numbers on the record labels, and that got me on so many mailing lists, I was just trying to blag as much upfront music as possible. I called up Dextrous and met up with him at Music House to cut some plates. Potential Bad Boy let me cut some plates too. I also met Zinc after I called the number on the label of one of his releases and I've been friends with him for years now. It was so organic back then. We have WhatsApp groups now, but it's not really the same as going to London for the day. That definitely changed as people used to meet up and chat and share their music. I met a lot of people doing that, but now we're all too busy to spend a day at a cutting house cutting dubs. Life moves at a different tempo these days!

Over the years you would get other genres that would pop up and be big for a couple of years and then lose their popularity, but drum n bass has always been there. We've had some big commercial moments from the start. There was a bit of a bubble when M-Beat made Incredible, but then nothing really happened on that front and it felt like the scene rebuilt its foundations a bit. From a mainstream point of view, it was sort of going away and coming back again, but it was always maintained in the underground. Back in the mid-90s Jungle was its own thing and it wouldn't be on a festival stage with loads of other genres, whereas now I could be coming on after a big house DJ or a band and it's fully integrated amongst the mainstream. I wouldn't have foreseen it being like

Friction, London (2002)

this but it's good that the music has been accepted. I do feel like the more minimal underground stuff needs to be focused on too as it doesn't always get the attention it deserves. The scene needs labels like Metalheadz and Exit pushing a more experimental sound forward, as well as the more jump up sound, or someone like Wilkinson doing a huge live tour. I think the genre is strongest when all the different sub-genres are fully represented, and all the angles are covered.

DJ DAZEE

Although much of the focus tends to be on London whenever the 90s drum n bass scene is discussed, the vibrant scene in Bristol also makes up a large part of the music's history. It is a city with a rich musical lineage that has been hugely influential over the years. The likes of the Wild Bunch/Massive Attack, Smith & Mighty and DJ Easygroove laid the groundwork for a new generation of producers and DJs. Most famously, of course, there was the Full Cycle crew but alongside Roni, Krust, Die and Suv, there were artists like Decoder, Substance, Flynn & Flora, MC Jakes, Mulder and later Distorted Minds and Clipz all representing for the city. DJ Dazee has been a part of the Bristol scene since the early days, starting as a raver before becoming a DJ, and setting up the infamous Ruffneck Ting club nights and record label...

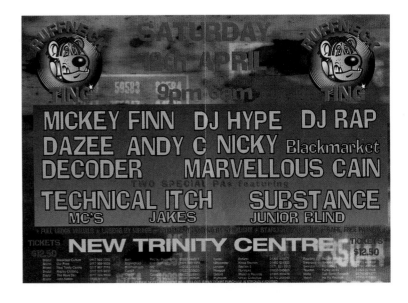

Dazee: I had just missed out on the Wild Bunch era when I came to Bristol. I got into the city's music scene through being friends with Nick Warren from Way Out West, and he was doing a night called Wiggle at the Hen & Chicken pub. You would hear everything from Black Sabbath to De La Soul to early house and Balearic stuff, so it was really eclectic, and it was great. Nick's partner was a guy called Disco Darren, and I was influenced by them and buying stuff like De La Soul, Jungle Brothers and Bim Sherman. Before this, I lived in Manchester so the records I bought with me were things like The Weather Prophets, Half Man Half Biscuit, early James and indie records so landing in Bristol sent me on a completely different direction musically. One of those records I had was a Warehouse Raves compilation with Smith & Mighty's Walk On By on it. For me, that was the standout track on that album and I played it over and over. It had that sample-based, breakbeat sound that jungle would grow out of.

When I first got into the rave sound, I hadn't quite distinguished between techno and the breakbeat jungle techno that was emerging. I remember being at a big rave and it was either Die or Jody – or Sub Love, which was both of them – DJing. The high-pitched clack of the break and the deep subs hit me, and that was it, like an epiphany. My heart and soul latched onto it, and that was all I wanted to hear from then on.

Bristol is a small place, so the hip hoppers, skaters, graffiti crews and the d&b crowd all overlaps. A lot of the artists that got into jungle started off making hip hop beats. You can hear the diverse cultural heritage of Bristol in the music, and each emerging style creates a sound and then that influences the next thing that comes out. The common denominator is probably the carefully crafted beats and basslines, and a soulful element; it's often melancholy. It was perhaps a bit less Amen driven and intense than the London sound was. You can hear the influences of Smith & Mighty, Tricky and Massive Attack who were driven by hip hop, funk, soul, reggae and dancehall, in the jungle and rave music that followed.

There were a lot of squat parties and free parties in and around Bristol back then. I remember parties in squats

on Ashley Road and the "Scout Hut" near Temple Meads. Then there were legal venues such as the Moon Club [now Lakota] and Sutra, which was a big rave based at the university. Acid jazz nights at The Thekla were a big thing in the late 80s and early 90s too; that whole movement doesn't get talked about much, but I think that was really influential. I started going out to free raves in the countryside and then eventually things like Universe and Dreamscape; it's all a bit of a blur now! Those free parties were significant for me though as that was where I first started out DJing.

A crew of us would go to AWOL, so when we started Ruffneck Ting, we wanted to bring what we heard in London back to Bristol. There were a few nights happening at the time, like Versatility which was Flynn & Flora's event and there was something called Positive Vibrations, but most of the South West scene was flourishing at the free parties. There were a lot of those going on, and then Castle Morton happened, and the Criminal Justice bill kicked in, and we didn't have those parties anymore. We were just desperate to hear the music after weekends of following cars to the middle of nowhere only to discover nothing was happening! We started off in 1993 doing Wednesday nights at a Jamaican pub in Stokes Croft called The Bank, which is now The Love Inn. That quickly took off, and from there we moved to the Malcolm X Centre and then on to The Depot, Trinity and Lakota. We were working with a reggae sound system called Excalibur, and we had a huge diverse cultural mix of people involved, although we didn't really think about it at the time as we were just all focused on the music. We were inspired by Randall and Kemistry & Storm so we started booking them. We always had the free party vibe, to begin with, and when there were two rooms, we would mix up the music to appeal to the people that hadn't got into d&b yet. We wanted to be accessible and warm and welcoming; the jungle poker face hadn't come to Bristol yet!

I started working on music with my housemate, Mark [who went on to form Kosheen] as Substance, and we

found our sound, which worked on the dancefloor at Ruffneck Ting. We decided to start the label and soon had a good deal with Vinyl Distribution in Reading, so that made it relatively easy to start putting out vinyl. While the club night had got us some attention, we started getting big press features when we started releasing music, but that wasn't why we were doing it. To be fair, we didn't really stop and think; it was just a natural process. We started the club because there weren't enough clubs and the reason we started making music was that we needed more music. We just wanted to create and contribute.

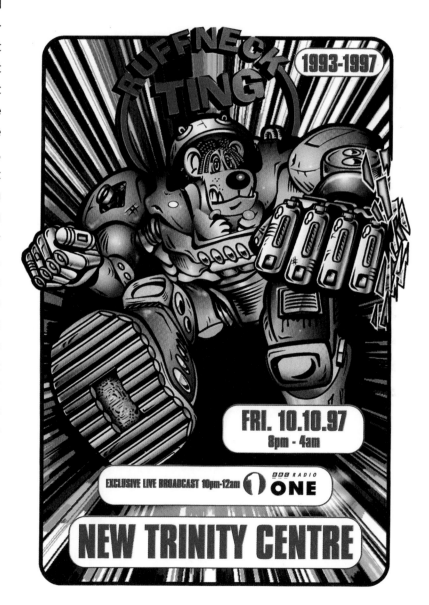

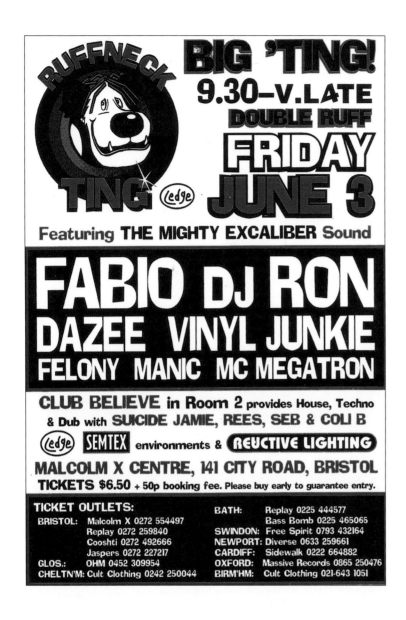

By the time I got booked at Dreamscape, it just felt like a part of what I needed to do. John Nation is a highly respected figure in Bristol, and he's a huge supporter of the music and graffiti scene and street art. He used to sort out the coaches to the raves and help organise line-ups, and I think that was how I got into playing there, so I have a lot to thank him for. I had played at a lot of things before

that, and I was used to big crowds, so I wasn't daunted. My main concern was that the needles wouldn't jump; that was always my worry! People tell me about tapes from certain events, or sets they've found on YouTube. I find it difficult remembering the actual moments, but the overall memory is that I liked being a raver as much as a DJ at those nights.

"We started Ruffneck Ting because there weren't enough clubs and the reason we started making music was that we needed more music. We just wanted to create and contribute."

These days I teach at BIMM [the British Institute of Modern Music], and a lot of my students are making d&b and starting labels so you can see the next generation coming through. We have new producers contacting Ruffneck Ting all the time and we've got a good roster of artists that keep delivering big tunes. There's a lot of music being made by a lot of people, so the difficulty is getting noticed so you have to do something really good to stand out.

It was great back in the day when M-Beat charted and then when New Forms won the Mercury and Roni put d&b on the map a bit more. There was a time in the late 00s when it seemed like the next generation was claiming d&b as theirs, but now there seems to be more respect for the foundations and the originators. The scene has always had that underground support which is what keeps it going. It fluctuates in popularity, but as long as it evolves, whilst keeping the respect for its roots, it will always be here.

MOVING FUSION
TURBULENCE (RAM RECORDS, 1998)

Following in the impressive lineage of drum n bass artists to emerge from Essex, Moving Fusion's debut on Ram Records was something of a changing of the guard and signalled that a new generation of producers was ready to step and make their mark. Turbulence was an immediate favourite with DJ, MCs and ravers and was the first in an impressive run of releases that went on well into the next decade, with the Atlantis EP, The Beginning EP and their remix of Bad Company's Four Days all being essential requirements for any DJ. One half of the duo, Sparfunk breaks down how it all came about...

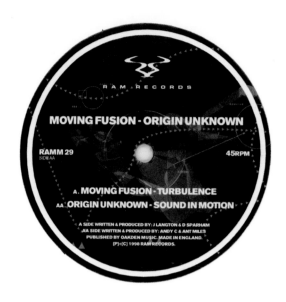

Sparfunk: I was into hardcore when it first started, then it got a bit industrial, and I went right off it. It was too dark with heavy sounds, and I didn't like the vibe it created in a rave. Then jungle came along, and I thought wow, and just got drawn back into it. I am happy to have lived through that period; I was seventeen, so it was the perfect time for me to be going out raving. I've got fond memories of those times. We would go around to our friends' houses that had decks because not all of us had them, but we were all buying vinyl here and there, and we'd play all different kinds of stuff. Shimon is a mate and massively inspired us with tracks like Quest and Nightflight.

Our first ever release was in 1997 under the name Outer Dynamics. It was a track called Bass Control which was on Trouble On Vinyl's Code Of The Streets album. I think Jeff had given the track to Clayton and he signed it; that was a good experience and got us a little buzz. We were bedroom producers to begin with and started off putting our tunes on tape. We knew Shimon so we'd pass them on to him and then Andy would hear them. I think he heard Bass Control but didn't really jump on it. When he saw it got

signed to TOV maybe he thought that we had something and started to listen a bit more.

People have said to us that Turbulence changed the game. We didn't know that at the time, we were just putting a beat together. It was all done using an Akai, so it was all sample-based but we built it from scratch rather than taking a big sample for a hook. We made it what it was.

On two occasions I had gone into a studio with someone I didn't know and tried to put a track together. I would turn up with a bunch of samples, and the guy was just trying to produce what I wanted. That was cool, but then Jeff bought a sampler, so we sat down, studied how to use it properly and learnt it inside out. We were good friends and were on the same wavelength, and having been doing this a long time I know that if you're working as a duo, chemistry is one of the main factors in coming up with good tunes. I am quite musical, and Jeff is really good at listening to things and suggesting how the track should be put together. We only had really basic

163

Moving Fusion, South West London (2002)

We were so young and naive at the time and just doing it for the fun of it. We weren't thinking about careers or DJing. We were making tunes for about two years before Turbulence came out. We had no idea how big it was going to be. We had put it on a tape and took it round to Shimon's and Andy turned up. We were on our way out, so we asked him to give it a listen. He was in the car in front of us, and he started putting his hand out of the window to signal he liked it. We took it to the studio to get it on to a DAT so he could cut it on dubplate. He was playing at Bar Rumba, and that was the first place it got played; it hadn't even been mixed down at this point. We were behind the decks with him and were watching the crowd; I remember the response when the bass came in, and it got a really good reaction. Andy obviously saw that too, so got us in the studio to mix it down. We didn't know what was planned as far as getting it released. I don't think we even knew what a mix down was!

We weren't DJing back then, we were just ravers. We'd go out and be with the people on the dancefloor, and that was a big factor in how Turbulence came about. We made something that we wanted to dance to. The scene was alive, and vinyl was selling. Ram was blowing up with tunes like Quest and Unlock The Secrets. I think the Sound In Motion album was probably already in the pipeline, so

equipment to begin with and made the best out of what we had, which really paid off when it came to that next stage of mixing it down. Everything had been finely tuned already, and then it got that extra boost when the Ram guys got involved as they had that experience and knew what to do with it. Shimon had been writing tunes on his own and Andy and Ant were still writing tracks as Origin Unknown. The stuff they were doing was sample-based in terms of how the beats were made, but there was no real hook. It had a certain sound to it, and the 2-step thing was just taking off.

they decided to include Turbulence on there, and they put it out on a one-sided 12" as a sampler for the album.

We were in the right place at the right time. We knew the right people who knew how to network it and release it, and we benefitted massively. The affiliation with Ram really helped us, and Jeff played a big part in taking us to the next level as he's quite business-minded so he knew we should get an agent and start DJing and really push things. Jeff had taken it a bit more seriously whereas I'd just wanted to get one release on Ram and I'd have been happy!

"It's just a proper raver's tune. It seems to have a never-ending life."

There was a remix of Turbulence, but it never came out because it was shockingly bad! We'd just got a new EMU sampler at the time, which was totally different from the Akai and we didn't really know how to use it. Someone suggested a remix so we did it, gave it to Andy and he cut it on dub. We heard it out. The build-up was ok but when it dropped it was just a mess! It took us a while to get used to the new sampler. I recently bought an Akai again and managed to retrieve the parts of Turbulence from the original disks so it's there if the time comes for a new mix, but it would have to be something special.

We'd made such a big tune and didn't really know how we had done it, so there was a feeling of will we be able to do this again. There was a bit of pressure, so now there was a different scenario in the studio. Before Turbulence, it was just us having fun.

The original still gets played now. It's just a proper raver's tune. It seems to have a never-ending life, perhaps more so than some of the other tracks that got released back then. I think we had a different texture to our drums, which are quite powerful and punchy. It's nice for the DJs to mix in from the intro and the build-up creates tension, and even now that comes through when it's played. I like to think it will just be played forever. There were a few big tunes from that period that still get played now, like Alien Girl and The Nine. Bad Company were big, and we'd been around D-Bridge and Maldini when they were Future Forces Inc, and they mixed down Bass Control for us as they were part of the TOV/Hardware crew. Vinyl was still selling back then so there was money to be made and Turbulence did massive things for us. I travelled the world off it, it changed our lives, and we experienced so much, and I look back on with great memories. Even when I was DJing a lot I still considered myself a raver. I didn't want to be behind the decks all night; I wanted to be in the crowd! We'd jump in the car with Andy when he was playing out and go along with him. I was still living at home and didn't really have any commitments.

Ram is a different label now, but back then there wasn't really any corporate involvement in the scene. The people making the music were doing it for the fun of it. We were doing things with a sampler that it probably wasn't designed for. We'd do crazy things to get some of the sounds we used. We'd record the sound you'd get when you skipped through a CD, filter it and make it part of a tune. The music now sounds extremely good in sonic quality, but I still appreciate the rawness of the sound back then, it was definitely the golden era of drum n bass.

ED RUSH, OPTICAL & FIERCE
ALIEN GIRL (PROTOTYPE, 1998)

By the second half of the 90s Matt Quinn, better known as Optical, had established himself as a highly regarded engineer and producer. Ben Settle [Ed Rush] had made his name with an impressive run of releases on labels such as Deejay and No U Turn. When the pair linked up, they took things to the next level with their Virus Recordings imprint becoming one of the biggest around and achieving "buy on sight" status almost immediately. In 1998 a collaboration with Fierce [Daniel Burke] for Grooverider's Prototype label resulted in one of the biggest drum n bass tracks of all time...

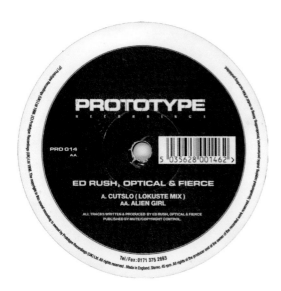

Optical: Me and my brother Matrix started learning how to make music when we were about 14 or 15. I had left home when I was 16 and lived in squats in London. This was in the early 90s, and I was DJing techno and hardcore playing for the Techno Travellers Soundsystem and Bedlam who were part of the free rave scene alongside Spiral Tribe. All of the rigs and DJs came together for the big raves like Castlemorton and Lechlade.

I had put my first record out at the end of '91 or early '92. A friend of mine from school had a packing job in the warehouse of Great Asset Distribution which was one of the first big distributors for dance music in England. Through him, I got a job making cups of tea in the studio. From there, I watched the engineers while they were working, and that was where I got my studio training from. I ended up being the studio manager for Pirate Club Records which was based in the Roller Express on Lea Valley Trading Estate. They had a studio in the back, and I basically lived in there on a little cot bed, so that was my home for a couple of years. I was engineering for other people, I did The Burial for Leviticus in there with Frost, and I worked with a lot of the happy hardcore guys like Billy Bunter. I had some releases on Just

Another Label and ran a studio for Stage 1000, who owns everyone's publishing these days. Through them, I started a bunch of labels. I had a techno label called Blame Technology, a drum n bass label, and then I was doing stuff for JAL too. It was a track a day, every day of the week at one point.

Ben [Ed Rush] lived near me in West London, and we both knew Nico from No U Turn, so I think we met around '94–'95 when the label was taking off. Nico had previously turned up at my mum's house and asked if I wanted to join his label as he had heard me and my brother made music, but at that point, I didn't really know him, so nothing came of it. My earlier drum n bass stuff was quite jazzy, but it wasn't just down to being involved with No U Turn that I got it into that harder style. I think that was just the way things were going at that time. Around '96–'97, we were all getting into experimenting with harder sounding tracks, and it was around that time I made To Shape The Future. The idea of techno in drum n bass was something that really appealed to me; I had the experience of working in both worlds, so

mixing the two made sense. In the late-90s, when that style became popular, it felt like things were moving more into my territory. I was getting a bit of recognition, so it made sense to get some releases on labels like Metalheadz and Prototype to become more well known.

"The idea of techno in drum n bass was something that really appealed to me."

The idea for Virus came along in '97. We had just started the label and needed a bunch of singles, so we were just cracking on and making tunes; we didn't think we were doing an album at the time. After a while, it became apparent that we had more than we could release, so we decided to put them all together, and that was Wormhole. I was working on that with Ben during the day, and then I would do another eight-hour session at night with Grooverider for his Mysteries Of Funk album. I was doing double sessions for most of '97 and '98. I was doing six days a week and 16 hours a day. I wasn't really aware of it at the time, but I had been on a bit of a roll in the studio, although I did burn out from that eventually in the end. Around 2005 I got bad tinnitus and was going deaf, I'm fine now, but at the time I thought it was the end of the world. There came a time where I realised I had to respect my body a bit more.

Alien Girl was made in the same period as Wormhole. Groove wanted something from me and Ben, and he already had the original version of Locuste, so it made sense for him to put it out. I think it's definitely one of the better 12"s we did as far as both sides being good. When we made tracks I was the one pushing the buttons in those days, and it was my studio, but like most engineers and producers I need other people to help create the vibe and come up with some of the ideas. It's hard to pinpoint who is responsible for what, but mostly it was about having a consensus on what was good and agreeing what should be in the track.

Like having a small committee of how the song should be. The primary reason for making those tunes was to play in our sets; if we were playing after Andy C at The End the next week, we wanted to have a bomb to drop on him.

The Simpsons sample wasn't discovered by us. It is interesting to know where it came from, but we had no idea at the time. We took it from a Zero G sample CD, but I didn't know it was the bus door from The Simpsons! It stood out though, and I think a lot of what was used on Alien Girl came from that one CD, but if you put those same samples in someone else's hands, I'm not sure what they would come up with. There was a feeling when we finished it that of all the things we'd made, this was the one I was really looking forward to dropping when I DJed that weekend because I knew it would just flatten people. Andy C was probably the first person to play it out, and I think the first time I heard it on a rig was at The End.

The way we worked back then meant you couldn't recall anything, so when you started something, it had to be finished. We haven't always constructed songs the way people do now. We would have all the loops running, and I would arrange the track by muting different parts on the mixing desk, so we might have to record it five times before it came out right. I think it's remained popular because you

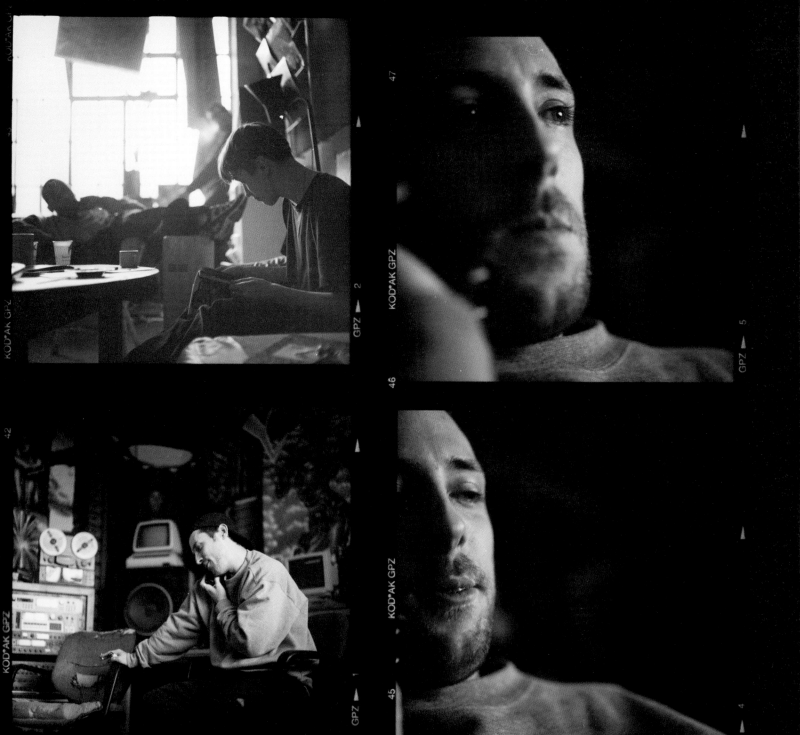

Optical in the studio (1997)

can still drop it in a modern set and it still has that feeling; that punch and that weight to it. A lot of old school does not come across that way compared to the mixdowns you get now on new music.

There was no real plan for Virus when we started, and we did not expect it to be a long-term thing, but sales were good from the first record, and I think we did about 40,000 copies of The Medicine. We had a six-figure offer for Wormhole, so when we said we were putting the album out ourselves, our agent and publicist told us we were fucking mad – they wanted us to take the money and run! At the time Trenton Harrison was my manager, and he also managed Goldie and Grooverider. I was doing Mysteries Of Funk for Sony, so we were constantly in meetings with major labels around that time, and I was doing remixes for all of them. There would be a couple a week for bands, and work on remixes for Grooverider – I did all his stuff for about five years. Trenton could get you three remixes a day if you wanted, although eventually I decided I was doing too many, and quit them altogether.

If we had put Wormhole out through a major it could have sat on the shelf for 18 months and then when it came out, they would tell us all the money had been spent on promotion. Starting Virus with that album was such a huge springboard for us. Before that, we might play tracks to other labels, and they would say it didn't fit their sound. No one else was making that style of music when we came out. It didn't sound like anything else, so we wanted control over it rather than risk leaving it up to people that didn't understand what we were doing. At the time there was no guarantee any of it would be well received by the public. We had a lot of help though, our publicist was Laurance Verfaillie, and she had worked with Geffen Records and Oasis, so she was really in with all the magazines and helped us go down the route of a semi-professional label without fucking it up. My publisher was Andrew King, who had managed Pink Floyd, so we had a lot of older, more experienced people helping us and giving advice. In the end, we sold over 100,000 copies of Wormhole, so we had

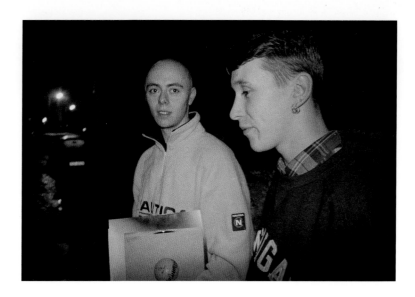

Ed Rush and Fierce outside Music House, North London (1997)

money in the company, bought a fat studio, got an office and had people working for us.

I didn't ever imagine how massive d&b would get and it took a while. We played Glastonbury in 1999 in the dance tent, and that was incredible. We had no idea people would go off like that, it was mad. That was an exciting time, and it was still quite a small group of us so we'd be travelling and bump into each other in random parts of the world. We played EDC in Las Vegas to 60,000 people which was mental.

The music wasn't really taken seriously by those outside of the scene until around '96–'97 when the big major labels started throwing money at everyone. The audience became a bit less diverse around that time too, but it felt safer. We all had a lot of trouble DJing in the mid-90s, getting attacked, bottles getting dashed at us, and I even had someone shoot a gun at me in a club. That was at the real peak of the jungle raves. A lot of people from that time say drum n bass died when garage came along, but I think that was just in their world. It turned into more of a student crowd, and the violent bad boy crowd moved on. Things got safer and a bit more fun, and it also seemed to be becoming more acceptable. Drum n bass has always had its ups and downs, but it's amazing how it never dies out.

BAD COMPANY
THE NINE (BC RECORDINGS, 1998)

As the 90s drew to a close, a changing of the guard began to emerge in the drum n bass world. The crowds were somewhat different, and tougher, darker music was dominating the raves. The foursome of D-Bridge, Vegas, Maldini and DJ Fresh, collectively known as Bad Company, were at the forefront of the new breed. Following a series of huge releases such as The Pulse and The Fear EP, their two albums Inside The Machine and Digital Nation (both released in 2000) would draw a line in the sand and set the standard for the next few years. However, The Nine is likely to be the track that most people first think of when you mention the group. Very much in the running for biggest d&b track of all time (and quite possibly the most played by DJs) it has continued to get a storming reaction from crowds since it was released in 1998, gradually growing in stature to become a peak time monster, with DJs teasing in its signature drop to instigate dancefloor mayhem

DJ Fresh: When I was 18, I decided to leave university to focus on my music. I'd spent my student loan on a sampler, but I had very limited equipment so it was hard to make anything that could be released. I knew MC Moose, and I think it was him that introduced me to DJ Ron. Lady Miss Kier from Deee-Lite was at Ron's studio, and she heard some of my music and asked me to produce some tracks for her album. The money she paid me for that gave me my first studio set up. I put out a 12" on K.U.S and then did a couple of things on Ron's label Picasso, one of which was a collaboration with Moose.

Around that time, I met Michael Vegas from Bad Company, who was my age but at the time had been a promoter in Japan working on some d&b parties. Moose introduced us and we hit it off. A guy called Aaron Ross, who manages

Jonas Blue, was a mate of mine from the pirate radio days and he took some of our tracks to Clayton at Renegade Hardware, and it was there that I met Darren [D-Bridge] and Jason [Maldini] from Future Forces. We started working together almost straight away and did a track called The Code (released as Absolute Zero & Subphonics). That was probably one of the biggest moments that any of us had experienced at that point. Off the back of that, we decided to start a record label, which was BC Recordings. The Nine was the first track we did under that guise.

Up until that point, I'd mostly been working on my own. The others were a bit more experienced than I was and a bit older. I didn't know many people, but they knew everyone like Ed Rush, Optical, Dom, Trace and Fierce, so they introduced me to a lot of those people. My input was the EMU 6400 sampler, which I guess I had become a bit of a virtuoso of. I was like the young kid with the new toy. I was obsessed with it and would spend every waking minute on it. It was becoming a popular piece of equipment at

the time because Optical was using it. I was showing them how to use that, and they were showing me how to do pretty much everything else.

I was playing on pirate radio and had been more into the jump-up sound and things like DJ Die and Full Cycle. Darren and Jason were more into techstep, and they helped me understand how minimal can be good, so through being around them and people like Optical and Trace, I started to get a feel for what made that music so cool and became more interested in that sound. I would sit there and play piano and strings, so they'd ask me about the more musical elements, like what key something was in or what notes would work. That was like a handicap for me almost; they would laugh because I'd write all these crazy orchestral sounding things and they'd say to remove 99% of it, and that's your drum n bass tune!

Jason and I made The Nine while still living at my mum's house, and I had a tiny studio in the attic with fairly basic equipment. The others guys in Bad Company think I jinx it when I do this, but there was a moment when I turned to Jason and told him I had a feeling it could be quite a big tune; he just smirked and didn't want to say anything. Even six months after it was released, it hadn't lived up to its potential, so it took a long time to become what it is now. People were playing it, but it wouldn't be the biggest track in the set. If you play The Nine on its own, it's actually quite mellow but I think it was when Andy C started to mix it in a way where he would double drop it with stuff, when you bring the Reese stab into the mix out of the blue and drop into that ride section; Andy played it in a way where it became a record with a big impact.

I think to begin with people had been more excited by The Code. That was massive, and everybody had been playing it, and it was on Renegade Hardware, so it had the credibility of Clayton's involvement and the other Hardware DJs playing it. I remember around the time we made it we were out with DJ Red from Trouble On Vinyl, and he asked if I felt under pressure to come up with something even better than The Code, as it was

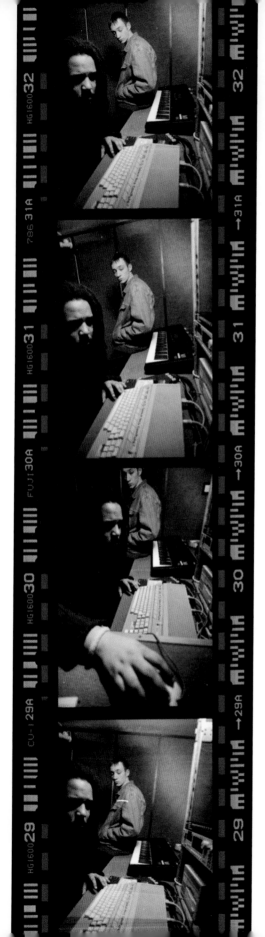

so popular. I decided I wouldn't let that ever affect the way I make music. You just try to make something good, and in theory, that's the winning train of thought: to feel free to make something unique. That mentality that we shared led to a lot of really cool stuff. None of us had things like houses or major overheads at that point, so we were just making and releasing the best music we could. We weren't driven by sales but we were probably selling more than most labels over that five-six year period. I'm tight with Andy and we'd discuss sales to get an idea of what was going on; I think us, Virus and Ram were leading the field at that point. The Nine was first released in 1998 and then we re-released it in 2001, there was a track on the B-side of the first pressing called The Bridge, but we had another track called Dog Fight that we liked so we thought rather than re-press the same version let's keep that one special and leave it as it was and then release a different version to make it a bit more collectable.

About 18 months after we started Bad Company and we were the big new thing, one journalist reviewed something of ours and was saying how sick it was, but asked if all we were capable of making was the dark sound. I remember thinking that was so annoying because I wanted to experiment and do other stuff and clearly if we stuck to the formula that people wanted, we would end up being pigeonholed. I made a point of trying to go against that even more, and I think that was what led to the styles changing by the time we did the Shot Down On Safari album which was much more across the board. We'd have something DJ Hype would play or something Fabio would play whereas, to begin with, we were just trying to perfect the sound we liked for particular DJs and a specific audience.

We were going out and seeing the excitement around the world, and there was a feeling that d&b was something people didn't know about and had yet to discover. We felt like this music was so good that surely anyone that heard it in the right circumstances would love it too. All of a sudden there was all this interest and along with Andy C and Hospital Records we felt that together the majority of the world was yet to experience the potential of what drum n bass could be and the talent that would come from it expanding. I remember being on the phone with Andy and sharing ideas and discussing what we could and couldn't do to make the music go further. Some things might dilute it too much. We wanted to try to get real d&b the kind of promotion it would need to get

DJ Fresh, London (1998)

into the spotlight so people could hear and appreciate it as it was. Around the time I started releasing Pendulum's music on Breakbeat Kaos, a friend introduced me to Zane Lowe, and he was a fan of Bad Company. Zane and Mary Anne Hobbs were a big part of the mainstream crossover; Mary Anne was one of the first people at Radio 1 to really support the music.

> *"We felt like this music was so good that surely anyone that heard it in the right circumstances would love it too."*

Bad Company had some other massive tracks that maybe weren't as big as The Nine, but something like Planet Dust arguably isn't far off. We might've had the biggest track of the year with something like that or The Pulse, but we never made anything that was going to equal The Nine in terms of its simplicity and its accessibility across the whole spectrum of D&B. It's the same with my solo stuff, and maybe I'll never have a vocal track that's as big as Gold Dust or Hot Right Now. The hard thing about being a producer is that you have these moments that you're blessed with, like some kiss from the heavens you get given this piece of music, and you don't know why you made it or where it came from. I've had a few of those throughout my career. You appreciate that they happen and it's incredible to see how they can change your life, but the irony is that once you've had one of those you're also very aware that you never have such a big musical moment again. Trying to make music whilst living with the thought that you might never make a bigger track is a bit of a head fuck, but at the same time, it's a blessing and an honour to have been part of the legacy of drum n bass with even just one tune.

Renegade Hardware crew, South London (1998)

THANKS TO EVERYONE WHO PRE-ORDERED THE BOOK

Stephen Allen, Errol Anderson, Lee Attreed, Christopher Au, Rob B, Andy Baddaley, Geoffrey Barnard, Denys Bassett-Jones, Dominic Bastyra, Richard Bellis, Matthew Bats Belwood, John Biddle, Frederik Birket-Smith, Tim Bond, Tom Botting, Dean Bowen, Michael Bradley, Luke Bradshaw, Abban Brennan, Scott Brewer, Neil Burdon, Todd Burns, Matt Butler, Dominic Castello, Sharon Chapman, Mark Cheesbrough, Gavin Cheung, Disorda Dub Chronicles, Fritz Clark, Paul Clarke, Will Clifford, Angela Coletta, Steve Collins, Sam Conran, David Cotgrave, Darren Cowley, Neil Cressy, John Crossland, Tom Culverwell, James Currie, James Curtis, Dean Cuthbert, Toby Cutler, Craig Czyz, DJ DS (Dave Da Silva), Nick 'Bionick' Davidson, Huw Davies, Ross Denoon, Philip Dewhurst, Justin Dolby, Olivier Ducret, Sam Duggan, Satinder Duhra, Anthony Finch, Ben Flanagan, Kara Fleisher, Paul Fletcher, Emma Flint, Tim Forrester, Elly Foster, Jon Fox, Paul Francombe, Evan Friel, Michele Galloway, Phil Gill, Sean Gill, Tobias Ginsberg, John Goodwin, Daniel Gould, Sandro Grünig, Thomas Gudgeon, Marc Hack, Lee Hammond, Robert Handrow, Mark Harford, Mathew Harwood, Jonatan Hasselkvist, Steve Haswell, Tommy Hazelwood, Frazer Healey (DJ Cronicle), Martin Hodgson, James Holloway, Craig Holmes, Nick Horn, Jonathan Horsfield, Chris Hughes, Edward Isherwood, Martin James, David Jemison, Neil Johnston, KALEV KÄÄPA, Si Kemp, Dave Kimberling, Kelley L Knight, Steffen Korthals, Elizabeth Labovitch, Kyan Laslett O'Brien, Andrew Latham, Jen Lau, Mr Lawson, Rosie Lee, Andrew Lees, Mark Lewis, Shane Lightowler, Dean Lofthouse, Robert Luis, Aly Lyon, Daniel Maddocks, Robert Martin, Steve Martin, Didac Trave Martos, Phil Meadows, Neil McCann, Neil McCullough, Oliver Moira, Tom Morgan, Ben Morris, Brendon Mullins, Lawrence Murphy, Hamza Murtaza, Lee Neville, Jackie Nolan, Steve Norris, Simon Oleary, Stuart Omoe, Steve Owen, Deliverance Oy, Malcolm Paine, Matthew Parsons, Elliot Payne, Samuel Perez-Velez, Martin Perrott, Karl Poulton, Aex Powell, Ryan Proctor, Mark Purcell, John Quinn, Damien Ratcliffe, Jonathan Richards, Nicholas Richards, Santino Roberts, Maxence Robinet, Scott Ronan, Edward Ross, Robert Russell, Marta Perez Sainero, Lee Sanders, Kaspar Schlüer, Michael Seddon, Doug Shipton, Sally Shone, Pablo Smet, Steven Snooks, Eivind Søreide Solsvik, Martyn Spencer, Mark Stafford, Anthony Stephenson, Shawn Stone, Leigh Strydom, Kristen Sundholm, James Symes, Kieron Swift, Michele Tessadri, Calvin Thurston, Claire Topliss, David Trigg, Bryn Tyson-Diggle, Russell Ventilla, Sascha Walter, Max Ward, Michael Ward, Mike Watkins, Bryan Webb, Dan Whittle, David Willard, James Wilson, Philip Wise, Mark Wood and Max, Zoe & Symon